AGATA & PiERRE TOROMANOFF

MODE
TRENDS, DIE IMMER WIEDERKEHREN

DÉJÀ VU

STYLE
FASHION TRENDS THAT MADE A COMEBACK

teNeues

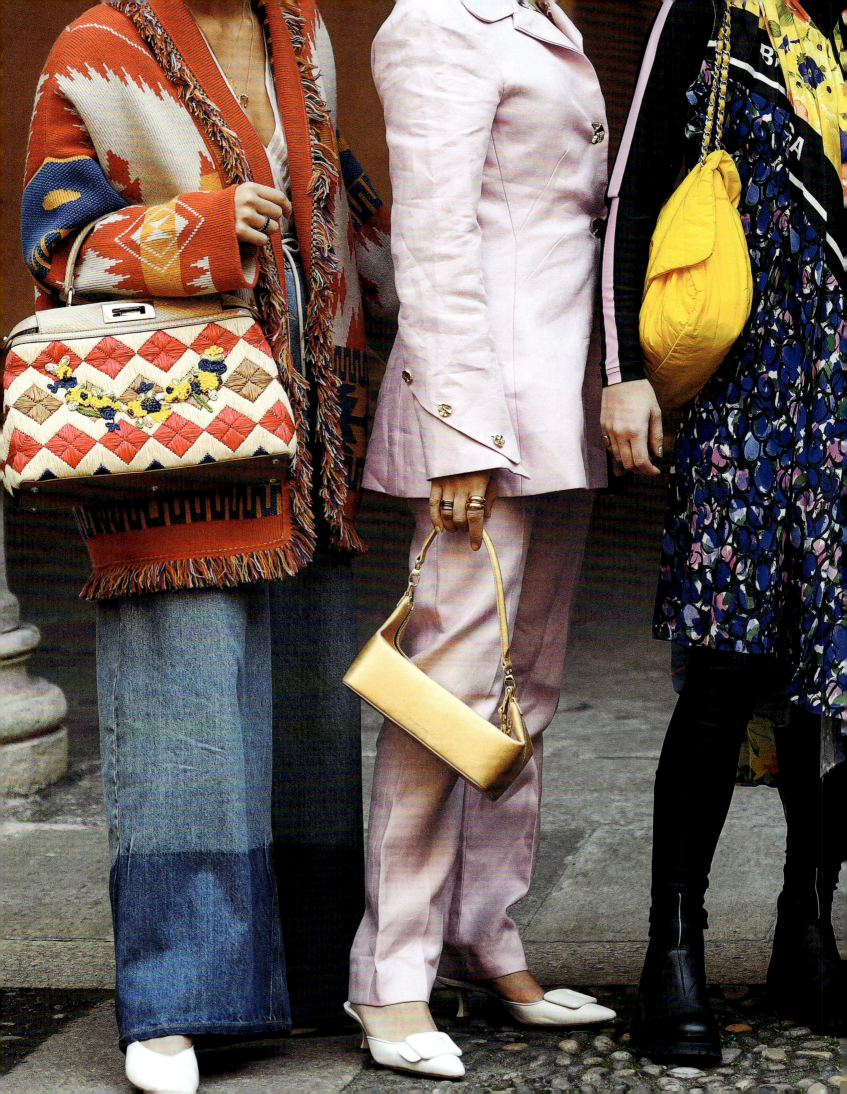

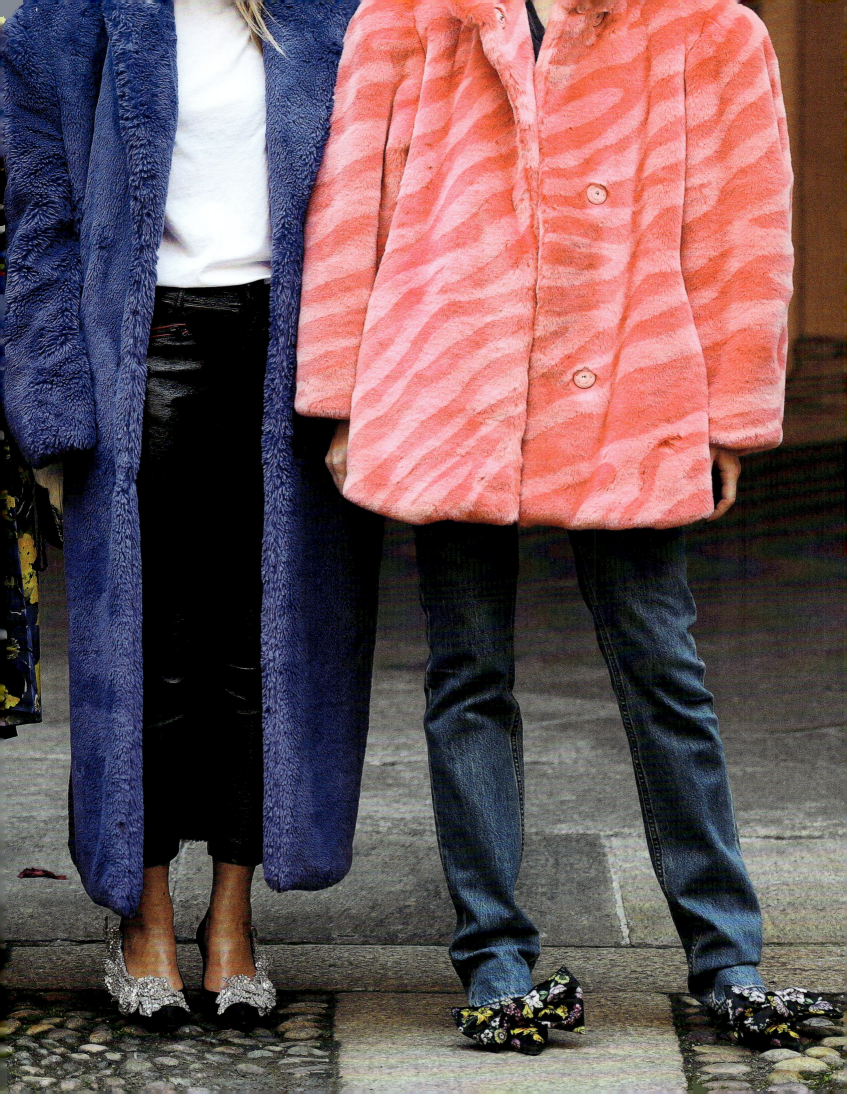

Contents

INTRODUCTION	6
A CONVERSATION WITH ELISABETH CLAUSS	8
CHAPTER 1: DRESSES AND SKIRTS	12
CHAPTER 2: BLOUSES AND JUMPERS	36
CHAPTER 3: TROUSERS, SHORTS, OVERALLS, JUMPSUITS, AND TRACKSUITS	58
CHAPTER 4: SUITS	88
CHAPTER 5: COATS AND JACKETS	94
CHAPTER 6: SHOES AND BOOTS	112
CHAPTER 7: ACCESSORIES	136
CHAPTER 8: STYLES AND TRENDS	158
CHAPTER 9: MATERIALS AND HANDICRAFTS	180
CHAPTER 10: PATTERNS	188
THINKING ABOUT SUSTAINABILITY?	204
LIST OF REFERENCES AND ACKNOWLEDGEMENTS	206
PHOTO CREDITS	207

Inhalt

EINLEITUNG — 7

EIN GESPRÄCH MIT ELISABETH CLAUSS — 10

KAPITEL 1: KLEIDER UND RÖCKE — 12

KAPITEL 2: BLUSEN UND PULLOVER — 36

KAPITEL 3: HOSEN, SHORTS, LATZHOSEN, OVERALLS UND TRAININGSANZÜGE — 58

KAPITEL 4: ANZÜGE UND KOSTÜME — 88

KAPITEL 5: MÄNTEL UND JACKEN — 94

KAPITEL 6: SCHUHE UND STIEFEL — 112

KAPITEL 7: ACCESSOIRES — 136

KAPITEL 8: STILE UND TRENDS — 158

KAPITEL 9: STOFFE UND HANDARBEITEN — 180

KAPITEL 10: MUSTER — 188

WIE KANN ICH MODE MIT NACHHALTIGKEIT VERBINDEN? — 205

QUELLENVERZEICHNIS UND DANKSAGUNG — 206

BILDNACHWEIS — 207

Introduction

"Yesterday's fashions are boring, those of the former days and the distant past keep charming us"[1]

Gilles Lipovetsky, *The Empire of Fashion*

We all played dress-up with mum's clothes and shoes when we were young, and loved discovering, in a corner of the attic, dresses, shoes, accessories and coats that were worn once by a grandmother or a great-grandmother. There were also dolls' clothes, often sewn at home from scraps of fabric or old garments, which reflected the fashions and colours of different periods, as the dolls themselves might have passed through the hands of aunts, cousins and siblings before landing in yours.
These games were an opportunity to explore textures, cuts, and ornamental patterns that sometimes looked out of fashion, but were all the more intriguing because of that. Another childhood pastime that provided insight into the fashions of times we never experienced, or only vaguely remembered: flipping through old photo albums and discovering ancestors dressed in the style of their era. And there was always a fair share of surprises such as coming across a photo of your grandfather, who now lives only for his vegetable garden, as a wild hippie in his youth, or your mom looking great in her fluorescent disco jumpsuit paired with go-go boots.

All these early encounters with clothing from another era may explain the current trend for what is coming back into fashion after a hiatus of one or two generations: they reawaken our visual memories, thus creating a familiar and pleasant feeling of déjà-vu. Fashion plays on our desires and our nostalgia, on our wish to appropriate the dress codes of a golden age, whether it be the cigarette trousers of the 1950s, the crochet dress of the 1970s or the crop top of the 1990s. The retro-vintage trend had already paved the way for these glimpses into the past, but its focus is to precisely recreate the look of a given time, or a particular style.
The idea of wearing again clothes that were once fashionable, or even cult items, before falling into temporary oblivion takes a different approach: it is about inventing a new look with elements borrowed from different styles, decades, and influences.
It means enjoying fashion à la carte rather than according to a set pattern. As the French philosopher Gilles Lipovetsky pointed out in *The Empire of Fashion*, a prescient essay written in 1987, "Inconstancy in terms of shapes and ornamentation is no longer the exception but the permanent rule"[2]. He thus acknowledged the end of fashion as a system driven by two annual seasons and the creative explosion that would characterise the decades to come. Fashion has become a huge, ever-expanding whirlwind that drags past trends in its wake and suddenly puts them back on top of the upward spiral. Fuelled by the genius of fashion designers, the new trends emerging on social networks and in the footsteps of streetwear, this fashion vortex has even swept away the notion of anti-fashion: henceforth, any trend that defines itself as going against the mainstream is potentially tomorrow's new fashion. It is almost dizzying to think about the infinite possibilities of today's fashion.

This book features around 100 garments and accessories that have experienced heydays and hiatuses and are now once again in the spotlight. Some of them have a long history dating back to antiquity, while others are due to (lucky) manufacturing mistakes. Many of them had a utilitarian role before becoming cult fashion items. Others were standards of a countercultural protest and have become classics over the years. Once you know their history and the reasons why they have been so popular, you may want to try them out in your own wardrobe, assuming they aren't already there, of course.

Einleitung

"Die Mode von gestern ist langweilig, aber die von früher und die von noch früher bezaubert uns immer wieder."[1]

Gilles Lipovetsky, *The Empire of Fashion*

Als wir klein waren, haben wir alle mit Mutters Kleidern und Schuhen gespielt und es geliebt, in einer Ecke des Dachbodens Kleider, Schuhe, Accessoires und Mäntel zu entdecken, die einst von unserer Großmutter oder Urgroßmutter getragen wurden. Wir besaßen auch Puppenkleider, die zum Teil aus Stoffresten oder alten Kleidungsstücken genäht wurden und die Mode und Farben der verschiedenen Epochen widerspiegelten, da die Puppen selbst durch die Hände von Tanten, Cousinen und Geschwistern gegangen waren, bevor sie bei uns landeten. Dank dieser Spielsachen konnten wir Strukturen, Schnitte und Ornamentmuster kennenlernen, die manchmal aus der Mode kamen, aber gerade deshalb umso faszinierender waren. Ein weiterer Zeitvertreib in der Kindheit, der uns Einblicke in die Mode der Vergangenheit ermöglichte, die wir nie erlebt haben oder an die wir uns nur vage erinnern können, war das Blättern in alten Fotoalben und das Entdecken von Vorfahren, die im Stile ihrer Zeit gekleidet waren. Dabei gab es immer wieder Überraschungen, wie z. B. ein Foto von einem Großvater, der heute nur noch für seinen Gemüsegarten lebt, aber in seiner Jugend ein wilder Hippie war, oder eines der Mutter, die in ihrem fluoreszierenden Discooverall und den Gogo-Stiefeln einfach toll aussah.

All diese frühen Begegnungen mit Kleidungsstücken aus anderen Epochen erklären vielleicht den aktuellen Trend zu dem, was nach ein oder zwei Generationen wieder in Mode kommt: Sie wecken unsere visuellen Erinnerungen und sorgen so für ein Déjà-vu, das uns ein vertrautes und angenehmes Gefühl beschert. Die Mode spielt mit unseren Sehnsüchten, unseren nostalgischen Gedanken und unserem Wunsch, uns die Kleiderordnung eines goldenen Zeitalters anzueignen, wie die Zigarettenhose der 1950er-Jahre, das Häkelkleid der 1970er-Jahre oder das bauchfreie Oberteil der 1990er-Jahre. Der Retro-Vintage-Trend hatte uns diesen Blick in die Vergangenheit bereits eröffnet, doch sein Schwerpunkt liegt auf der genauen Nachbildung des Looks einer bestimmten Zeit oder eines bestimmten Stils. Die Idee, Kleidungsstücke wieder zu tragen, die einst modisch waren oder sogar Kultstatus besaßen, bevor sie vorübergehend in Vergessenheit gerieten, verfolgt einen anderen Ansatz: Es geht darum, einen neuen Look mit Elementen zu erfinden, die aus verschiedenen Stilen, Jahrzehnten und Einflüssen stammen. So wird Mode à la carte und nicht nach einem festen Schema zelebriert. Wie der französische Philosoph Gilles Lipovetsky in seinem 1987 verfassten Essay *The Empire of Fashion* resümierte, „stellt die Unbeständigkeit der Formen und Verzierungen nicht mehr die Ausnahme, sondern die Regel dar"[2]. Er räumte damit das Ende der Mode als ein von zwei jährlichen Saisons bestimmtes System ein und honorierte gleichzeitig die explodierende Kreativität, die die kommenden Jahrzehnte prägen sollte. Die Mode ist zu einem riesigen, sich immer weiter ausbreitenden Wirbelwind geworden, der vergangene Trends mit sich reißt und sie plötzlich wieder auf Erfolgskurs bringt. Angetrieben vom Genie der Modedesigner, den neuen Trends in den sozialen Netzwerken und den Spuren der Streetwear hat dieser Modewirbel sogar den Begriff der Anti-Mode hinweggefegt: Von nun an ist jeder Trend, der sich gegen den Mainstream richtet, potenziell die neue Mode von morgen. Es ist geradezu schwindelerregend, über die unendlichen Möglichkeiten der heutigen Mode nachzudenken.

In diesem Buch werden rund 100 Kleidungsstücke und Accessoires vorgestellt, die ihre Blütezeit erlebt haben und nun wieder ins Rampenlicht zurückgekehrt sind. Einige von ihnen haben eine lange Geschichte, die bis in die Antike zurückreicht, während andere auf (glückliche) Herstellungsfehler zurückzuführen sind. Viele von ihnen dienten als Gebrauchsgegenstände, bevor sie zum heiß begehrten Modeartikel wurden. Andere gehörten zu einer sich gegen das Establishment auflehnenden Gegenkultur und sind im Laufe der Jahre zu Klassikern geworden. Wenn Sie ihre Geschichte kennen und wissen, warum sie so beliebt gewesen sind, möchten Sie sie vielleicht selbst einmal tragen – falls sie nicht schon längst in Ihrem Kleiderschrank vorhanden sind.

A conversation with Elisabeth Clauss

Elisabeth Clauss is a fashion journalist who also writes about societal themes for the women's press and general news organisations (*Elle* and *L'Officiel Belgique*, *Madame Figaro*, among many others). Her field of interest embraces the sociological dimension of fashion, its paradoxes, quandaries, and constant renewal. To her fashion reflects our lives, foretells what's coming next, and it opens new horizons each season.

After the revival of fashions from the 1950s to the 1970s around the turn of the millennium, we are now seeing updated takes on iconic garments from the 1990s. What do you think makes clothing styles worn by previous generations so appealing?

As it is often the case with trends and sociology, fashion operates through crossroads, just like the architecture of a city: styles intersect, there are junctions where several elements meet, and a new phenomenon emerges. The interest in an era that was stylistically strong is driven by nostalgia and by designs that are emblematic of a certain way of life. In a time of tension and uncertainty about the future, there is something familiar and comforting about the idealised recent past. By adopting the styles of previous eras, you immerse yourself into familiar territory. Interestingly, it is usually the next generation that picks up on the dress codes of the previous one, rather than the one that was involved diving back into its wardrobes.

Let's take, for example, Netflix's *Stranger Things*, a sci-fi series set in the early 1980s; its audience was born after the 2000s, and so didn't live through the years in which the plot is set, since it's when Generation Z's parents were young. But fans of the series idealise the 1980s as a decade of freedom, of innovation — which it was, but not only that: there were also difficulties and tensions, but these have been swept aside. In the 1990s, the generation of teenagers who were rediscovering the 1970s had not experienced them because they had just been born. Instead, it was their parents' everyday life. To rediscover the fashion trends of an era is to become anchored in them, to appropriate them and to choose to grow up with them. Because all these elements of fashion from the 1970s, such as bell bottom pants, are social codes even more than clothes. Fashion is above all sociology, with codes, reference marks, signs of belonging and rebellion: by appropriating one style or another, we adopt a universe and an attitude. Choosing elements from various styles and epochs, and mixing them is different from a total look approach, where girls, for instance, would adopt a very 1950s pin-up look, or the boys a pronounced rock style — in this case, we are more into retro.

The pace at which the world moves is accelerating, and this phenomenon also affects fashion. New trends follow one another, the possibilities expand, and the rhythm of the two seasons (spring-summer and autumn-winter) that structured the fashion market not so long ago has almost been forgotten. New garments are being launched all the time. In reaction to this phenomenon, referring to a past era allows us to stop time, at least temporarily. By adopting the look of the 1980s, which are still very much in the air, we escape the frenzy of the present day, even if there is never a real comeback to the past: the clothes of that era are revisited and reinvented, enriched by the experience of the years that followed, in a kind of snowball effect. We see the hippie style of the 1970s in the light of the years that have passed in the meantime. What is coming back to the forefront is not a carbon copy of what was there before. Nostalgia is enriched and nourished by the history that has unfolded since that time. Moreover, to get back to the notion of social codes, we don't have the same rebellious mood or the same intentions today when we wear hippie clothes as those who wore them fifty years ago. The next day, you can very easily put on a jacket with shoulder pads reminiscent of an executive woman in the 1980s. Fashion is a vector of our mood, of our state of mind, it helps us to identify and express ourselves in our current context.

What do you think are the qualities that allow a garment to come back to the fore after a long eclipse: Its functionality? The historical period to which it belongs? The fact that it is still avant-garde and original?

It is often a combination of several elements. However, in terms of functionality, new materials and technological innovations have brought more comfort. Today we have synthetic or natural fabrics that are more and more elaborate, weather resistant and pleasant to wear, soft, adjustable, and washable. This enables us to have clothes that are perfectly cut without requiring special care. The functionality of a garment is not necessarily a determining factor for its comeback, since technological innovation adds comfort, and cuts are taken up and readapted. As for the avant-garde side, a garment that was avant-garde in the 1960s is no longer so by definition, but wearing it sends a message of identification with a particular community or urban tribe: hippie, punk, grunge. It is an element of belonging, but it can equally reflect a momentary mood, especially among young people who may switch from one style to another to fit in with a group.

In the same spirit, we can also observe the comeback of iconic haircuts, such as the typical mullet cut of the 1980s. In the fashion shows, I saw a move from very structured haircuts to more natural, loose, 'out of bed' ones – even though it's all very calibrated – the 'tousled' style gives an impression of spontaneity, but it's actually very elaborate. There has been a revival of the bun, then various phases of fringes, or crushes on a particular hair colour. Trends for naturalness follow years of sophistication, but in this day and age you can go from one to the other in a week. We have limitless possibilities. It is always important to remember that hair and make-up are as much a part of the look as the clothes.

Luxury brands, such as Gucci, Hermès, and Prada, no longer hesitate to appropriate accessories or pieces of clothing from streetwear such as the fanny pack and the bucket hat, or certain elements of style (punk, grunge). What role can designers and established fashion brands play in bringing this or that garment or accessory back to the catwalk?

Luxury brands have long appropriated elements of streetwear, and vice versa. It is how fashion works, in a constant conversation between the catwalk and the street: they inspire each other, they keep a fruitful dialogue, even if there have been splits, like the punk trend in the 1970s. We can usually find several reasons for a garment to enjoy a comeback: commercial motivations, when you see that a piece of clothing meets public support and popularity, it is then normal that it is relaunched in an updated version. The role of fashion is to create a desire, to create a formal language. Some garments fall into oblivion because they seem obsolete at a given moment – I'm thinking in particular of corsets – but they always end up resurfacing. I can't think of any garment that's ever been thrown away – except maybe pannier (basket) dresses. Peplum jackets, for example, are a reminiscence of crinolines. It's not necessarily fatigue that pushes clothes out the door, it's more the evolution of fashion: suddenly you get excited about something else, you move to another style. Variations in style also play a role: take the turtleneck jumper, which is available in different collar shapes. All of them correspond to a particular fashion era.

What role do TV series, films and social networks play in this phenomenon of reviving past fashions?

In the case of series, it's hard to know what influence they have, because we don't usually watch just one, or several about the same historical epoch. Generations Y and Z tend to compose their look from several eras and according to their mood. The series promote and reinterpret iconic looks, and it allows you to choose and sort. Sometimes you may want to try on something you've never worn before, but it's a long way from changing your wardrobe. Designers and costume designers are inspired by what they see on the catwalk – we are back to the idea of the ongoing conversation – and this has an amplifying effect because the audience then has the impression that they have already seen this.

We have so many sources of inspiration today, with social networks, movies, and series that it is almost impossible to know what really influenced you. You need various elements to create your own look, your personality, and to define your identity. Fashion is very cyclical, but it's a spiral cycle, not a circular one, you never come back to the same place, you pick up a little bit on your way, like a snowball. What seems to be out of fashion today will be back in fashion tomorrow, but differently.

What clothes from past decades would you personally like to see again on the catwalk?

What I like about fashion is that it is always changing, and that it reflects historical times, their evolution, our society, and its aspirations. I do not think of any clothes from past decades that I would like to see come back: what I find interesting is what next fashion trends will tell us and reflect. I'm not nostalgic about fashion, I'm curious about the future.

Ein Gespräch mit Elisabeth Clauss

Elisabeth Clauss ist Modejournalistin und schreibt auch über gesellschaftliche Themen für die Frauenpresse und allgemeine Nachrichtendienste (*Elle*, *l'Officiel Belgique*, *Madame Figaro* und viele andere). Ihr Interessengebiet umfasst die soziologische Dimension der Mode, ihre Paradoxien, Konflikte und ständige Erneuerung. Für sie spiegelt die Mode unser Leben wider, sagt unsere Zukunft voraus und erweitert unseren Horizont in jeder Saison.

Nach dem Revival der Mode aus den 1950er- bis 1970er-Jahren um die Jahrtausendwende werden nun ikonische Kleidungsstücke aus den 1990er-Jahren neu interpretiert. Was macht Ihrer Meinung nach den Kleidungsstil früherer Generationen so attraktiv?

Wie bei Trends und in der Soziologie gibt es auch in der Mode Querstraßen: Stile überschneiden sich, es gibt Kreuzungen, an denen mehrere Elemente aufeinandertreffen und ein neues Phänomen entsteht. Das Interesse an einer stilistisch starken Epoche wird von Nostalgie und Designs angetrieben, die für eine bestimmte Lebensart stehen. In einer Zeit voller Spannungen und Ungewissheit über die Zukunft bietet die idealisierte jüngste Vergangenheit etwas Vertrautes und Tröstliches. Indem Sie die Stile früherer Epochen übernehmen, betreten Sie vertrautes Terrain. Interessanterweise ist es in der Regel die nächste Generation, die die Kleiderordnung der vorangegangenen Generation übernimmt, und nicht die Generation, die dafür noch auf ihre eigenen Kleiderschränke zurückgreifen könnte. Nehmen wir zum Beispiel die Netflix-Serie „Stranger Things", eine Science-Fiction-Serie, die in den frühen 1980er-Jahren spielt. Die Zuschauer sind nach den 2000er-Jahren geboren und haben die Jahre, in denen die Handlung spielt, nicht miterlebt, da die Eltern der Generation Z zu dieser Zeit jung waren. Aber die Fans der Serie idealisieren die 1980er-Jahre als ein Jahrzehnt der Freiheit und der Innovationen – das war es auch, aber eben nicht nur: Es gab auch Schwierigkeiten und Spannungen, aber diese werden beiseite geschoben. In den 1990er-Jahren hatte die Generation der Jugendlichen, die die 1970er-Jahre wiederentdeckte, diese selbst nicht erlebt, weil sie gerade erst geboren worden war. Stattdessen handelte es sich um das Alltagsleben ihrer Eltern. Die Modetrends einer Epoche wiederzuentdecken, bedeutet, sich in ihnen zu verankern, sie sich anzueignen und mit ihnen aufzuwachsen. Denn all diese Elemente der Mode der 1970er-Jahre wie z.B. die Schlaghosen stellen nicht nur Kleidung dar, sondern vor allem soziale Codes. Mode ist vor allem Soziologie – mit Codes, Bezügen, Zeichen der Zugehörigkeit und der Rebellion. Indem wir uns den einen oder anderen Stil aneignen, übernehmen wir ein Universum und eine Haltung. Wenn man Elemente aus verschiedenen Stilen und Epochen auswählt und mischt, folgt man dabei nicht dem Total-Look-Ansatz, bei dem sich die Mädchen beispielsweise einen Pin-up-Look aus den 1950er-Jahre und die Jungs etwas im ausgeprägten Rock Style aussuchen würden – in diesem Fall stehen wir mehr auf Retro.

Das Tempo, in dem sich die Welt bewegt, beschleunigt sich und dieses Phänomen betrifft auch die Mode. Neue Trends folgen aufeinander, die Möglichkeiten vervielfachen sich und der Rhythmus der beiden Jahreszeiten (Frühling/Sommer und Herbst/Winter), der den Modemarkt vor nicht allzu langer Zeit strukturierte, ist fast vergessen. Ständig werden neue Kleidungsstücke auf den Markt gebracht. Als Reaktion auf dieses Phänomen erlaubt uns der Verweis auf eine vergangene Epoche, die Zeit zumindest vorübergehend anzuhalten. Indem wir uns den Look der 1980er-Jahre zu eigen machen, der immer noch in der Luft liegt, entkommen wir der Hektik der Gegenwart, auch wenn es nie eine wirkliche Rückkehr in die Vergangenheit gibt: Die Kleider dieser Epoche werden wieder aufgegriffen und neu erfunden und zwar anhand einer Art Schneeballeffekt, der sich aus den Erfahrungen der darauf folgenden Jahre speist. Wir sehen den Hippie Style der 1970er-Jahre im Licht der Jahre, die inzwischen vergangen sind. Was jetzt wieder in den Vordergrund rückt, ist keine Kopie dessen, was vorher da war. Die Nostalgie nährt sich von der Geschichte, die sich seit dieser Zeit ereignet hat. Außerdem – um auf den Begriff der sozialen Codes zurückzukommen – haben wir heute nicht die gleiche rebellische Stimmung oder die gleichen Absichten, wenn wir Hippiekleidung tragen, wie diejenigen, die sie vor fünfzig Jahren trugen. Am nächsten Tag können Sie ganz einfach eine Jacke mit Schulterpolstern anziehen, die an eine Managerin in den 1980er-Jahren erinnert. Mode ist ein Stimmungsträger. Sie hilft uns, uns in unserem aktuellen Kontext zu identifizieren und auszudrücken.

Was sind Ihrer Meinung nach die Eigenschaften, die es einem Kleidungsstück ermöglichen, nach einer langen Zeit aus der Versenkung zurückzukehren? Seine Funktionalität? Die historische Periode, zu der es gehört? Die Tatsache, dass es immer noch avantgardistisch und originell ist?

Oft handelt es sich um eine Kombination aus mehreren Aspekten. Was jedoch die Funktionalität betrifft, so haben neue Materialien und technologische Innovationen für mehr Komfort gesorgt. Heute gibt es synthetische und natürliche Stoffe, die immer raffinierter, wetterbeständiger, angenehmer auf der Haut, weicher, anpassungsfähiger und waschbarer werden. Dadurch haben wir perfekt geschnittene Kleidungsstücke, die keine besondere Pflege erfordern. Die Funktionalität eines Kleidungsstücks ist nicht unbedingt ausschlaggebend für sein Comeback, denn technologische Innovationen erhöhen den Komfort und Schnitte werden aufgegriffen und neu angepasst. Was die Avantgarde betrifft, so ist ein Kleidungsstück, das in den 1960er-Jahren avantgardistisch war, heute per Definition nicht mehr avantgardistisch, aber das Tragen eines solchen Kleidungsstücks vermittelt eine Botschaft der Identifikation mit einer bestimmten Gemeinschaft oder einer urbanen Bewegung: Hippie, Punk, Grunge. Das Kleidungsstück stellt ein Element der Zugehörigkeit dar, kann aber auch eine momentane Stimmung widerspiegeln, insbesondere bei jungen Menschen, die von einem Stil zum anderen wechseln, um zu einer Gruppe zu gehören.

In diesem Sinne sollte auch das Comeback ikonischer Haarschnitte betrachtet werden, wie etwa die typische Vokuhilafrisur der 1980er-Jahre. Bei den Modeschauen habe ich eine Entwicklung von sehr strukturierten Schnitten hin zu natürlicheren und lockeren Frisuren beobachtet, die wie ‚gerade aus dem Bett gestiegen' aussehen. Auch wenn das alles sehr kalkuliert ist, vermittelt der ‚zerzauste' Stil den Eindruck von Spontaneität, obwohl er eigentlich ein sehr aufwendiger Look ist. Es gab ein Revival des Dutts, dann kamen verschiedene Ponyfrisuren und bestimmte Haarfarben in Mode. Der Trend zur Natürlichkeit folgt auf Jahre der Raffinesse, aber in der heutigen Zeit kann man innerhalb einer Woche vom einen zum anderen wechseln. Wir haben grenzenlose Möglichkeiten. Es ist immer wichtig, daran zu denken, dass Haare und Make-up genauso zum Look gehören wie die Kleidung.

Luxusmarken wie Gucci, Hermès und Prada zögern nicht länger, sich Accessoires und Kleidungsstücke aus der Streetwear wie die Gürteltasche und den Fischerhut sowie bestimmte Stilelemente (Punk, Grunge) anzueignen. Welche Rolle können Designer und etablierte Modemarken dabei spielen, dieses oder jenes Kleidungsstück oder Accessoire wieder auf den Laufsteg zu bringen?

Luxusmarken haben sich schon seit langer Zeit Elemente aus der Streetwear angeeignet und umgekehrt. So funktioniert Mode. Sie findet in ständigem Austausch zwischen Laufsteg und Straße statt. Sie inspirieren sich gegenseitig, sie führen einen fruchtbaren Dialog, auch wenn es Entzweiungen gab, wie zur Zeit des Punktrends in den 1970er-Jahren. In der Regel gibt es mehrere Gründe für ein Comeback eines Kleidungsstücks. Wenn man sieht, dass ein Kleidungsstück auf öffentliche Unterstützung und Beliebtheit stößt, ist es normal, dass es aus kommerziellen Gründen in einer aktualisierten Version neu aufgelegt wird. Die Rolle der Mode besteht darin, ein Verlangen zu wecken und eine formale Sprache zu entwickeln. Es gibt Kleidungsstücke, die in Vergessenheit geraten, weil sie ab einem bestimmten Zeitpunkt altmodisch erscheinen. Ich denke da vor allem an Korsetts, aber sie tauchen immer wieder auf. Mir fällt kein einziges Kleidungsstück ein, das jemals weggeworfen wurde – außer vielleicht Panierkleider. Schößchenjacken sind zum Beispiel eine Reminiszenz an Reifröcke. Es ist nicht unbedingt Langeweile, die dafür sorgt, dass beliebte Kleidungsstücke mit der Zeit unmodisch werden, sondern eher die Entwicklung der Mode: Wenn man sich plötzlich für etwas anderes begeistert, wechselt man zu einem anderen Stil. Auch Stilvariationen spielen eine Rolle: So gibt es den Rollkragenpullover mit verschiedenen Kragenformen. Sie alle entsprechen einer bestimmten Modeepoche.

Welche Rolle spielen Fernsehserien, Filme und soziale Netzwerke bei dem Phänomen des Revivals vergangener Trends?

Bei Serien ist es schwer zu sagen, welchen Einfluss sie haben, da wir uns in der Regel nicht nur eine oder mehrere Serien über dieselbe historische Epoche ansehen. Die Generationen Y und Z neigen dazu, ihren Look aus verschiedenen Epochen und je nach Stimmung zusammenzustellen. Serien interpretieren ikonische Looks neu und unterstützen ihre Verbreitung. So können Sie wählen und sortieren. Hin und wieder möchten Sie vielleicht etwas anprobieren, das Sie noch nie getragen haben, aber Sie sind weit davon entfernt, Ihre Garderobe zu ändern. Designer und Kostümbildner lassen sich von dem inspirieren, was sie auf dem Laufsteg sehen – da sind wir wieder bei der Idee des ständigen Austausches – und das hat einen verstärkenden Effekt, weil das Publikum dann den Eindruck hat, dass es das schon einmal gesehen hat.

Wir verfügen heute dank der sozialen Netzwerke sowie Filmen und Serien über so viele Inspirationsquellen, dass es fast unmöglich ist, zu wissen, was einen wirklich beeinflusst hat. Sie brauchen verschiedene Elemente, um Ihren eigenen Look, Ihre Persönlichkeit und Ihre Identität zu definieren. Die Mode ist sehr zyklisch, aber es ist ein spiralförmiger Zyklus, kein kreisförmiger, man kommt nie wieder an denselben Ort zurück, man nimmt auf seinem Weg immer etwas auf – genau wie ein Schneeball. Was heute aus der Mode zu sein scheint, liegt morgen wieder im Trend, aber auf andere Weise.

Welche Kleider aus vergangenen Jahrzehnten würden Sie persönlich gerne wieder auf dem Laufsteg sehen?

An der Mode gefällt mir, dass sie sich immer wieder verändert und die Geschichte, ihre Entwicklung, unsere Gesellschaft und ihre Bestrebungen widerspiegelt. Mir fällt kein Kleidungsstück aus den vergangenen Jahrzehnten ein, das ich gerne wiedersehen würde. Ich finde es interessant, was die nächsten Modetrends uns sagen und widerspiegeln werden. Ich bin nicht nostalgisch, was die Mode angeht, sondern neugierig auf die Zukunft.

Dresses and skirts

1

Kleider und Röcke

A-line dress

During the 1954-1955 fashion season, French couturier Christian Dior launched three distinct, yet closely related collections, which he named using letters that corresponded to the shapes of his designs: A, H, and Y. The A-line followed a pattern characterized by narrow shoulders, with a waistline around the hips forming the crossbar of the A, and a skirt slanting outwards in straight lines, thus echoing the letter's legs. The sober and elegant design of the A-line dresses echoed the taste of the time, and soon not only dresses, but also skirts and tunics adopted the new trend that was modern enough to appeal to young people and classic enough to be accepted by older generations. In a superb anachronism, Liz Taylor wore several A-line dresses in the epic historical film *Cleopatra* (1963). The form of the dress proved sufficiently adaptable to evolve with fashion: the hemline rose above the knee in the era of mini dresses and miniskirts, before falling again toward the ankle in the following decades. The A-line is a beloved wedding dress shape as it flatters all body types and brings a poetic, delicately retro touch. It is, therefore, not surprising that fashion-conscious Kate Middleton has made it her favourite dress design.

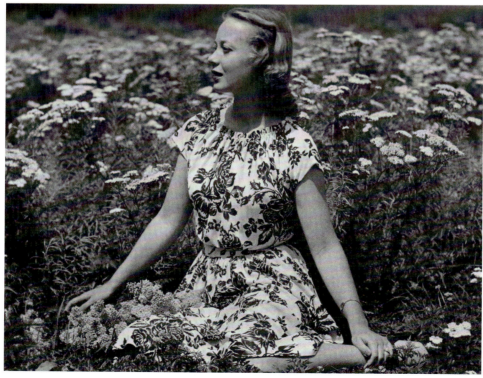

Dresses and skirts / Kleider und Röcke

In der Modesaison 1954/55 brachte der französische Modeschöpfer Christian Dior drei verschiedene, aber eng miteinander verbundene Kollektionen heraus, die er mit Buchstaben benannte, die den Formen seiner Entwürfe entsprachen: A, H und Y. Die A-Linie folgt einer Form, die durch schmale Schultern, eine Taillenlinie um die Hüften, die den Querbalken des A bildet, und einen Rock, der in geraden Linien nach außen fällt und so die Beine des Buchstabens widerspiegelt, gekennzeichnet ist. Das schlichte und elegante Design der A-Linien-Kleider entsprach dem Geschmack der Zeit. Schon bald war der Trend nicht nur an Kleidern, sondern auch an Röcken und Tuniken sichtbar, denn er war modern genug, um junge Menschen anzusprechen, und klassisch genug, um von älteren Generationen akzeptiert zu werden. In einem herrlichen Anachronismus trug Liz Taylor in dem epischen Historienfilm *Cleopatra* (1963) mehrere A-Linien-Kleider. Die Form des Kleides erwies sich als so anpassungsfähig, dass sie mit der Mode gehen konnte: Der Saum endete in der Ära der Minikleider und Miniröcke über dem Knie, bevor er in den folgenden Jahrzehnten wieder bis zum Knöchel fiel. Die A-Linie ist eine beliebte Brautkleidform, da sie allen Körpertypen schmeichelt und dem Kleid einen leicht poetischen Retro-Touch verleiht. Es ist daher nicht verwunderlich, dass die modebewusste Kate Middleton dieses Kleid zu ihrem Lieblingsdesign gemacht hat.

A-Linien-Kleid

Crochet dress

There is an unmistakable sense of sunny holidays and the 1970s to the crochet dress, as if the simple, lightweight, distinctive, and sustainable material had the power to take us back in time.
True, crochet lends itself perfectly to the decorative motifs that were *en vogue* in the seventies: flower power, geometric lines in vivid colours, or op-art effects. It gives the wearer an effortless, cool-girl summer look. The crochet dress arises from the *coconut girl* aesthetic popular on Tik Tok, which means dressing as if you were in a subtropical resort and then you could post the result. As crochet can be done only by hand, each piece is unique, which adds to the pleasure of wearing it. Some people embrace a total crochet look, with handbag, bandana, swimsuit, bucket hat, clogs, and even crochet earrings.

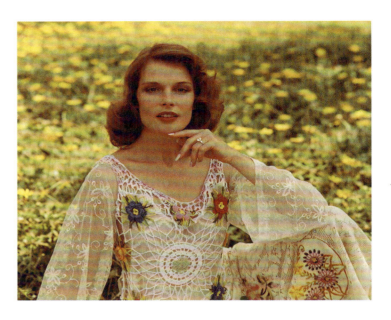

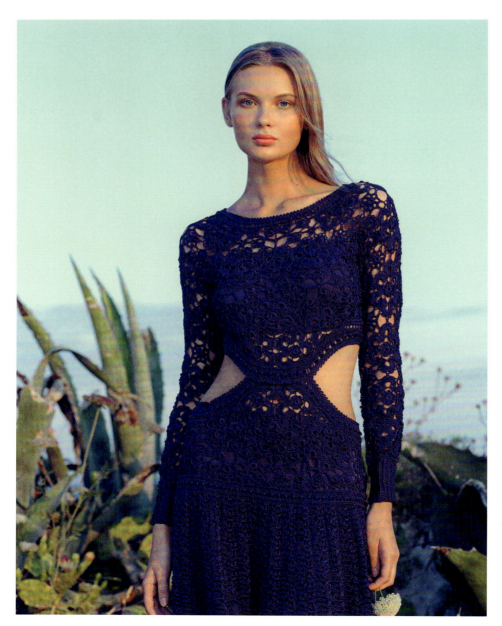

Handmade crochet dresses make the perfect outfit for summer days

Handgefertigte Häkelkleider sind das perfekte Outfit für Sommertage

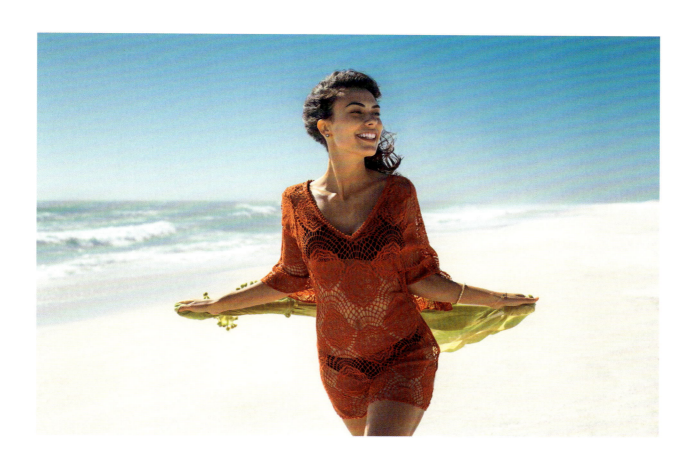

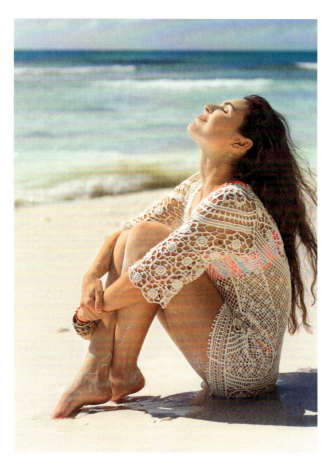

Das Häkelkleid vermittelt ein unverwechselbares Gefühl von Sommerurlaub und den 1970er-Jahren, als ob das leichte, unverwechselbare und nachhaltige Material uns in die Vergangenheit versetzen könnte. Häkeln eignet sich hervorragend für die dekorativen Motive, die in den siebziger Jahren *en vogue* waren: Flower-Power, geometrische Linien in leuchtenden Farben und Op-Art-Effekte. Es verleiht der Trägerin einen mühelos coolen Sommerlook. Das Häkelkleid entstammt der bei Tik Tok beliebten Ästhetik des *Coconut Girl*, bei der man sich für einen Post so kleidet, als wäre man an einem subtropischen Urlaubsort. Da Häkeln nur in Handarbeit möglich ist, ist jedes Stück ein Unikat, was die Freude am Tragen noch erhöht. Manche Menschen bevorzugen den Häkellook von Kopf bis Fuß – mit Handtasche, Halstuch, Badeanzug, Hut, Clogs und sogar gehäkelten Ohrringen.

Häkelkleid

Maxi dress

After a decade of minimalist simplicity, 2020 marked the return of exuberance and maximalism in fashion, with the maxi dress as a key element of this new fashion cycle. Dominican-born American fashion designer Oscar de la Renta was considered the creator of the maxi dress in the 1960s, which emerged just in time to become an icon of boho style in the 1970s, and inspired the best couturiers of the time such as Yves Saint-Laurent and Christian Dior. Although versatile in shape, maxi dresses have in common a fitted top – even if some have puffed sleeves – and a full skirt that falls to the ankles. After vanishing in the 1980s, losing the battle to less lengthy designs, the maxi dress made a timid comeback in the early 2010s, thanks in particular to the movie *Sex and the City 2*, before regaining its place on the catwalks. Now it is a must-have casual dress for the summer. Celebrities such as Selena Gomez, Eva Longoria, Jennifer Lawrence, Jennifer Lopez, and Miranda Kerr have all been seen in retro-chic maxi dresses.

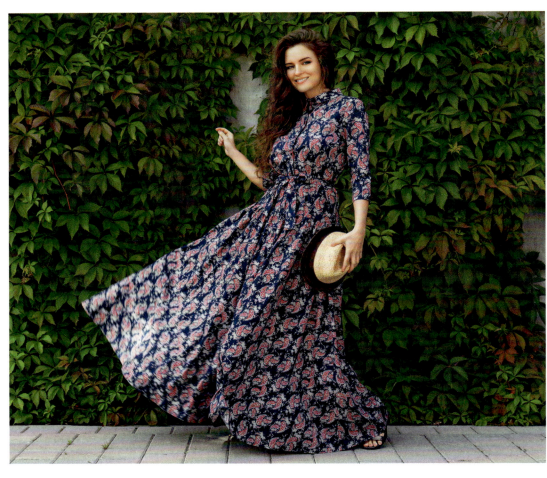

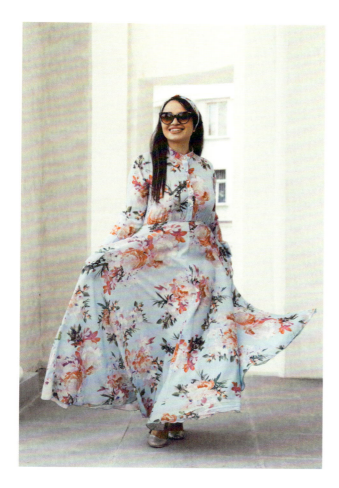

The maxi dress provides an extra touch of romantic elegance

Das Maxikleid sorgt für einen zusätzlichen Hauch romantischer Eleganz

Nach einem Jahrzehnt der minimalistischen Schlichtheit markiert das Jahr 2020 die Rückkehr zur maximalen Überschwänglichkeit in der Mode, wobei das Maxikleid ein Schlüsselelement dieses neuen Modezyklus ist. Der in der Dominikanischen Republik geborene US-amerikanische Modedesigner Oscar de la Renta gilt als Erfinder des Maxikleides in den 1960er-Jahren, das gerade rechtzeitig auftauchte, um in den 1970er-Jahren zu einem Symbol des *Boho Style* zu werden und die besten Modeschöpfer dieser Zeit wie Yves Saint-Laurent und Christian Dior zu inspirieren. Obwohl die Form vielseitig ist, haben alle Maxikleider ein tailliertes Oberteil – auch wenn manche Puffärmel haben – und einen Rock, der bis zu den Knöcheln reicht. Nachdem das Maxikleid in den 1980er-Jahren verschwunden war, weil es den Kampf gegen weniger lange Modelle verloren hatte, erlebte es Anfang der 2010er-Jahre vor allem wegen des Films *Sex and the City 2* ein zaghaftes Comeback und eroberte sich seinen Platz auf den Laufstegen zurück. Jetzt ist es ein unverzichtbares Freizeitkleid für den Sommer. Berühmtheiten wie Selena Gomez, Eva Longoria, Jennifer Lawrence, Jennifer Lopez und Miranda Kerr wurden alle schon in Maxikleidern im Retro-Chic gesichtet.

Maxikleid

Slip dress

The slip dress, traditionally made of silk or satin, offers the same sensuousness and freedom of movement as the undergarment that provided its name and shape. True, some might feel as if they were walking down the street in nightwear when wearing a slip dress, but once you've experienced its silky comfort, it's easy to adopt as it gives a chic yet casual look that's perfect for a summer evening out, a shopping session or a date. The first slip dresses were launched in the 1930s by couturiers such as Jeanne Lanvin and Madeleine Vionnet. They were ankle-length to balance their sensual aspect, while the slip dresses of the 1990s – now considered the golden age of this garment – were more likely to be knee-length, thus making them more practical. Slip dresses of the 1990s are particularly associated, in the collective memory, with Kate Moss and her fellow partying supermodels. The current popularity of the slip dress is due to a combination of factors: the Y2K generation's nostalgia for the 1990s, and the minimalist design of the dress that beguiles actresses such as Sienna Miller, Diane Kruger, Dakota Johnson, and singer Rihanna, among many other regular wearers.

Both stylish and practical, the slip dress will look just as good in the city as on holiday.

Stilvoll und praktisch zugleich: Das Slipkleid macht in der Stadt genauso eine gute Figur wie im Urlaub.

Dresses and skirts / Kleider und Röcke

Das Slipkleid, das traditionell aus Seide oder Satin gefertigt wird, bietet die gleiche Sinnlichkeit und Bewegungsfreiheit wie das Unterkleid, das ihm seinen Namen und seine Form gab. Manch einer mag sich beim Tragen eines Slipkleides fühlen, als würde er in Nachtwäsche über die Straße laufen, aber wenn man erst einmal den seidigen Tragekomfort erlebt hat, fällt es leicht, sich für dieses Kleid zu entscheiden, denn es sorgt für einen schicken und doch lässigen Look, der perfekt für einen Sommerabend, einen Einkaufsbummel oder ein Date ist. Die ersten Slipkleider wurden in den 1930er-Jahren von Modeschöpfern wie Jeanne Lanvin und Madeleine Vionnet auf den Markt gebracht. Sie waren knöchellang, um ihren sinnlichen Touch auszugleichen, während die Slipkleider der 1990er-Jahre, die heute als das goldene Zeitalter dieses Kleidungsstücks gelten, eher knielang und damit praktischer waren. Die Slipkleider der Neunziger werden im kollektiven Gedächtnis vor allem mit Kate Moss und den feiernden Supermodels in Verbindung gebracht. Die derzeitige Popularität des Slipkleides ist auf eine Kombination von Faktoren zurückzuführen: die Nostalgie der Generation Z für die 1990er-Jahre und das minimalistische Design des Kleides, das Schauspielerinnen wie Sienna Miller, Diane Kruger, Dakota Johnson sowie die Sängerin Rihanna und viele andere regelmäßig verzaubert.

Slipkleid

Wrap dress

A classical wrap dress consists of a closure formed by wrapping one side of the dress across the other then tying it together around the waist, creating a V-neck that highlights the bust thus enhancing the silhouette, with an elegant, knee-length A-line skirt. This style has the advantage of flattering everyone regardless of the body's morphology or the wearer's age. Although wrap dresses were invented by Elsa Schiaparelli in the 1930s, their popularity took off in the early 1970s when New York-based fashion designer Diane von Fürstenberg relaunched the style and turned the design into a symbol of women's emancipation: "What we do is celebrate freedom and empower women, and sell confidence, because, in the end, it's the confidence that makes you beautiful"[3], explained the designer. The wrap dress has made women feel comfortable, confident, and beautiful for multiple generations since then. It has enjoyed a revival in the 1990s, and again in the early 2020s as a timelessly elegant, stylish, and flirtatious dress.

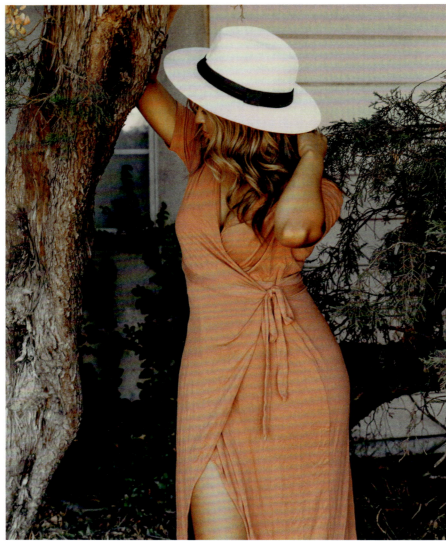

Feel like a star in a wrap dress

In einem Wickelkleid fühlen Sie sich wie ein Star

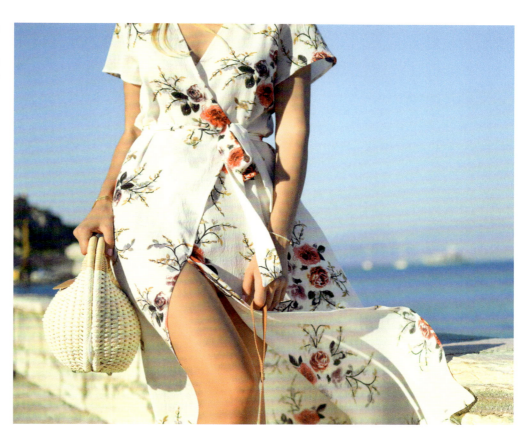

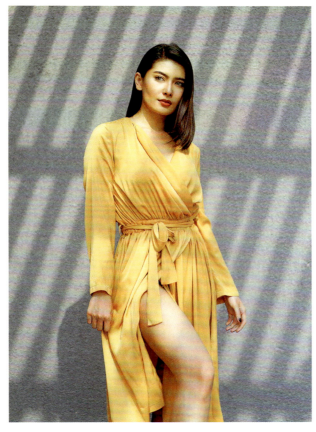

Ein klassisches Wickelkleid besteht aus einem Verschluss, der gebildet wird, indem eine Seite des Kleides über die andere gewickelt und dann um die Taille zusammengebunden wird, wodurch ein V-Ausschnitt, der die Brust und die Silhouette betont, und ein eleganter, knielanger Rock in A-Linie entsteht. Dieser Stil hat den Vorteil, dass er jedem schmeichelt – unabhängig von Körperform oder Alter. Obwohl Wickelkleider in den 1930er-Jahren von Elsa Schiaparelli erfunden wurden, erlebten sie Anfang der 1970er Jahre einen Popularitätsschub, als die New Yorker Modedesignerin Diane von Fürstenberg das Kleid neu auflegte und es zu einem Symbol für die Emanzipation der Frau machte: „Was wir tun, ist, die Freiheit zu feiern, Frauen zu stärken und Selbstvertrauen zu verkaufen, denn letztendlich ist es das Selbstvertrauen, das Sie schön macht"[3], erklärt die Designerin. Das Wickelkleid verleiht Frauen seither ein Gefühl von Komfort, Selbstbewusstsein und Schönheit. In den 1990er-Jahren und Anfang der 2020er-Jahre erlebte es ein Revival als zeitlos elegantes, stilvolles und kokettes Kleid.

Wickelkleid

Bubble skirt (aka tulip skirt, balloon skirt)

Both fun and stylish, the bubble skirt inspires many unusual comparisons and analogies: it will remind some people of the baggy Spanish breeches worn by gentleman during the Renaissance, while others may find similarities in shape with a wrapped candy – indeed the bubble skirt sometimes gives off a bit of a girlish vibe. Alternatively, you might be suspected of hiding an inflatable lifebuoy under the skirt's fabric. However, they would all miss the main point: as a bubble skirt is always short – it rests mid-thigh or above the knee – its shape highlights the legs and the figure by bringing volume and a certain dynamism. It was launched in this spirit in the mid-1950s by avant-garde couturiers Pierre Cardin and Christian Dior, but its initial success was short-lived when it was promptly replaced by the miniskirt in the early 1960s. It came back in a more exuberant style in the 1980s, thanks to the fashion designers Oscar de la Renta and Christian Lacroix, although it was seen primarily as a party outfit rather than a streetwear garment. It gained in popularity again in the late 2000s, when socialite Paris Hilton was spotted in flashy, mini-length bubble skirts, and since then the style has been adopted by singer Selena Gomez, actresses Emma Watson and Elle Fanning, to name but a few.

Dresses and skirts / Kleider und Röcke

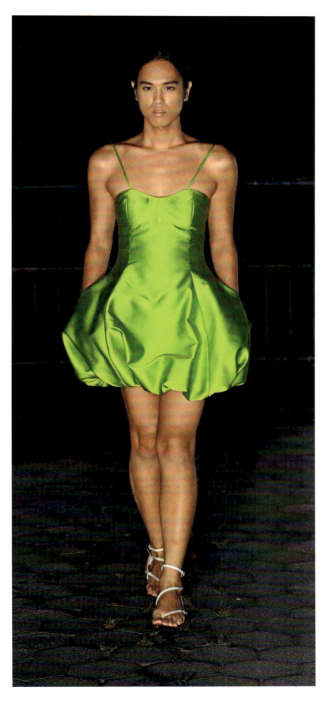

The best way to stand out from the crowd

Die beste Art, sich von der Masse abzuheben

Der witzige und zugleich elegante Ballonrock regt zu vielen ungewöhnlichen Vergleichen und Analogien an: Er erinnert manche an die weiten Heerpauken, die von Männern in der Renaissance getragen wurden, während andere Ähnlichkeiten zu einem eingewickelten Bonbon sehen – in der Tat hat der Tulpenrock manchmal einen etwas mädchenhaften Touch. Oder man könnte Sie verdächtigen, einen aufblasbaren Rettungsring unter dem Rock zu verstecken. Alle Annahmen würden jedoch das Wesentliche verfehlen: Da ein Ballonrock immer kurz ist (er reicht bis zur Mitte des Oberschenkels oder oberhalb des Knies), betont seine Form die Beine und die Figur, indem sie für Volumen und eine gewisse Dynamik sorgt. In diesem Sinne wurde er Mitte der 1950er-Jahre von den avantgardistischen Modeschöpfern Pierre Cardin und Christian Dior eingeführt, doch sein anfänglicher Erfolg war nur von kurzer Dauer, da er Anfang der 1960er-Jahre schnell durch den Minirock ersetzt wurde. In den 1980er-Jahren kehrte er dank der Designer Oscar de la Renta und Christian Lacroix in einem üppigeren Stil zurück, obwohl er in erster Linie als Partyoutfit und nicht als Streetwear angesehen wurde. In den späten 2000er-Jahren gewann er wieder an Popularität, als die Hotelerbin Paris Hilton in auffälligen Minitulpenröcken gesichtet wurde. Seitdem wurde der Stil unter anderem von Sängerin Selena Gomez und den Schauspielerinnen Emma Watson und Elle Fanning übernommen.

Ballonrock (auch Tulpenrock genannt)

Miniskirt

If you thought the miniskirt had become conventional and mellowed as it approached seventy years of existence, you would be wrong. The latest trend is the micro miniskirt, even shorter and closer to the crotch, in the same spirit as the minimalist crop top which reveals the curve of the breasts. We'll see if this new iteration of the iconic skirt will cause as many indignant protests from modesty advocates, and as many traffic accidents due to drivers' distraction as its older sister of the 1960s. In the avant-garde atmosphere of the swinging decade, three leading fashion designers are said to have contributed to the emergence of the miniskirt: British designer John Bates, who was famous for his modernistic minidresses, and is now considered the true inventor of the miniskirt; French couturier André Courrèges, who brought the new skirt to the catwalk as early as 1964; and London-based designer Mary Quant, who popularized it in her iconic boutique, *Bazaar*, on King's Road. The 1960s miniskirt is inseparable from two other pieces of clothing that form the typical look of the Swinging Sixties: go-go boots and the turtleneck jumper. In the typical pendulum swing of fashion, the 1970s saw the emergence of its perfect opposite, the maxi style, with ankle-length dresses and skirts. However, the miniskirt survived thanks to the punk era, and carried on its provocative style. In another radical turn, the miniskirt moved away from the punk scene in the 1980s to become a garment worn by executive businesswomen. With the micro miniskirt of the 2020s, the garment remains true to its origins: as a blogger noted, "it teasingly attempts to cover and reveal at the same time. In all of its contradictions and reinventions, the miniskirt still provokes, challenges, and demands attention from both men and women alike."[4]

Bottom: Street scene in Berlin, 1969

Unten: Straßenszene, Berlin, 1969

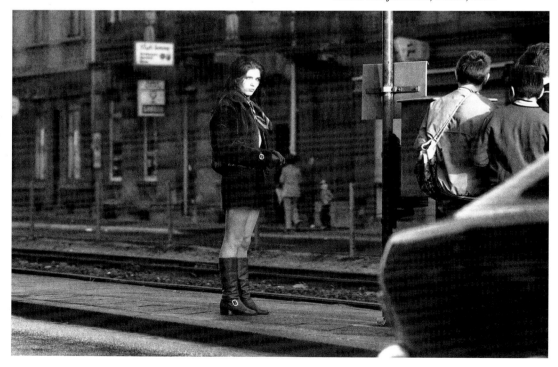

Wer dachte, dass der Minirock nach siebzig Jahren konventionell geworden sei, hat sich getäuscht. Die Aufregung um ihn ist noch nicht verflogen. Der Mikrominirock ist der neueste Trend. Er ist noch kürzer und näher am Schritt als das Original und erinnert damit an das minimalistische bauchfreie Top, das den unteren Teil der Brüste enthüllt. Wir werden sehen, ob diese neue Version des ikonischen Rocks ebenso viel Empörung von Sittenwächtern und ebenso viele Verkehrsunfälle durch die Ablenkung von Autofahrern hervorrufen wird wie das Original aus den 1960er-Jahren.
In der avantgardistischen Atmosphäre der *Swinging Sixties* sollen drei führende Modedesigner zum Aufkommen des Minirocks beigetragen haben: Der britische Designer John Bates, der wegen seiner modernen Minikleider berühmt war und heute als der eigentliche Erfinder des Minirocks gilt, der französische Modeschöpfer André Courrèges, der den neuen Rock bereits 1964 auf den Laufsteg brachte, und die Londoner Designerin Mary Quant, die ihn in ihrer legendären Boutique *Bazaar* in der King's Road populär machte. Der Minirock der 1960er-Jahre ist untrennbar mit zwei anderen Kleidungsstücken verbunden, die den typischen Look der *Swinging Sixties* ausmachen: die Gogo-Stiefel und der Rollkragenpullover. In den 1970er-Jahren, als sich die Mode einmal komplett umkehrte, entstand der perfekte Gegentrend: der *Maxi Style* mit knöchellangen Kleidern und Röcken. Der Minirock überlebte jedoch dank der Punkära und behielt seinen provokanten Stil bei. Eine weitere radikale Wandlung erfuhr der Minirock in den 1980er-Jahren, als er sich von der Punkszene löste und zu einem Kleidungsstück wurde, das von Geschäftsfrauen in Führungspositionen getragen wurde. Mit dem Mikrominirock der 2020er-Jahre bleibt das Kleidungsstück seinen Ursprüngen treu: Wie eine Bloggerin feststellte, „versucht er aufreizend zu bedecken und gleichzeitig zu enthüllen. In all seinen Widersprüchen und Neuerfindungen provoziert der Minirock noch immer, fordert heraus und verlangt Aufmerksamkeit von Männern und Frauen gleichermaßen."[4]

Minirock

Circle skirt

The circle skirt takes us back to the 1950s, the era of rock-n-roll and *Dolce Vita*, a pivotal period when post-war youth aspired to happiness and carefree living after years of deprivation and austerity. This skirt, cut from circular pieces of fabrics (hence its name) was worn by Audrey Hepburn in *Roman Holiday* (1953). The style was also adopted by Sophia Loren and Grace Kelly, establishing it as the ensemble of elegant and fashionable women. It was in line with Christian Dior's *New Look* vision of classic women's clothing with a twist of modernity. The skirt fell to just below the knee, thus complying with the moral codes of the time, but it did not restrict movement, making it the perfect garment on the dance floor. Although it quickly fell out of fashion after its golden age, the circle skirt still has devoted fans among rock-n-roll lovers, and its comeback owes as much to vintage fashion as it does to television series recreating the atmosphere of the fifties. Singer Taylor Swift, burlesque dancer Dita von Teese, and actress Eva Mendes are regularly seen wearing a circle skirt, or its shorter version, the skater skirt.

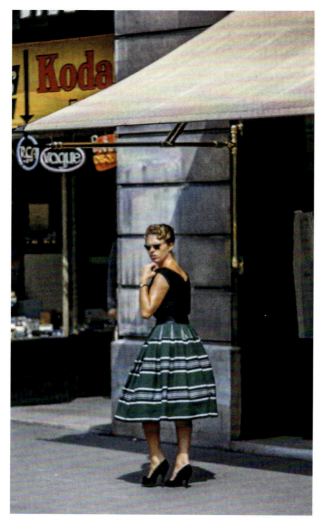

Back to the golden age of rock-n-roll

Zurück ins goldene Zeitalter des Rock 'n' Roll

Der runde Rock versetzt uns in die 1950er-Jahre, die Ära des Rock 'n' Roll und des *Dolce Vita*. Nach Jahren der Entbehrung strebte die Jugend der Nachkriegszeit in dieser entscheidenden Zeit nach Glück und Unbeschwertheit. Dieser Rock, der aus kreisförmigen Stoffstücken geschnitten ist (daher der Name), wurde von Audrey Hepburn in *Ein Herz und eine Krone* (1953) getragen. Der Stil wurde auch von Sophia Loren und Grace Kelly übernommen und etablierte sich als Ensemble für elegante und modische Frauen. Der Rock entsprach Christian Diors New-Look-Vision von klassischer Damenmode mit einem Hauch von Modernität. Er fiel bis knapp unter das Knie und entsprach damit den damaligen Moralvorstellungen, schränkte aber die Bewegungsfreiheit nicht ein, was ihn zum perfekten Kleidungsstück für die Tanzfläche machte. Obwohl er nach seiner Blütezeit schnell aus der Mode kam, ist der Tellerrock bei Rock-'n'-Roll-Liebhabern immer noch sehr beliebt. Sein Comeback verdankt er sowohl der Vintage-Mode als auch den Fernsehserien, die die Atmosphäre der fünfziger Jahre nachstellen. Die Sängerin Taylor Swift, die Burlesque-Tänzerin Dita von Teese und die Schauspielerin Eva Mendes werden regelmäßig in einem Tellerrock oder seiner kürzeren Version – dem Skaterrock – gesichtet.

Tellerrock

Pencil skirt

In a completely different style to the circle skirt, the pencil skirt is another child of the 1950s. Its origin was claimed both by Cristóbal Balenciaga, who liked designing dresses and skirts that followed the contours of the figure, and also by Christian Dior who launched his famous H-line in 1954, with the aim of elongating the women's silhouette and giving the waist a central role. Worn by Marilyn Monroe in *Some Like It Hot* (1959) and Grace Kelly in *Rear Window* (1954), the figure-hugging pencil skirt became an element of seduction. However, its simple straight line has also made it a garment for professional life. In fact, the pencil skirt would establish itself as the standard for office wear at a time when women were joining the workforce *en masse*. The skirt's neutral, chic look is ideal for women with public facing roles, whether in politics, finance, or industry, as shown by the examples of Michelle Obama, Nicola Sturgeon, Scotland's prime minister, and Christine Lagarde, the head of the European Union Central Bank.

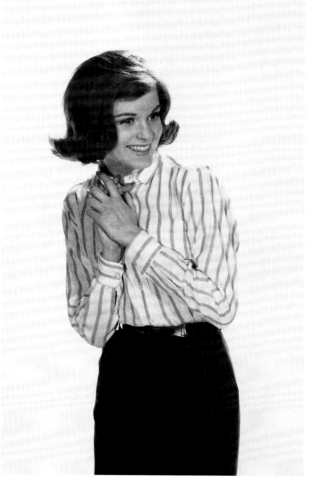

The perfect companion for a timeless and chic look

Der perfekte Begleiter für einen zeitlos-schicken Look

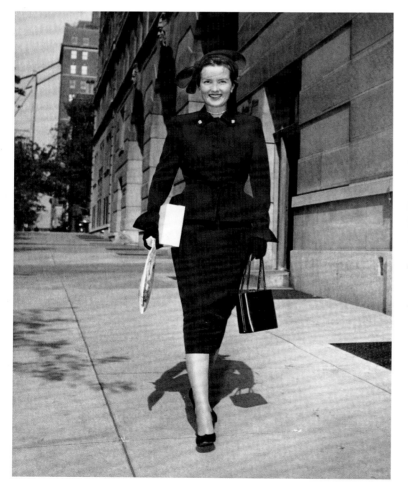

Dresses and skirts / Kleider und Röcke

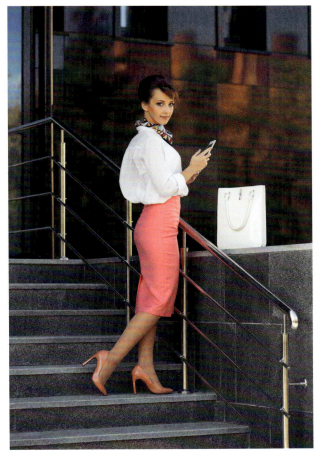

Obwohl er ganz anders als der Tellerrock ist, stammt der Bleistiftrock auch aus den 1950er-Jahren. Sein Ursprung geht sowohl auf Cristóbal Balenciaga zurück, der gerne Kleider und Röcke entwarf, die den Konturen der Figur folgten, als auch auf Christian Dior, der 1954 seine berühmte H-Linie vorstellte, um die weibliche Silhouette zu verlängern und die Taille in den Mittelpunkt zu stellen. Der figurbetonte Bleistiftrock, der von Marilyn Monroe in *Manche mögen's heiß* (1959) und Grace Kelly in *Das Fenster zum Hof* (1954) getragen wurde, wurde zum Inbegriff der Verführung. Seine schlichte gerade Linie hat ihn aber auch zu einem Kleidungsstück für das Berufsleben gemacht. Der Bleistiftrock etablierte sich als Standard der Bürokleidung in einer Zeit, in der Frauen *en masse* ins Berufsleben eintraten. Der neutrale, schicke Look des Rocks ist ideal für Frauen, die in der Öffentlichkeit stehen, sei es in der Politik, im Finanzwesen oder in der Industrie, wie die Beispiele von Michelle Obama, der schottischen Premierministerin Nicola Sturgeon und der Präsidentin der Europäischen Zentralbank Christine Lagarde zeigen.

Bleistiftrock

Suede skirt (and faux suede)

One can only wonder why suede skirts went out of fashion from the late 1970s until 2015, when they made a sudden comeback onto the catwalk, while suede jackets, blouses and shoes continued to thrive. The elasticity of suede and its softness to the touch should have ensured its continuing use in the design of skirts, even if it is more delicate to care for than other materials. In the late 1960s, suede embraced two rather opposite styles: that of the miniskirt due to its natural look and hues that complimented the tone of most legs, and that of ankle-long hippie skirts, some decorated with fringes as a tribute to Native American traditions. In either case, you could find patchwork variants that added a multicoloured, cheerful pattern to the outfit. Suede skirts were rediscovered in spring 2015 by designers at Gucci, Yves Saint Laurent, and Miu Miu in the wake of a vintage-boho wave that brought natural materials back into focus. It pairs equally well with a t-shirt, jumper, blouse, top tank, or polo shirt, and with any kind of shoes or boots.

Es ist schon verwunderlich, dass Röcke aus Wildleder seit den späten 1970er-Jahren nicht mehr in Mode waren und erst 2015 ein plötzliches Comeback auf den Laufstegen feiern konnten, während sich Wildlederjacken, -blusen und -schuhe die ganze Zeit über großer Beliebtheit erfreuten. Die Elastizität des Wildleders und sein weicher Griff dürften dafür gesorgt haben, dass es weiterhin für die Gestaltung von Röcken verwendet wird, auch wenn es in puncto Pflege empfindlicher ist als andere Materialien. In den späten 1960er-Jahren war Wildleder für zwei eher gegensätzliche Stile typisch: den Minirock, der aufgrund seines natürlichen Aussehens und seiner Farbgebung den meisten Beinen schmeichelte, und den knöchellangen Hippierock, der als Hommage an die Traditionen der amerikanischen Ureinwohner teilweise mit Fransen versehen war. In jedem Fall konnten Patchworkvariationen die Röcke zieren, die dem Outfit ein buntes, fröhliches Muster verliehen. Wildlederröcke wurden im Frühjahr 2015 von den Designern von Gucci, Yves Saint Laurent und Miu Miu im Zuge eines Vintage-Boho-Trends wiederentdeckt, der natürliche Materialien in den Fokus rückte. Der Rock lässt sich ebenso gut mit einem T-Shirt, einem Pullover, einer Bluse, einem Tanktop oder einem Poloshirt kombinieren wie mit jeder Art von Schuhen oder Stiefeln.

Rock aus Wildleder (oder Wildlederimitat)

Pleated skirt

The technique of pleating fabrics has been known since ancient Egypt, where it was used for the ceremonial clothing of dignitaries and high-ranking priests. Ancient Greek statues also show women wearing long pleated tunics, a garment that inspired French designer Henriette Negrin and her husband, Spanish artist Mariano Fortuny, to create the *Delphos* dress in 1907, thus bringing pleats back into fashion. A few years later, in the early 1920s, as tennis was becoming a fashionable sport for wealthy ladies, French couturier Jean Patou designed a pleated skirt that conformed to the rules of the time but gave the legs greater freedom of movement. Worn for the first time by French tennis champion, Suzanne Lenglen, during a tournament at Wimbledon, Patou's pleated skirt became the uniform of female tennis players and the leisure wear of educated, sporty bourgeois women. This association with the wealthy class would, in the decades to come, earn the skirt, and also the kilts, a reputation as a conformist garment, a prejudice that stuck to it even when it followed the trend of the 1960s and was turned into a pleated miniskirt. After an eclipse in the 1970s, the pleated skirt came back into fashion in the late 1980s thanks to Japanese fashion designer, Issey Miyake, and his *Pleats Please* collection. They made a more unexpected return to the streets in the late 2010s as mid-season clothing with the support of celebrities such as Beyoncé, Emmy Rossum, and Victoria Beckham.

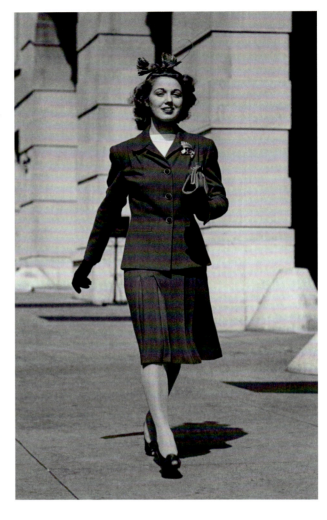

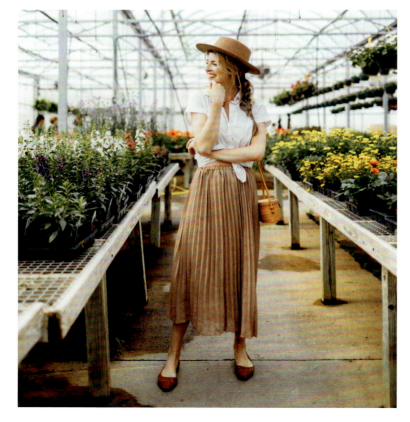

Whether short or long, a pleated skirt will always sway elegantly when you walk

Ob kurz oder lang, ein Faltenrock verleiht dem Gang durch seinen sanften Schwung immer eine gewisse Eleganz

Dresses and skirts / Kleider und Röcke

Die Technik des Faltens von Stoffen ist seit dem alten Ägypten bekannt, wo sie für die zeremonielle Kleidung von Würdenträgern und hochrangigen Priestern verwendet wurde. Die antiken griechischen Statuen zeigen auch Frauen, die lange gefaltete Tuniken tragen – ein Kleidungsstück, das die französische Designerin Henriette Negrin und ihren Mann, den spanischen Künstler Mariano Fortuny, 1907 zu dem Kleid *Delphos* inspirierte und damit Falten wieder modisch machte. Einige Jahre später, in den frühen 1920er-Jahren, als Tennis zu einer Trendsportart wohlhabender Damen wurde, entwarf der französische Modeschöpfer Jean Patou einen Faltenrock, der den damaligen Regeln entsprach, aber den Beinen mehr Bewegungsfreiheit ließ. Der Plisseerock von Patou, der zum ersten Mal von der französischen Tennisspielerin Suzanne Lenglen während eines Turniers in Wimbledon getragen wurde, wurde zur Uniform der Tennisspielerinnen und zur Freizeitkleidung der gebildeten, sportlichen Frauen der Bourgeoisie. Diese Assoziation mit der wohlhabenden Klasse sollte dem Rock und auch den Schottenröcken in den folgenden Jahrzehnten den Ruf eines konformistischen Kleidungsstücks einbringen – ein Vorurteil, das ihm auch dann noch anhaftete, als er dem Trend der 1960er-Jahre folgte und zum plissierten Minirock wurde. Nachdem der Plisseerock in den 1970er-Jahren von den Laufstegen verschwunden war, kam er in den späten 1980er-Jahren dank des japanischen Modedesigners Issey Miyake und seiner Kollektion *Pleats Please* wieder in Mode. In den späten 2010er-Jahren kehrte er unerwartet auf die Straße zurück und wurde von Prominenten wie Beyoncé, Emmy Rossum und Victoria Beckham als Kleidungsstück für die Zwischensaison aufgegriffen.

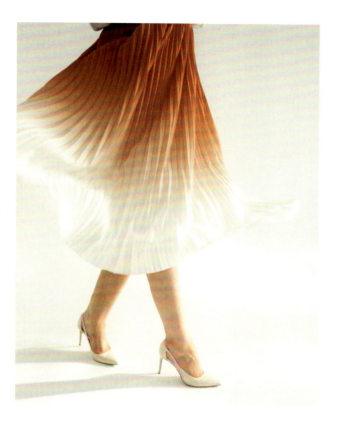

Plisseerock

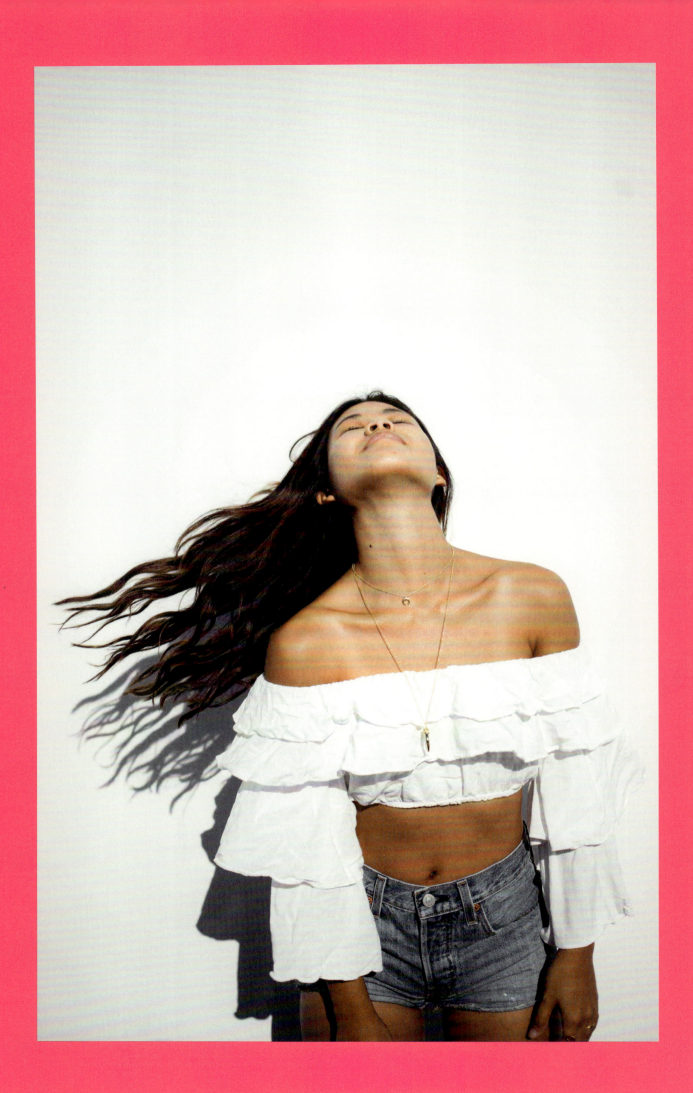

Blouses and jumpers

2

Blusen und Pullover

Crop top (aka midriff top, half shirt)

On the Indian subcontinent, the crop top is a truly traditional garment. Its existence was first considered one hundred years BCE: the *choli*, a shortened blouse leaving the midriff bare is worn along with the sari. Its equivalent in the western world didn't reach the Pacific shores until the 1930s, when Hollywood stars such as Ginger Rogers, Lauren Bacall, and Rita Hayworth wore them to play *ingénue* roles. In real life, however, shorts and crop tops were still confined to beachwear: a young lady was even fined $2 for wearing such an outfit in Central Park in 1945. However, this incident did not stop the crop top's progress eastwards. It finally crossed the Atlantic in the 1960s as a symbol of women's liberation. Since then, the crop top has been a mainstay of fashion throughout, from the aerobic trend of the early 1980s to the Madonna look, to the pop stars of the 1990s such as Britney Spears, the Spice Girls and Christina Aguilera. Anecdotally, a crochet crop top in which Jane Birkin was photographed in 1970, was reissued in 2014. There are so many choices that you can pick a crop top from your favourite decade or opt for a Bollywood-style choli!

A staple garment for sunny days

Ein unverzichtbares Kleidungsstück für sonnige Tage

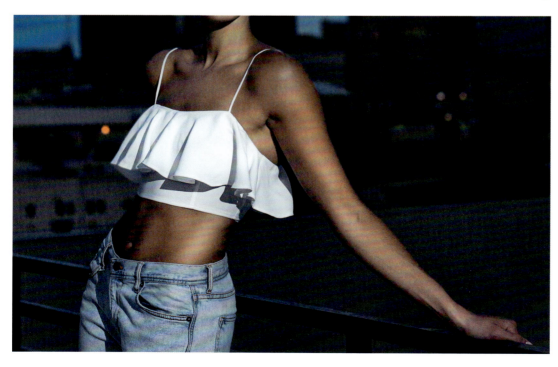

Blouses and jumpers / Blusen und Pullover

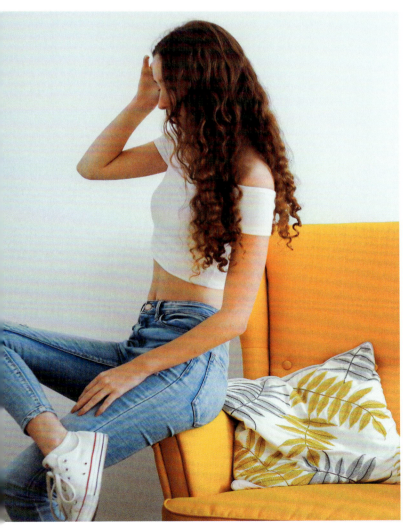

Auf dem indischen Subkontinent sind bauchfreie Oberteile wahrhaft traditionelle Kleidungsstücke. Ihre Existenz wurde erstmals hundert Jahre v. Chr. erwähnt: Die *Choli*, eine verkürzte Bluse, die nur bis zur Taille reicht, wird zusammen mit dem Sari getragen. Ihre Entsprechung in der westlichen Welt erreichte die Pazifikküste erst in den 1930er-Jahren, als Hollywood-Stars wie Ginger Rogers, Lauren Bacall und Rita Hayworth sie für ihre Rollen als unschuldige Naivchen trugen. Im wahren Leben galten Shorts und bauchfreie Tops jedoch immer noch als Strandbekleidung: Eine junge Dame wurde 1945 für das Tragen eines solchen Outfits im Central Park sogar mit einer Geldstrafe von 2 US-Dollar belegt. Dieser Vorfall konnte den Vormarsch des bauchfreien Oberteils in Richtung Osten jedoch nicht aufhalten. In den 1960er-Jahren überquerte es schließlich den Atlantik als Symbol der Frauenbewegung. Seitdem ist das bauchfreie Top ein fester Bestandteil der Mode – vom Aerobic-Trend der frühen 1980er-Jahre über den Madonna-Look bis hin zu den Popstars der 1990er-Jahre wie Britney Spears, den Spice Girls und Christina Aguilera. Anekdotischerweise wurde 2014 ein gehäkeltes bauchfreies Oberteil, in dem Jane Birkin 1970 fotografiert wurde, neu aufgelegt. Die Auswahl ist so groß, dass Sie ein bauchfreies Top aus Ihrem Lieblingsjahrzehnt wählen oder sich für einen Choli im *Bollywood Style* entscheiden können!

Bauchfreies Top
(auch verkürztes oder kurz geschnittenes Oberteil genannt)

Tube top

Halfway between a crop top and a bikini top, the tube top (also known in the United Kingdom by the more explicit name of boob tube) was "invented" in 1971. Elie Tahari is credited with its creation and its success put him on the road to fame. In fact, legend has it that a manufacturing error resulted in a pile of elasticated fabric tubes, and some of these mistakes ended up in a New York store, where Tahari found them. He intuitively decided to buy the whole stock and resold them in a single day at a New York fashion trade show shortly afterwards. The tube top was embraced during the hippie craze – where it was seen as an alternative to the bra – and returned to favour again in the wild 1990s. It is still provocative enough nowadays to appeal to celebrities, and to be popular among partygoers at nightclubs.

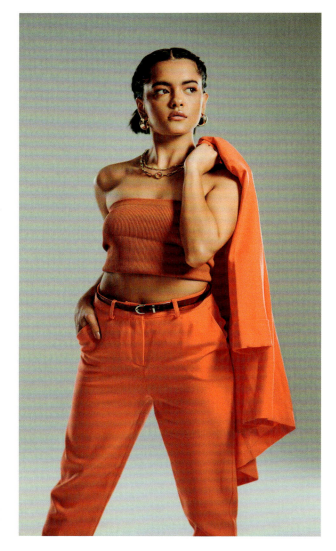

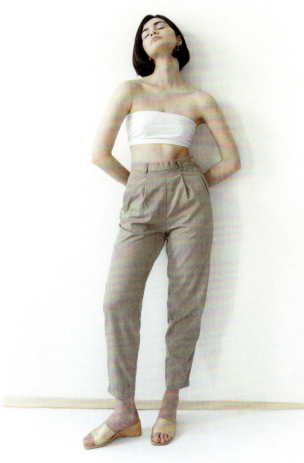

Auf halbem Weg zwischen einem bauchfreien Top und einem Bikinioberteil wurde das Röhrentop 1971 „erfunden". Elie Tahari wird die Kreation zugeschrieben und sein Erfolg hat ihn berühmt gemacht. Die Legende besagt, dass durch einen Herstellungsfehler ein Haufen elastischer Stoffschläuche entstand, von denen einige in einem New Yorker Geschäft landeten, wo Tahari sie fand. Er beschloss intuitiv, den gesamten Bestand zu kaufen, und verkaufte diesen kurz darauf an einem einzigen Tag auf einer New Yorker Modemesse weiter. Das Röhrentop wurde während der Hippiewelle als Alternative zum BH geschätzt und kam in den wilden 1990er-Jahren wieder in Mode. Das Top ist auch heute noch aufreizend genug, um bei Prominenten und Partygängern beliebt zu sein.

Röhrentop (auch Schlauchoberteil genannt)

Bandana top (aka scarf top)

This most versatile of all fashion accessories makes for a seductive summer bustier and is a fashion trend that comes back on a regular basis. The only difficulty is, as always with the bandana, finding the right amount of tightness around the torso: if it's too loose it might slip off, but if it's too tight it might be uncomfortable or rip when you burst out laughing. *En vogue* in the late 1990s, the bandana top is back in the spotlight these days, along with most of the Y2K fashion accessories.

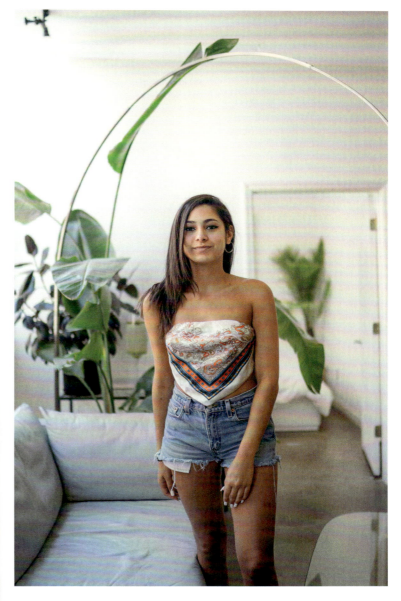

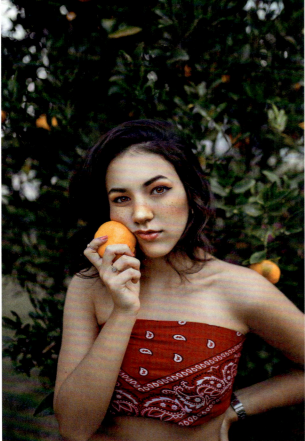

Dieses verführerische Sommerbustier gilt als das vielseitigste Accessoire und ist ein Modetrend, der immer wieder auftaucht. Die einzige Schwierigkeit besteht beim Bandana darin, die richtige Spannung um den Oberkörper zu finden: Wenn es zu locker sitzt, kann es herunterrutschen, aber wenn es zu eng ist, kann es unbequem sein oder beim Lachen reißen. In den späten 1990er-Jahren war das Bandana-Top schon *en vogue* und heute steht es wieder im Rampenlicht – ebenso wie die meisten anderen Modeaccessoires der 2000er-Jahre im Rahmen des Y2K-Trends.

Bandana-Top (auch Schaltop genannt)

Tank top

Sleeveless shirts have been known since the 1860s, at that time they were worn by dockers and warehouse workers. However, even though their shapes are very similar, this utilitarian garment isn't the direct forerunner of the tank top: the top derives from the one-piece bathing suit imposed on sports swimmers of both sexes in the 1920s, when swimming pools were still called "swimming tanks". This tight-fitting suit had a sleeveless top and straps and was well suited to sports where arm movements played an essential role, such as basketball, tennis, and other athletics. Over the following decades, it extended its popularity across many sports, before moving into the field of women's fashion with the sportswear trend of the late 1970s, which saw the introduction of V-neck tank tops. Twenty years later, the white tank top became part of supermodel Kate Moss' off duty looks and reached a new level of popularity among urban women. The minimalist style and comfort of this casual garment have taken it to the height of fashion in 2022, with many leading brands featuring it in their catwalk shows. As *Vogue* magazine commented on this occasion "the tank top brings a certain *je-ne-sais-quoi*: the right dose of cool to any silhouette."[5]

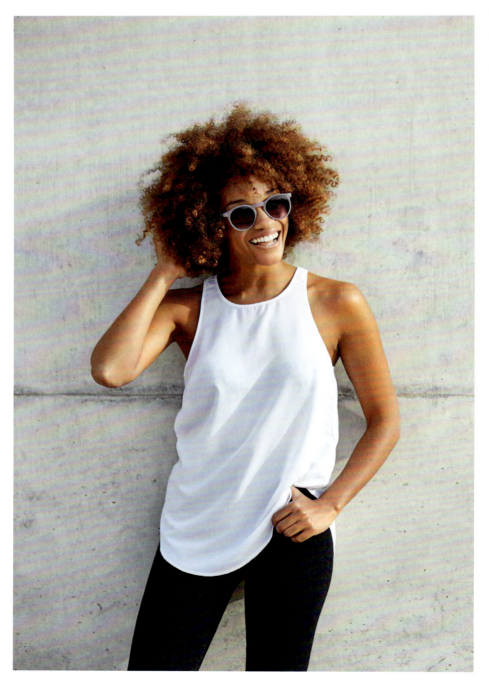

Loose or fitted, the tank top is back on trend

Locker oder eng, das Tanktop ist wieder im Trend

Blouses and jumpers / Blusen und Pullover

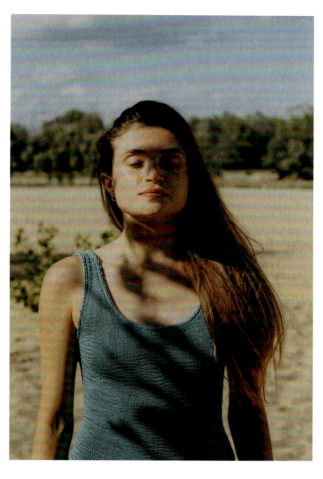

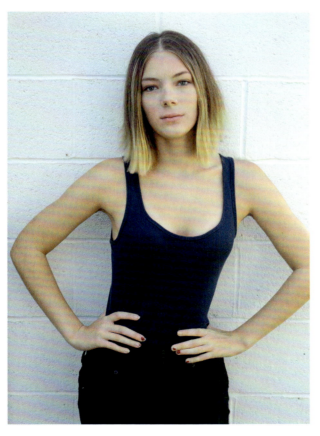

Ärmellose Hemden kamen in den 1860er-Jahren auf. Damals wurden sie von Hafen- und Lagerarbeitern getragen. Auch wenn sich die Formen sehr ähneln, ist dieses praktische Kleidungsstück nicht der direkte Vorläufer des Tanktops: Das Top geht auf den einteiligen Badeanzug zurück, den Sportschwimmer beider Geschlechter in den 1920er-Jahren tragen mussten. Solch ein eng anliegender Anzug war mit einem ärmellosen Oberteil mit Trägern versehen und eignete sich für Sportarten, bei denen Armbewegungen eine wesentliche Rolle spielen, wie Basketball, Tennis und bestimmte Leichtathletikformen. In den folgenden Jahrzehnten wurde er in vielen Sportarten populär, bevor es mit dem Sportbekleidungstrend der späten 1970er-Jahre, der die Einführung von Tanktops mit V-Ausschnitt mit sich brachte, in die Damenmodewelt einzog. Zwanzig Jahre später gehörte das weiße Tanktop zu den Freizeitlooks von Supermodel Kate Moss und war bei Städterinnen äußerst beliebt. Der minimalistische Stil und der Komfort dieses lässigen Kleidungsstücks haben es 2022 in den Modeolymp gehoben, denn viele führende Marken zeigten es bei ihren Laufstegshows. Die Zeitschrift *Vogue* kommentierte diesen Anlass wie folgt: „Das Tanktop verleiht jeder Silhouette das gewisse Etwas – nämlich die richtige Portion Coolness."[5]

Tanktop

Nordic jumper

The winter sports craze of the 1930s led budding alpinists and skiers to look for clothing designed to withstand the extreme cold. The Norwegian hand-knitted wool jumper, known under the name of *lusekofte* for more than four hundred years, soon became popular for the pleasant warmth it offered. The ornamental patterns at the top of the jumper added a decorative touch to the garment that has stood the test of time and weather. One of these traditional motifs, the *selburose*, was inspired by an eight-petalled rose, but its shape also resembled a snowflake, and was therefore a perfect choice for fans of winter sports. A Swedish variant of the jumper, made in Bohus, became an iconic fashion item in the 1940s thanks to the most Nordic of Hollywood beauties, Ingrid Bergman. Its designs later inspired a cardigan, also handknitted in Bohus, and worn by Grace Kelly in the 1960s. Although on ski slopes of the 1980s the jumper was replaced by the ski suit or anorak, the simple and chic Nordic sweater is still a must-have for *après-ski*. Its natural, handmade look appeals to environmentally friendly fashionistas.

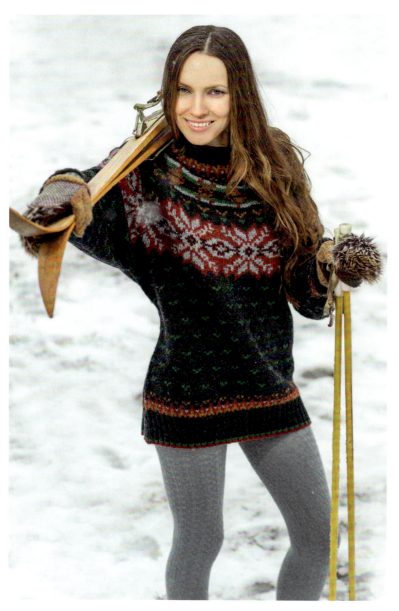

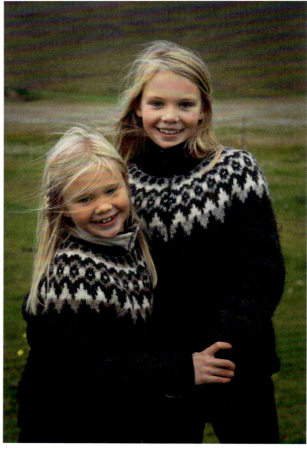

Blouses and jumpers / Blusen und Pullover

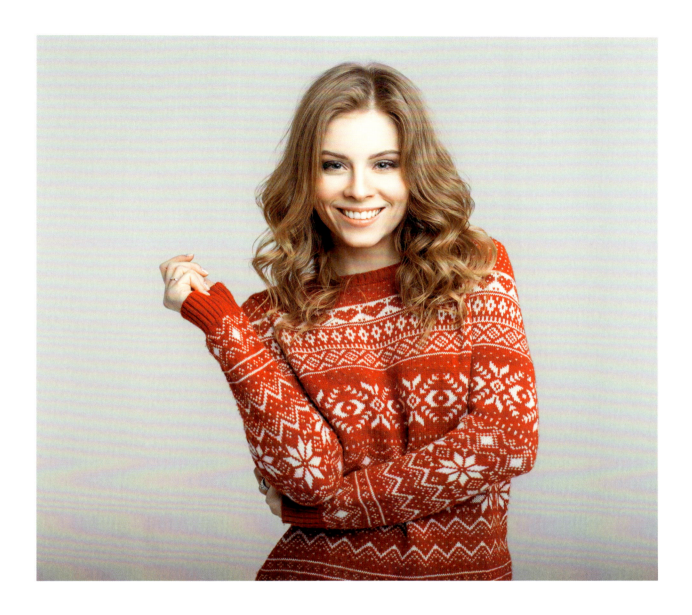

Die Wintersportbegeisterung der 1930er-Jahre veranlasste angehende Alpinisten und Skifahrer dazu, nach Kleidung zu suchen, die der extremen Kälte standhielt. Der handgestrickte norwegische Wollpullover, der seit mehr als 400 Jahren unter dem Namen *Lusekofte* bekannt ist, wurde bald wegen seiner angenehmen Wärme beliebt. Die ornamentalen Muster am oberen Rand des Pullovers verleihen dem Kleidungsstück einen dekorativen Touch, der sich im Laufe der Zeit und bei jedem Wetter bewährt hat. Die *Selburose*, eines dieser traditionellen Motive, wurde von einer achtblättrigen Rose inspiriert. Ihre Form ähnelt aber auch einer Schneeflocke und war daher die perfekte Wahl für Wintersportfans. Eine schwedische Variante des Pullovers, der in Bohus gestrickt wurde, wurde in den 1940er-Jahren dank Ingrid Bergman – der nordischsten aller Hollywood-Schönheiten – zu einem ikonischen Kleidungsstück. Die Entwürfe inspirierten später eine Strickjacke, die ebenfalls in Bohus handgestrickt und von Grace Kelly in den 1960er-Jahren getragen wurde. Obwohl der Pullover in den 1980er-Jahren auf den Skipisten durch den Skianzug oder den Anorak ersetzt wurde, ist der schlichte und schicke Norwegerpullover immer noch ein Must-have für den Après-Ski. Der natürliche, handgefertigte Look spricht umweltbewusste Fashionistas an.

Norwegerpullover

Peter Pan collar

Wearing a Peter Pan collar gives you a stylish, retro look, no matter what else you have on. While its origin is disputed, its birth date lies clearly in the early years of the 20th century. It is mentioned by the French author Colette in her novel *Claudine à l'école*, published in 1900, where the schoolgirl heroine wears on – the flat, round collar was part of the school uniform at that time –, and it is still called *col Claudine* in French. Shortly afterwards, the American actress Maud Adams played the role of Peter Pan wearing a costume featuring a similar collar, which prompted a lasting children's fashion phenomenon. In the 1950s, the Peter Pan collar made the switch to adult fashion, and gradually moved away from the unique white shade that had characterised it until then. Thanks to Audrey Hepburn, it became the accessory for young women whose personality is more layered than their look might suggest: the list of regular wearers includes, among many others, Kate Middleton, French actress Léa Seydoux, Scarlet Johansson, and Nicole Kidman.

A charming retro feel

Der Bubikragen steht für Retro-Charme

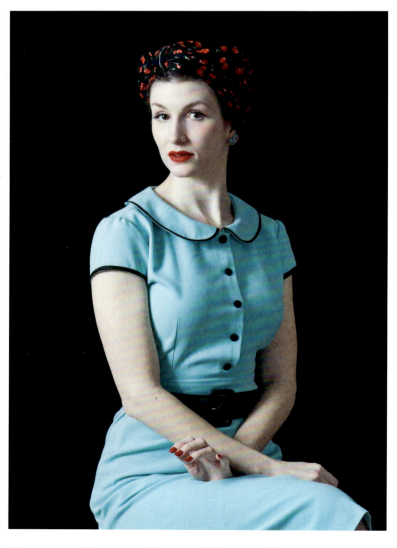

46 **Blouses and jumpers / Blusen und Pullover**

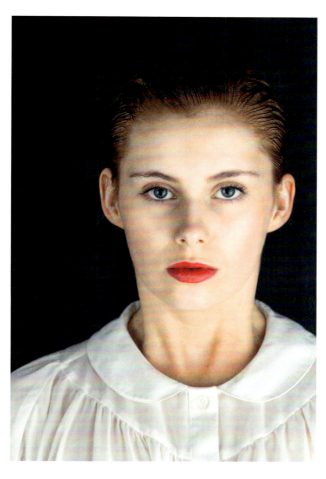

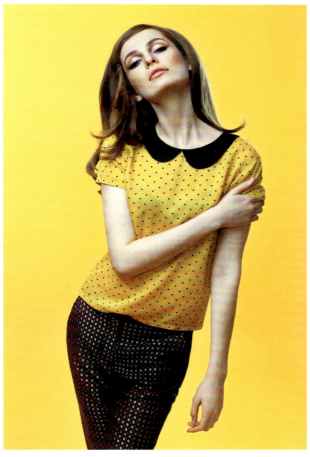

Ein Bubikragen verleiht Ihnen einen stilvollen Retrolook – ganz gleich, was Sie sonst tragen. Sein Ursprung ist zwar umstritten, aber seine Geburtsstunde liegt eindeutig in den ersten Jahren des 20. Jahrhunderts. Die französische Schriftstellerin Colette erwähnt ihn in ihrem 1900 erschienenen Roman *Claudine erwacht*, in dem die Heldin, ein Schulmädchen, einen solchen Kragen trägt – der flache, runde Kragen war damals Teil der Schuluniform. Im Französischen wird er immer noch *Col Claudine* genannt. Kurz darauf spielte die US-amerikanische Schauspielerin Maud Adams die Rolle des Peter Pan und trug ein Kostüm mit einem ähnlichen Kragen, der zu einem dauerhaften Phänomen der Kindermode wurde. In den 1950er-Jahren ging der Bubikragen in die Erwachsenenmode über und entfernte sich allmählich von dem weißen Farbton, der ihn bis dahin charakterisiert hatte. Dank Audrey Hepburn wurde er zum Accessoire für junge Frauen, deren Persönlichkeit vielschichtiger ist, als ihr Aussehen vermuten lässt: Auf der Liste der regelmäßigen Trägerinnen stehen unter anderem Kate Middleton, die französische Schauspielerin Léa Seydoux sowie Scarlet Johansson und Nicole Kidman.

Sailor collared blouse (aka middy blouse)

In current popular culture, blouses with sailor collars are associated with Japanese schoolgirls and their avatars in manga comics. The uniform-like *seifuku*, as it is called in the Land of the Rising Sun, has thus maintained the image of an outfit that is worn primarily by children. In the 19th century, male children of royal families across Europe were the first to wear sailor uniforms adapted to their size. This aristocratic fashion was widely followed by the rest of the population, especially as the craze for fancy seaside resorts and sea bathing began, and promptly extended to adults. The resounding success of the sailor dress at the beginning of the 20th century marked the introduction of the sailor collar into women's clothing. This straight and proper dress was rapidly adopted as a school uniform in several countries, including Japan in the 1920s. Blouses of the same type, worn with a navy-blue skirt, followed at the same time, and remained in fashion until the late 1940s. The middy blouse resurfaced in the 1970s, a time when it moved away from the usual white and blue to explore more cheerful shades. Its most recent comeback is linked to that of the ubiquitous *marinière* (Breton top), which may one day be supplanted by the sailor-collared blouse.

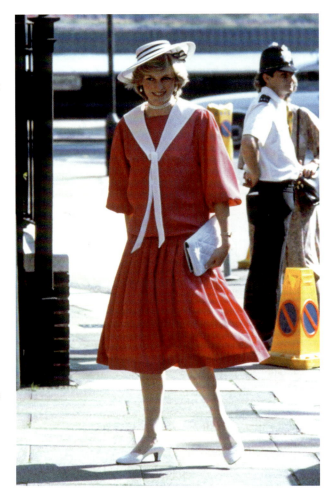

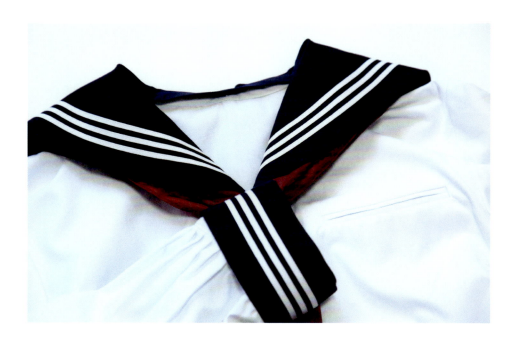

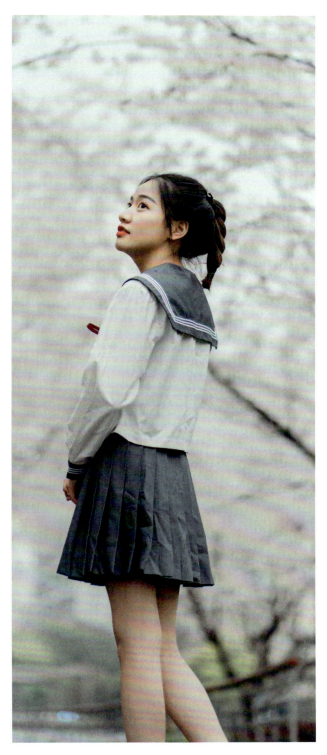

A youthful, dynamic look

Für einen jugendlichen und dynamischen Look

In der aktuellen Popkultur werden Matrosenblusen mit japanischen Schulmädchen und ihren Avataren in Mangas in Verbindung gebracht. Die uniformähnliche *Seifuku*, wie sie im Land der aufgehenden Sonne genannt wird, hat sich somit das Image eines Outfits bewahrt, das vor allem von Kindern getragen wird. Im 19. Jahrhundert trugen die männlichen Kinder der europäischen Königsfamilien als Erste eine ihrer Größe entsprechende Matrosenuniform. Diese aristokratische Mode wurde von der übrigen Bevölkerung weitgehend übernommen, insbesondere als die Begeisterung für mondäne Badeorte und das Baden im Meer einsetzte und sich rasch auf die Erwachsenen übertrug. Der durchschlagende Erfolg des Matrosenkleides zu Beginn des 20. Jahrhunderts führte zur Einführung des Matrosenkragens in die Damenbekleidung. Diese geradlinige und korrekte Kleidung wurde in mehreren Ländern schnell als Schuluniform übernommen, wie auch in Japan in den 1920er-Jahren. Blusen derselben Art, die mit einem marineblauen Rock getragen wurden, kamen zur gleichen Zeit auf und blieben bis in die späten 1940er-Jahre in Mode. In den 1970er-Jahren tauchten die Matrosenblusen wieder auf und entfernten sich von den üblichen Weiß- und Blautönen, um fröhlichere Farben zu entdecken. Ihr jüngstes Comeback ist mit dem der allgegenwärtigen *Marinière* (Matrosen- oder Bretagne-Shirt) verbunden, die vielleicht eines Tages von der Matrosenbluse verdrängt wird.

Matrosenbluse

Turtleneck jumper

The turtleneck jumper was part of every major social battle in the second half of the 20th century, serving as a uniform for beatniks and the bohemian generation of the 1960s, and as a unisex outfit for feminists, radical academics, philosophers, and left-oriented intellectuals in the 1970s, before becoming the flagship garment of computer geeks in the wake of Steve Jobs. The turtleneck has remained true to its original military purpose: designed in the Middle Ages to be worn by knights under their chainmail and to spare them the discomfort that metal would have caused on bare skin during battle. Renaissance fashion adapted it to civilian use in the form of the ruff. Its purpose was to highlight the length of the neck, which was perceived as a sign of refinement and dignity. The turtleneck took its present shape in the 19th century, in naval uniforms, although there are actually several variants besides the classic turtleneck such as cowl-neck, funnel turtleneck, knit turtleneck, to name but a few. While most of the turtleneck jumpers of the past were skin-tight, the latest trend is to wear them oversized.

As the garment is available in various styles, colours, and fabrics, you can find your own unique look with such a wide range from which to choose.

Keep warm in style

Warmhalten mit Stil

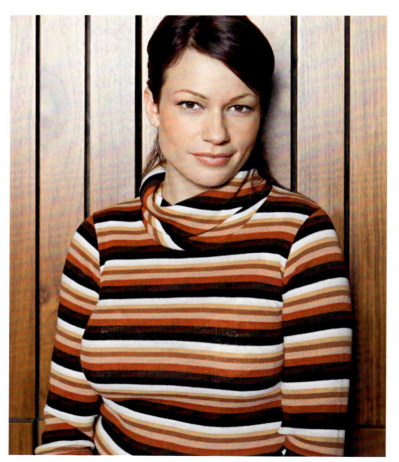

Blouses and jumpers / Blusen und Pullover

Der Rollkragenpullover war Teil aller großen gesellschaftlichen Auseinandersetzungen in der zweiten Hälfte des 20. Jahrhunderts. Er diente als Uniform der Beat- und der Boheme-Generation der 1960er-Jahre, als Unisexoutfit für Feministinnen, radikale Akademiker, Philosophen sowie linksgerichtete Intellektuelle in den 1970er-Jahren und wurde schließlich durch Steve Jobs zum Lieblingskleidungsstück der Computerfreaks. Der Rollkragen ist seinem ursprünglichen militärischen Zweck treu geblieben: Er wurde im Mittelalter entwickelt, um von Rittern unter ihrem Kettenhemd getragen zu werden und ihnen die Unannehmlichkeiten zu ersparen, die das Metall auf der nackten Haut im Kampf verursacht hätte. Die Mode der Renaissance adaptierte ihn in Form der

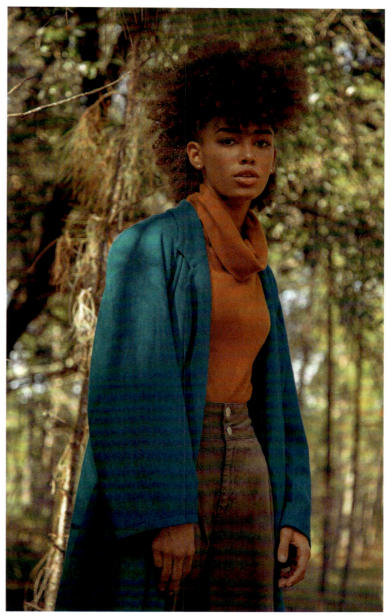

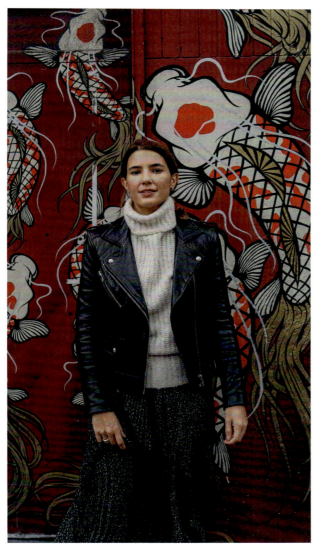

Halskrause für den zivilen Gebrauch. Der Rollkragen sollte die Länge des Halses betonen, die als Zeichen von Kultiviertheit und Würde galt. Der Rollkragen hat seine heutige Form im 19. Jahrhundert als Teil von Marineuniformen erhalten, obwohl es neben dem klassischen Rollkragen mehrere Varianten gibt, wie z. B. den Wasserfallausschnitt, den Trichterkragen und den gestrickten Rollkragen. Während die meisten Rollkragenpullover in der Vergangenheit hauteng waren, ist der neueste Trend, ihn übergroß zu tragen. Da das Kleidungsstück in verschiedenen Stilen, Farben und Stoffen erhältlich ist, können Sie in dieser großen Auswahl Ihren eigenen Look ganz einfach finden.

Rollkragenpullover

Sweater vest

Oh, no, not the old-fashioned sweater vest! And yet, moms in the 2020s feel compelled to steal from their daughters' wardrobe this antiquated, all too conformist piece of clothing that should not really have made a comeback – but managed nevertheless to become retro-cool. Not so long ago, though, sweater vests would have looked as passé as, say floppy disks, and you would put one on to imitate your grandpa in his rocking chair. However, it proved to be the unexpected Cinderella of recent fashion seasons, with stylish variants that changed the way we perceive a garment that was once characteristic of preppy style in the 1930s and 1970s. Oversized variants in neutral hues with a turtleneck or crochet pattern, for example, transform the sweater vest into a chic, feminine attire which is lighter than a jumper and ultimately works well with dresses, skirts, or even under a suit.

Blouses and jumpers / Blusen und Pullover

Retro-cool and comfortable, the sweater vest is back in fashion

Retro-cool und bequem, der Pullunder ist wieder in Mode

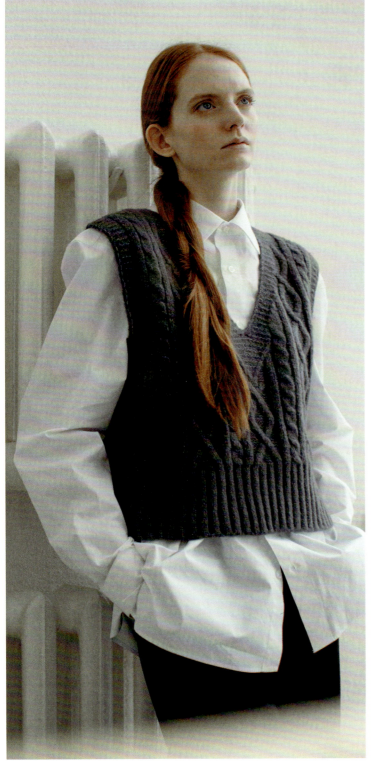

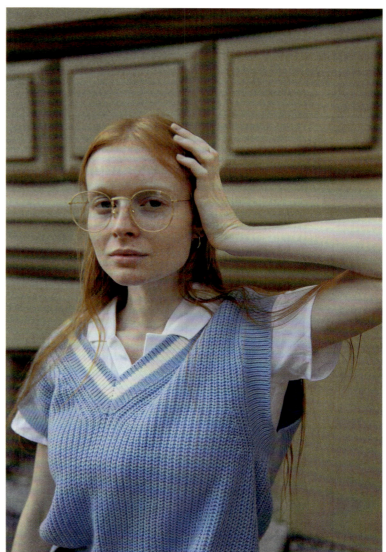

Oh nein, bloß kein altmodischer Pullunder! Und doch fühlen sich Mütter in den 2020er-Jahren gezwungen, ihren Töchtern dieses antiquierte und allzu konforme Kleidungsstück aus dem Kleiderschrank zu klauen, das eigentlich kein Comeback erleben sollte – und es dennoch geschafft hat, zum coolen Retrolook aufzusteigen. Es ist noch gar nicht so lange her, da waren Pullunder so passé wie etwa Disketten. Man zog sie nur an, um den Opa im Schaukelstuhl nachzuahmen. Das Kleidungsstück erwies sich jedoch als unerwartetes Aschenputtel der letzten Modesaisons mit stilvollen Varianten, die seine Wahrnehmung als Teil des *Preppy Style* der 1930er- und 1970er-Jahre veränderte. Übergroße Varianten in neutralen Farben mit Rollkragen oder Häkelmuster verwandeln den Pullunder beispielsweise in ein schickes, feminines Kleidungsstück, das leichter ist als ein Pullover und dadurch gut zu Kleidern, Röcken oder sogar unter einen Anzug passt.

Pullunder

Puffed sleeves

From the Renaissance to the Belle Époque, puffed sleeves have often been associated with times of prosperity and female empowerment: in Elizabethan times they were called *Juliet sleeves*, in honour of the Shakespearean heroine, and at the dawn of the 20th century, they were a symbol of the *Gibson Girl*, an early American model of the emancipated woman. The Roaring Twenties should logically have adopted the puffed sleeve style, but Art Deco imposed strict geometric lines. Fortunately, more extravagant designers, inspired by surrealism, brought them back into fashion in the early 1930s. The puffed sleeves resurfaced at the end of the Swinging Sixties, in the golden age of feminism, and then again in the 1980s, along with shoulder pads, as the outfit of the executive woman embodied by Joan Collins in the *Dynasty* series. It is probably coincidental, but their latest comeback, along with the hippie-inspired balloon sleeves, seems to occur in the wake of the #metoo wave.

A delicate and distinctive touch

Zart und dennoch unübersehbar

Blouses and jumpers / Blusen und Pullover

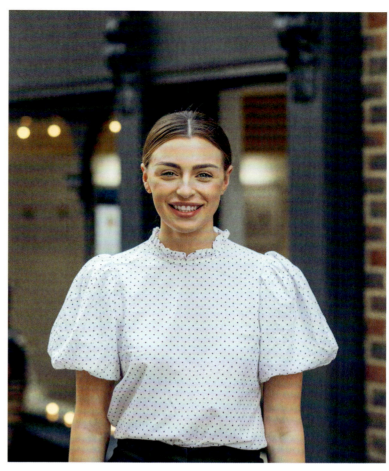

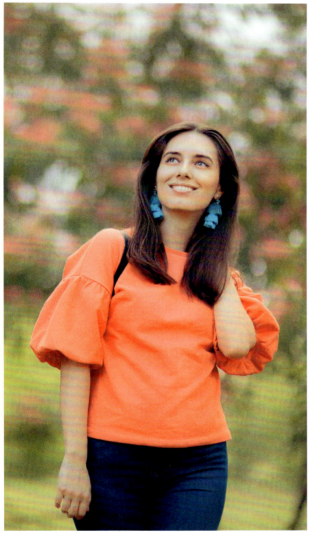

Von der Renaissance bis zur *Belle Époque* wurden Puffärmel oft mit Zeiten des Wohlstands und der weiblichen Macht assoziiert: In der elisabethanischen Zeit wurden sie zu Ehren der Shakespeare-Heldin *Julia-Ärmel* genannt und zu Beginn des 20. Jahrhunderts waren sie ein Symbol des *Gibson Girl*, eine frühe US-amerikanische Version der emanzipierten Frau. Die Goldenen Zwanziger hätten logischerweise die Puffärmel übernehmen müssen, aber der vorherrschende Stil des Art déco schrieb strenge geometrische Linien vor. Glücklicherweise holten extravagantere Designer, die sich vom Surrealismus inspirieren ließen, sie in den frühen 1930er-Jahren wieder in den Modeolymp zurück. Puffärmel tauchten Ende der *Swinging Sixties* – im goldenen Zeitalter des Feminismus – wieder auf und dann in den 1980er-Jahren zusammen mit Schulterpolstern als Outfit der von Joan Collins in der Serie *Der Denver-Clan* gespielten Managerin. Wahrscheinlich ist es Zufall, aber ihr jüngstes Comeback in Kombination mit den von den Hippies inspirierten Ballonärmeln scheint im Zuge der #metoo-Welle zu erfolgen.

Puffärmel

Bodysuit

A 19th century French gymnast, Jules Léotard, was the first sportsman to devise, and wear a sleeveless, skin-tight sports shirt for exercises on the trapeze. In the years that followed, the *leotard*, as the garment was named after its inventor, spread to many sporting disciplines, and became the favourite rehearsal outfit for ballerinas as well as for weightlifters. The bodysuit crossed the threshold between sport and fashion in the early 1940s thanks to designers such as legendary American sportswear designer Claire McCardell and Mildred Orrick, and to the first female superhero, *Catwoman*, created in 1940 in the first issue of *Batman* comics. Clad in a skin-tight bodysuit, the feline-inspired character embodied the seduction of evil and was one of Batman's recurrent love interests. The bodysuit became an essential piece of clothing for the modern, sporting woman. In the decades that followed, it was closely related to two major trends that paid cult-like tribute to the female body: the 1950s pin-up fashion personified by Bettie Page, and Jane Fonda's aerobics videos in the 1980s. As a fashion historian noted, "women loved it; men loved it"[6]. The 1990s, with their taste for anything risky and edgy, upgraded the bodysuit from casual streetwear to the catwalks. It is now a garment for every woman who wants to celebrate their curves, thus following the examples of Rihanna, Jennifer Lopez and Lady Gaga.

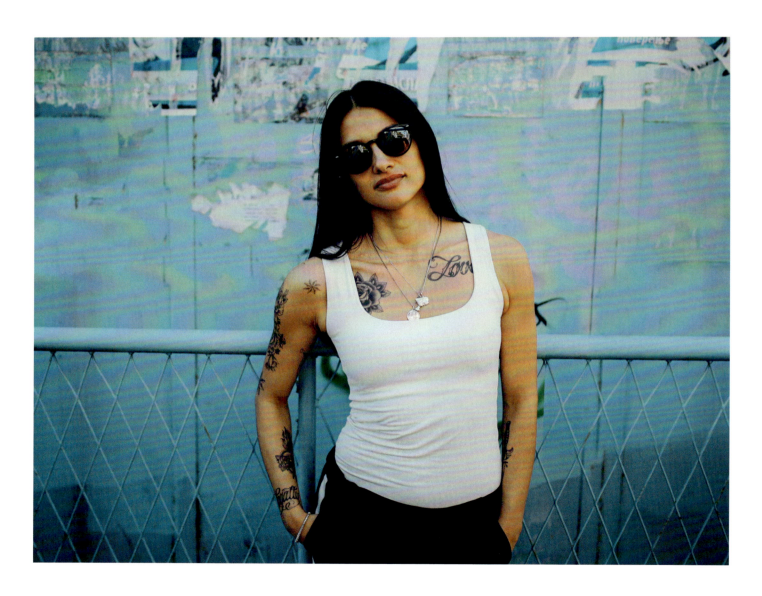

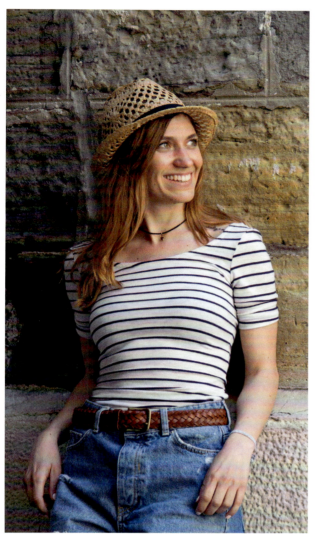

Jules Léotard, ein französischer Turner aus dem 19. Jahrhundert, war der erste Sportler, der ein ärmelloses, hautenges Sporthemd für Übungen am Trapez erfand und trug. In den folgenden Jahren verbreitete sich das *Leotard*, wie das Kleidungsstück nach seinem Erfinder benannt wurde, in vielen Sportarten und wurde zum bevorzugten Trainingsanzug für Ballerinas und Gewichtheber. In den frühen 1940er-Jahren überschritt der Body die Schwelle zwischen Sport und Mode dank Designern wie den legendären US-amerikanischen Sportbekleidungsdesignerinnen Claire McCardell und Mildred Orrick und dank *Catwoman*, der ersten weiblichen Superheldin, die 1940 in der ersten Ausgabe der *Batman*-Comics auftauchte. In einem hautengen Body verkörperte die von Katzen inspirierte Figur die Verführung des Bösen und war eine von Batmans wiederkehrenden Liebesbeziehungen. Der Body wurde zu einem unverzichtbaren Kleidungsstück für die moderne, sportliche Frau. In den folgenden Jahrzehnten war der Body mit zwei großen Trends eng verbunden, die den weiblichen Körper kultisch verehrten: der Pin-up-Mode *à la* Bettie Page in den 1950er-Jahren und der Aerobic-Videos von Jane Fonda in den 1980er-Jahren. Ein Modehistoriker fasste treffend zusammen: „Frauen und Männer liebten ihn gleichermaßen."[6] Die 1990er-Jahre mit ihrer Vorliebe für alles, was riskant und ausgefallen war, brachten den lässigen Streetwear-Body auf die Laufstege. Heute ist er ein Kleidungsstück für jede Frau, die ihre Kurven betonen und damit den Beispielen von Rihanna, Jennifer Lopez und Lady Gaga folgen möchte.

Trousers, shorts, overalls, jumpsuits, and tracksuits

3

Hosen, Shorts, Latzhosen, Overalls und Trainingsanzüge

Bell-bottom trousers (aka Flares, Loons, Elephant trousers)

A symbol of the 1960s and 70s, bell-bottom trousers originated in the early 19th century, when sailors serving in the nascent US Navy decided to wear them in lieu of a uniform. Strangely enough, the young United States did not have enough money to provide uniforms for its sailors, at least until 1841. The legs of the trousers which became wider from the knees down, were deemed to be very practical, as it made it easy to roll them up or to kick the trousers off depending on the weather and activity, and if knotted properly, could offer extra flotation when immersed in water (voluntarily or not). Bell-bottom trousers moved from the deck to the catwalk thanks to Coco Chanel and her yachting pants in the late 1920s. However, wearing trousers was still too revolutionary for many women, and the trend did not take off until the mid-1960s when hippies adopted the denim flare pants as a part of their identity. Bell-bottoms became mainstream in the early 1970s when Sonny and Cher went on TV shows in fancy "loons", as they were renamed by then. Another variant, called "elephant trousers", was long enough to cover the shoes, and hit the streets shortly afterwards. Actresses such as Joan Collins, Raquel Welch, and the young Olivia Newton-John were spotted wearing them. A little later, bell-bottom trousers in funky colours would become a part of Afro style. After a long absence during the 1980s and early 1990s, the trousers made a lasting comeback around 1996, in a new style, the "boot cut" pants, which were said to elongate the figure, before giving way to their polar opposite, the skinny jeans. Bell-bottom pants are back again these days, and the current fascination for the 1970s guarantees them a secure future.

Back to the crazy 1970s!

Zeitreise in die verrückten 1970er-Jahre!

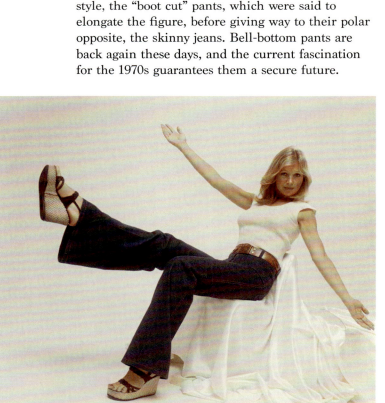

60 **Trousers, shorts, overalls, jumpsuits, and tracksuits / Hosen, Shorts, Latzhosen, Overalls und Trainingsanzüge**

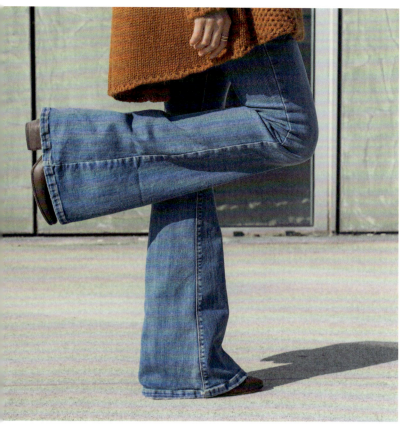

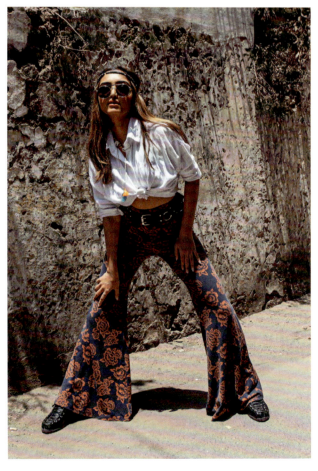

Die Schlaghose, ein Symbol der 1960er- und 1970er-Jahre, hat ihren Ursprung im frühen 19. Jahrhundert, als Matrosen in der sich herausbildenden US Navy beschlossen, sie anstelle einer Uniform zu tragen. Erstaunlicherweise hatten die jungen Vereinigten Staaten bis 1841 nicht genug Geld, um Uniformen für ihre Seeleute zu kaufen. Die Hosenbeine, die von den Knien abwärts breiter wurden, galten als sehr praktisch, da sie je nach Wetterlage und Aktivität einfach hochgekrempelt oder ausgezogen werden konnten. Wenn sie richtig geknotet waren, boten sie beim Eintauchen ins Wasser (freiwillig oder unfreiwillig) außerdem zusätzlichen Auftrieb. Dank Coco Chanel und ihren *Yachting Pants* in den späten 1920er-Jahren gelangten die Schlaghosen von Deck auf den Laufsteg. Für viele Frauen war das Tragen von Hosen jedoch noch zu revolutionär und der Trend setzte sich erst Mitte der 1960er-Jahre durch, als die Hippies Schlaghosen aus Jeansstoff als Teil ihrer Identität annahmen. Schlaghosen kamen in den frühen 1970er-Jahren im Mainstream an, als Sonny und Cher damit in Fernsehshows auftraten. Eine andere Variante, die so genannte Elefantenhose, war lang genug, um die Schuhe zu bedecken, und kam kurz darauf in Mode. Schauspielerinnen wie Joan Collins, Raquel Welch und die junge Olivia Newton-John wurden mit ihnen gesichtet. Wenig später wurden Schlaghosen in flippigen Farben Teil des Afrolooks. Nach einer langen Abwesenheit von der Modewelt in den 1980er- und frühen 1990er-Jahren erlebte die Hose um 1996 ein dauerhaftes Comeback und zwar in einem neuen Stil: der *Boot Cut Jeans*, die die Figur verlängern sollte, bevor sie ihrem genauen Gegenteil – der *Skinny Jeans* – Platz machte. Hosen mit Schlag sind wieder im Kommen und dank der aktuellen Faszination für die 1970er-Jahre ist ihre Zukunft gesichert.

Schlaghose (auch Flare-Hose genannt)

Carrot pants

Carrot pants belong to the panoply of the 1980s as much as shoulder pads do, and Lady Diana wore both. As the name suggests, the pants are shaped like a carrot, wide at the top and tapered toward the ankle. Pleats at the hip level create extra volume and so are particularly suited to those with slender figures. Back in the 1980s, carrot pants in pastel hues made the perfect summer outfit, although not a style that flattered every body type – it helps to be tall and slim. Probably because of this constraint, carrot trousers abruptly fell out of fashion by the end of the decade, only to return to favour recently. They are now worn for leisure, business, and formal occasions alike, thus gaining versatility. Pairable with any type of top, they are now available in an endless variety of colours – from beige to black and all the colours in-between.

Vogue's Executive Fashion Director Lisa Aiken

Lisa Aiken, Modechefin der Vogue

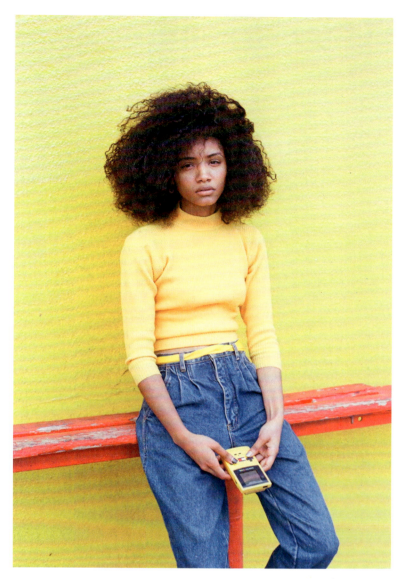

A basic piece for a chic and stylish look

Gehört zur Grundausstattung für einen schicken und stilvollen Look

Karottenhosen gehören ebenso zum Repertoire der 1980er-Jahre wie Schulterpolster – Lady Diana trug beides. Wie der Name schon sagt, ist die Hose wie eine Karotte geformt: oben weit und zum Knöchel hin verjüngt. Falten auf Hüfthöhe schaffen zusätzliches Volumen und eignen sich daher besonders für schlanke und große Figuren. In den 1980er-Jahren waren Karottenhosen in Pastelltönen das perfekte Sommeroutfit, auch wenn dieser Stil nicht jedem Körpertyp schmeichelt. Wahrscheinlich wegen dieser Einschränkung kamen Karottenhosen gegen Ende des Jahrzehnts abrupt aus der Mode und kehrten erst in jüngster Zeit wieder zurück. Sie werden heute in der Freizeit, im Beruf und bei formellen Anlässen gleichermaßen getragen und sind dadurch vielseitig einsetzbar. Sie lassen sich mit jeder Art von Oberteil kombinieren und sind jetzt in einer unendlichen Vielfalt von Farben erhältlich – von Beige bis Schwarz und allen Farben dazwischen.

Karottenhose (auch Mom-Jeans genannt)

Cigarette pants (aka Capri pants)

High waisted, cropped above the ankle, slim and straight, cigarette trousers hint at the 1950s' Dolce Vita and the beatnik generation. Next to the little black dress, they are the iconic outfit we associate with Audrey Hepburn, the one that bestowed her with her signature *gamine* look. Introduced in 1948 by German fashion designer, Sonja de Lennart, whose first collection was called *Capri*, a tribute to the Italian island where she used to spend pre-war holidays. Their innovative shape, which was meant to enhance youthful figures, was quickly taken up by many fashion designers in Europe and the United States. Audrey Hepburn made one of her first screen appearances in capri trousers – designed by Hubert de Givenchy – in Billy Wilder's comedy *Sabrina* (1954), where she starred opposite Humphrey Bogart. From then on, capri trousers were adopted by all Hollywood goddesses, from Grace Kelly to Marilyn Monroe and Natalie Wood, as well as celebrities of the time, including Jackie Kennedy. After fading into the background in the 1970s and 1980s, cigarette trousers found their way back into the limelight thanks to Uma Thurman in *Pulp Fiction* (1994), and have become a staple of summer fashion ever since.

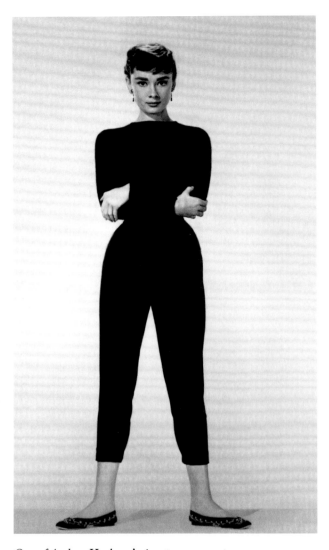

One of Audrey Hepburn's signature garments

Ein fester Bestandteil von Audrey Hepburns Garderobe

64 **Trousers, shorts, overalls, jumpsuits, and tracksuits / Hosen, Shorts, Latzhosen, Overalls und Trainingsanzüge**

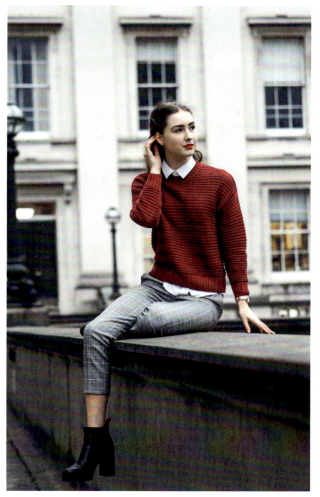

Die schlanken, geraden und hoch taillierten Zigarettenhosen, die über dem Knöchel abgeschnitten sind, erinnern an das *Dolce Vita* der 1950er-Jahre und die *Beat Generation*. Neben dem kleinen Schwarzen sind sie das ikonische Outfit, das wir mit Audrey Hepburn assoziieren und das ihr ihren unverwechselbaren femininen Look verliehen hat. Die Hose wurde 1948 von der deutschen Modedesignerin Sonja de Lennart eingeführt, deren erste Kollektion den Namen *Capri* trug, eine Hommage an die italienische Insel, auf der sie in der Vorkriegszeit Urlaub machte. Ihre innovative Form, die jugendliche Figuren betonen sollte, wurde schnell von vielen Modedesignern in Europa und den USA aufgegriffen. Audrey Hepburn hatte einen ihrer berühmtesten Leinwandauftritte in einer Caprihose, die von Hubert de Givenchy entworfen wurde, und zwar in Billy Wilders Komödie *Sabrina* (1954), wo sie neben Humphrey Bogart zu sehen war. Von da an wurde die Zigarettenhose von allen Hollywood-Schönheiten getragen – von Grace Kelly über Marilyn Monroe und Natalie Wood bis hin zu anderen Berühmtheiten der Zeit wie Jackie Kennedy. Nachdem die Zigarettenhose in den 1970er- und 1980er-Jahren in den Hintergrund getreten war, fand sie dank Uma Thurman in *Pulp Fiction* (1994) ihren Weg zurück ins Rampenlicht und ist seither ein fester Bestandteil der Sommermode.

Zigarettenhose (auch Caprihose genannt)

Corduroy pants

Corduroy pants have enjoyed growing popularity in recent years as a consequence of the 1970s fashion revival. True, their colours are now less flashy than in their original heyday – pink, dark green, purple, and red have given way to more subtle hues, but fortunately the soft touch of the fabric, hasn't changed – corduroy is a highly tactile textile, one we love for the comfort it provides.
While corduroy can be worn with elegance, it always has a more casual feel that appealed to the protesting youth of the 1970s. Its rustic appearance gave a hip and eco-friendly look to those who wore it, in contrast to the synthetic garments that were flourishing at the time. This may explain why it has made a steady comeback nowadays: it is cool, pleasant to wear, and it looks natural.

Trousers, shorts, overalls, jumpsuits, and tracksuits / Hosen, Shorts, Latzhosen, Overalls und Trainingsanzüge

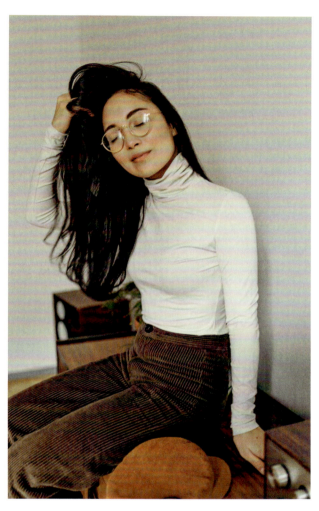

Enjoy comfort in many hues

Komfort in vielen Tönen

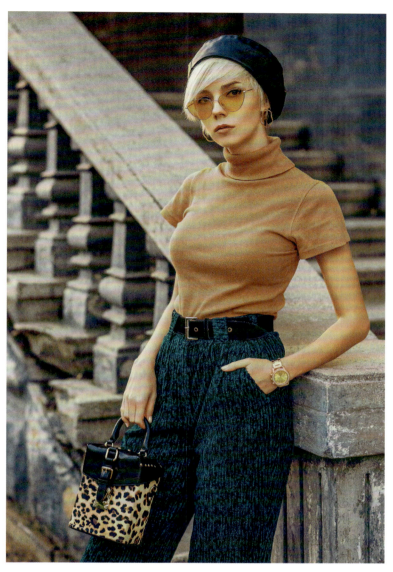

Kordhosen erfreuen sich in den letzten Jahren aufgrund des modischen Revivals der 1970er-Jahre wachsender Beliebtheit. Zwar sind die Farben heute nicht mehr so knallig wie zu ihrer Blütezeit – Pink, Dunkelgrün, Lila und Rot sind dezenteren Tönen gewichen, aber zum Glück ist der weiche Griff des Stoffes geblieben. Kord ist ein sehr taktiles Textil, das wir wegen seines Komforts lieben. Kord kann zwar elegant getragen werden, hat aber immer einen legeren Charakter, der der protestierenden Jugend der 1970er-Jahre gefiel. Ihr rustikales Aussehen verlieh den Trägern ein modernes und umweltfreundliches Aussehen im Gegensatz zu den synthetischen Kleidungsstücken, die zu dieser Zeit in Mode waren. Das mag erklären, warum sie heutzutage ein erfolgreiches Comeback erlebt: Sie ist cool, angenehm zu tragen und sieht natürlich aus.

Daisy Duke shorts

Even in the liberal America of the late 1970s, the skimpy denim shorts worn by Catherine Bach, the actress playing Daisy Duke in *The Dukes of Hazzard*, caused a minor scandal – and awakened sexual desires across, and even beyond, the US. The cut-off shorts, also known as hot pants, with their deliberately provocative look, were not, however, a new addition to the girls' wardrobes. They were already common in the punk counterculture of the mid-1970s, and singer Patti Smith was often spotted wearing them as early as 1977. The lasting popularity of denim cut-offs is partly due to their low cost – it's a great way to recycle worn-out jeans for the summer – and partly to their practicality: they are an ideal outfit for biking or hiking in the sun. Although they had never disappeared from the summer wardrobe, cut-off shorts made a dramatic comeback in the late 1980s, this time combined with knee socks. Hot pants make regular appearances whenever the temperature rises – with global warming, the future looks bright for shorts.

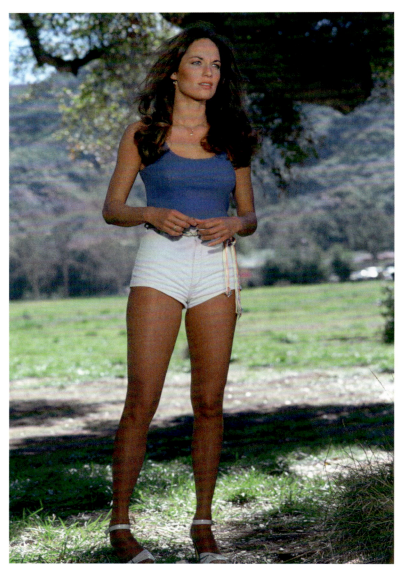

Selbst im liberalen Amerika der späten 1970er-Jahre sorgten die knappen Jeansshorts der Schauspielerin Catherine Bach, die Daisy Duke in *Ein Duke kommt selten allein* spielte, für einen kleinen Skandal – und weckten sexuelle Begierden in den gesamten USA und sogar darüber hinaus. Die abgeschnittenen Shorts, auch *Hot Pants* genannt, mit ihrem bewusst aufreizenden Aussehen waren in weiblichen Kleiderschränken jedoch keine Neuheiten. Durch die Gegenkultur der Punks waren sie schon seit Mitte der 1970er-Jahre weit verbreitet und die Sängerin Patti Smith wurde bereits 1977 häufig mit ihnen gesichtet. Die anhaltende Beliebtheit von Denimshorts ist zum einen auf ihre geringen Kosten zurückzuführen – eine tolle Möglichkeit, abgenutzte Jeans für den Sommer zu recyceln – und zum anderen auf ihre Praktikabilität: Sie sind ein ideales Outfit zum Radfahren oder Wandern in der Sonne. Obwohl sie nie aus der Sommergarderobe verschwunden waren, erlebten die abgeschnittenen Shorts in den späten 1980er-Jahren ein dramatisches Comeback – diesmal in Kombination mit Kniestrümpfen. Wenn die Temperaturen steigen, werden *Hot Pants* regelmäßig aus dem Kleiderschrank geholt – durch die globale Erwärmung sieht die Zukunft der Shorts rosig aus.

Shorts

Leggings

The invention of lycra (or spandex) by chemist Joseph Shivers in 1958 paved the way for the launch of modern-day leggings, with their stretchy, form-fitting mesh. Initially, however, leggings were considered to be just underwear or sports attire, similar to dance tights, horse-riding trousers, or the tight-fitting breeches worn by men in the late Middle Ages. The very idea of wearing them instead of a dress or trousers would have been viewed as totally indecent and outlandish.

Although Olivia Newton-John wore leggings in the final scene of *Grease* as early as 1978 – as did Charlie's Angels at the same time – and their use became widespread in gyms, their acceptance as a normal garment came with Madonna in the 1990s. It was really at the turn of the millennium that leggings as a regular element of streetwear, were adopted by celebrities such as Nicole Richie and Paris Hilton, and fashion designers.

From Grace Jones to Madonna, leggings are the hallmark of the modern woman

Von Grace Jones bis Madonna: Leggings sind das Markenzeichen der modernen Frau

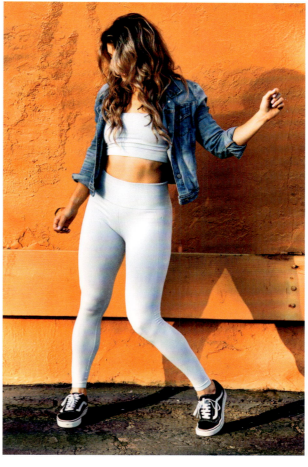
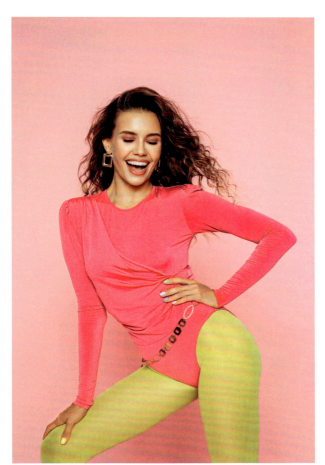

Die Erfindung von Lycra (bzw. Elastan) durch den Chemiker Joseph Shivers 1958 ebnete den Weg für die Einführung der modernen Leggings mit ihrem dehnbaren, figurbetonten Gewebe. Ursprünglich galten Leggings jedoch nur als Unterwäsche oder Sportbekleidung, ähnlich wie Tanzstrumpfhosen, Reithosen oder die eng anliegenden Kniebundhosen, die von Männern im späten Mittelalter getragen wurden. Allein die Vorstellung, sie anstelle eines Kleides oder einer Hose zu tragen, wäre als völlig unanständig und bizarr empfunden worden. Obwohl Olivia Newton-John bereits 1978 in der Schlussszene von *Grease* Leggings trug – ebenso wie zur gleichen Zeit die *Drei Engel für Charlie* – und ihre Verwendung in Fitnessstudios weit verbreitet war, wurden sie erst in den 1990er-Jahren durch Madonna als normales Kleidungsstück akzeptiert. Erst um die Jahrtausendwende wurden Leggings als fester Bestandteil der Streetwear von Prominenten wie Nicole Richie und Paris Hilton sowie von Modedesignern übernommen.

Bike shorts

Bike shorts could be described as a short, high-waisted version of leggings. Following in the latter's wake, bike shorts moved from sportswear to casual wear in the 1990s, driven by the urban cycling craze, but they did not become as much a part of everyday lifestyle as leggings at that time. It took a decade more for them to get full-fledged streetwear status. By the mid-2010s, under the influence of the athleisure trend, they were the perfect companions to sneakers and sleeveless hoodies. In 2021, CNN's fashion expert, Lauren Caruso, called bike shorts "the fashion staple of the summer"[7], thus paying tribute to the numerous influencers who promoted them on social media. As one of them, Stephanie Arant, stated, "they are not only comfortable, but they are also easy to style in various ways."[8]

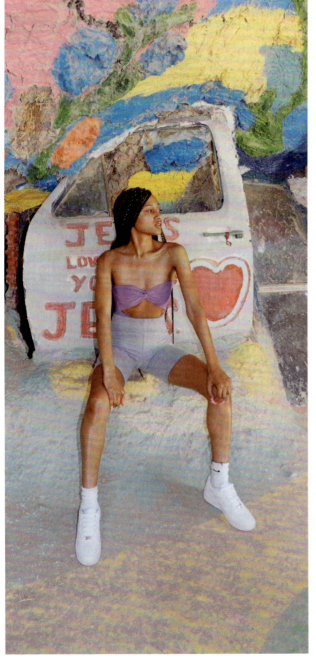

Radlerhosen könnte man als eine kurze, hoch taillierte Version von Leggings bezeichnen. In den 1990er-Jahren wurde die Radlerhose im Zuge der urbanen Radsportbegeisterung von der Sport- zur Freizeitkleidung, aber sie wurde nicht so sehr Teil des täglichen Lebens wie die Leggings. Es dauerte ein weiteres Jahrzehnt, bis sie als vollwertiger *Streetwear Style* wahrgenommen wurde. Mitte der 2010er-Jahre war sie dank des *Athleisure*-Trends der perfekte Begleiter zu Sneakers und ärmellosen Kapuzenpullovern. 2021 bezeichnete die CNN-Modeexpertin Lauren Caruso Radlerhosen als „das modische Must-have des Sommers"[7] und zollte damit den zahlreichen Influencern Tribut, die sie in den sozialen Medien bewarben. Wie eine von ihnen, nämlich Stephanie Arant, feststellte, „sind sie nicht nur bequem, sondern lassen sich auch leicht auf verschiedene Arten stylen"[8].

Radlerhose

Overalls (aka Dungarees)

Clothes change gender more easily than humans. At the beginning of the 20th century, overalls were the uniform of the male worker. Whether you were employed in a factory or on a farm, dungarees were the attire of a working-class man. This all changed with the outbreak of the First World War. Women were encouraged to replace men in factories and workshops, as male workers left for the front. Doing the same job, they naturally took over the same working clothes as the men. They put on overalls (or coveralls) and bravely supported the war effort. Yet the overalls were just a working uniform – no respectable middle-class woman would wear any form of trousers until the mid-1950s, even if the sight of women in pants and overalls was already gaining momentum during the Second World War. Interestingly, overalls for little girls were already relatively common in the 1930s, as many pictures of young Shirley Temple in this outfit can attest. First accepted as work apparel, then as leisurewear in the 1950s – for gardening or boating – overalls quickly broke through the barriers of social convention to impose themselves on the ready-to-wear industry and follow the fashion: the overalls of the 1970s inevitably had bell-bottoms, and in the 1990s the style was to wear them with the straps undone. Overalls are also a must-have for the pregnant woman, and so never completely go out of fashion.

Practical and easy to wear, overalls have made their way into streetwear and beyond

Praktisch und einfach zu tragen – Latzhosen sind wieder Teil der Garderobe

Trousers, shorts, overalls, jumpsuits, and tracksuits / Hosen, Shorts, Latzhosen, Overalls und Trainingsanzüge

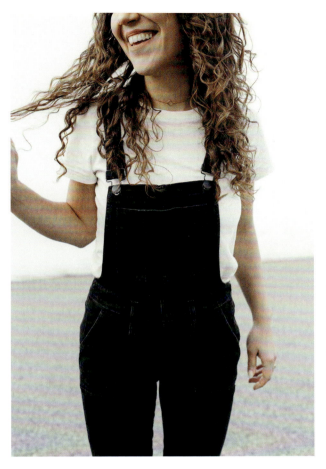
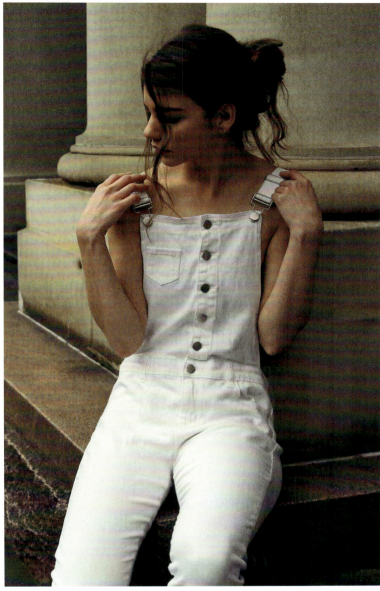

Kleidung wechselt das Geschlecht leichter als Menschen. Zu Beginn des 20. Jahrhunderts war die Latzhose die Uniform des männlichen Arbeiters. Egal, ob man in einer Fabrik oder auf einem Bauernhof arbeitete, Latzhosen waren die Kleidung der Arbeiterklasse. Das änderte sich mit dem Ausbruch des Ersten Weltkriegs. Frauen wurden ermutigt, Männer in Fabriken und Werkstätten zu ersetzen, wenn die männlichen Arbeiter an die Front gingen. Da sie die gleiche Arbeit verrichteten, trugen sie natürlich auch die gleiche Arbeitskleidung wie die Männer. Sie zogen sich Latzhosen an und unterstützten tapfer die Kriegsanstrengungen. Die Latzhose war jedoch nur eine Arbeitsuniform. Bis Mitte der 1950er-Jahre trug keine respektable Frau aus der Mittelschicht irgendeine Art von Hose, auch wenn der Anblick von Frauen in Hosen und Latzhosen schon während des Zweiten Weltkriegs immer üblicher wurde. Interessanterweise waren Latzhosen für kleine Mädchen bereits in den 1930er-Jahren relativ weit verbreitet, wie viele Bilder der jungen Shirley Temple in diesem Outfit bezeugen. Die Latzhose, die zunächst als Arbeitskleidung und dann in den 1950er-Jahren als Freizeitkleidung – für die Gartenarbeit oder das Bootfahren – akzeptiert war, durchbrach schnell die gesellschaftlichen Konventionen, um sich in der Konfektionsindustrie durchzusetzen und der Mode zu folgen: Die Latzhosen der 1970er-Jahre hatten zwangsläufig einen Schlag und in den 1990er-Jahren lag es im Trend, sie mit offenen Trägern zu tragen. Latzhosen sind auch für Schwangere ein Must-have und kommen daher nie ganz aus der Mode.

Latzhose

Jumpsuits

No matter what kind of look or style you fancy, you can be sure there is a jumpsuit that will suit your taste and needs. Whether elegant and sophisticated, business-like, psychedelic, military, sportive, sexy, or simply functional, the answer is: a jumpsuit! It is arguably one of the most versatile outfits ever invented. When wearing one, you can look like a disco star of the late 1970s, re-enact some of ABBA's iconic concerts, play Rosie the riveter or dream that you are walking the red carpet at the Academy Awards. Jumpsuits were created at the end of the First World War for aviators who sometimes had no other way to escape from their burning aircraft than to parachute out, hence the garment's name. It made its way to the women's *haute couture* in the late 1930s thanks to Elsa Schiaparelli, a designer famous for her eccentric, visionary fashions. While becoming a favourite blue-collar garment because of its practicality, the jumpsuit became the "ball gown of the next century"[9], as American designer Geoffrey Beene prophesized in the 1980s, as well as the outfit of the flashiest rock stars and actresses.
The jumpsuit makes regular comebacks in new variations – sleeveless, with an open back, tight or floating, minimalist or jaw-dropping – and in countless textures.

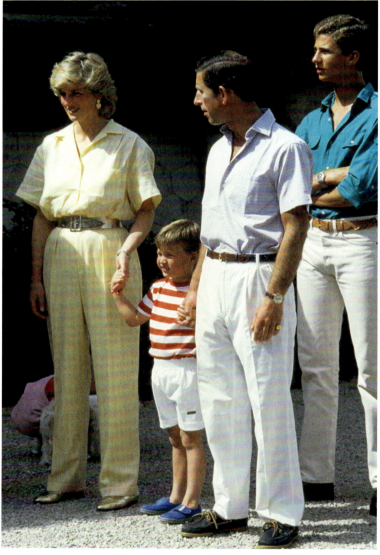

As elegant as a dress, as functional as trousers: the jumpsuit ticks all the boxes

Elegant wie ein Kleid, funktionell wie eine Hose: Der Overall erfüllt alle Anforderungen

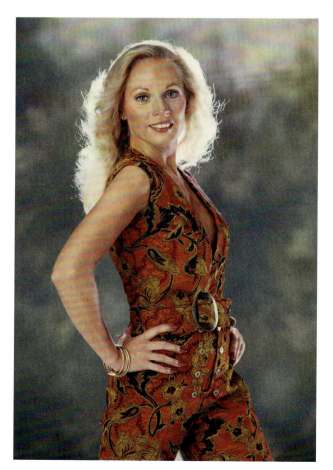

Trousers, shorts, overalls, jumpsuits, and tracksuits / Hosen, Shorts, Latzhosen, Overalls und Trainingsanzüge

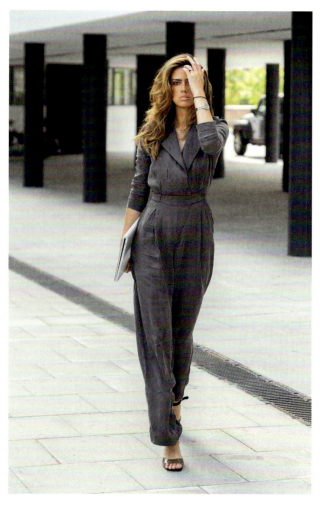

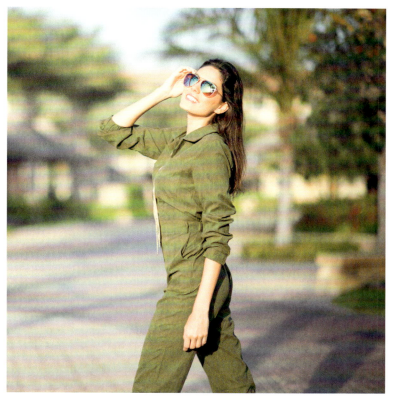

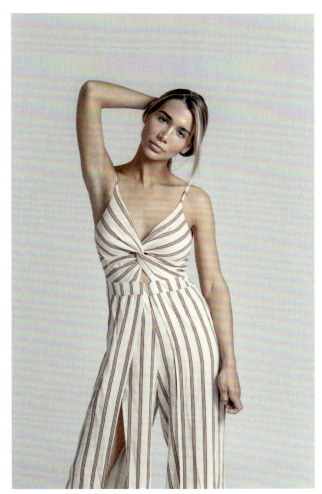

Egal, welche Art von Look oder Stil Sie bevorzugen, Sie können sicher sein, dass es einen Overall gibt, der Ihrem Geschmack und Ihren Bedürfnissen entspricht. Ob elegant und raffiniert, geschäftsmäßig, psychedelisch, militärisch, sportlich, sexy oder einfach nur funktional, es gibt für jeden Stil einen Overall! Er ist wohl eines der vielseitigsten Outfits, die je erfunden wurden. Damit können Sie wie ein Discostar der späten 1970er-Jahre aussehen, einige der legendären ABBA-Konzerte nachspielen oder davon träumen, über den roten Teppich der Oscar-Verleihung zu laufen. Overalls wurden am Ende des Ersten Weltkriegs für Flieger entwickelt, die manchmal keine andere Möglichkeit hatten, sich aus ihrem brennenden Flugzeug zu retten, als mit dem Fallschirm abzuspringen, daher werden sie auch Jumpsuits genannt. In den späten 1930er-Jahren fanden sie ihren Weg in die *Haute Couture* der Damen dank der Designerin Elsa Schiaparelli, die für ihre exzentrische, visionäre Mode bekannt war. Der Overall, der wegen seiner Praktikabilität ein beliebtes Kleidungsstück von Arbeitern war, wurde zum „Ballkleid des nächsten Jahrhunderts"[9], wie der US-amerikanische Designer Geoffrey Beene in den 1980er-Jahren prophezeite, und zum Outfit der schillerndsten Rockstars und Schauspielerinnen. Der Jumpsuit kehrt regelmäßig in neuen Varianten – ärmellos, mit offenem Rücken, eng oder fließend, minimalistisch oder umwerfend – und in unzähligen Strukturen zurück.

Overall (oder Jumpsuit)

Wide legs pants

In the 1920s, orientalism was a big trend in western fashion. The fashion of wearing embroidered kimonos at home spread among women in high society, and with it the habit of putting on silk, pyjama-inspired clothes as loungewear. These wide legged pants echoed Coco Chanel's first beach pyjamas, launched in 1918, which were considered risqué by the social standards of the time. However, the wide legs gave them the appearance of a dress, and it was acceptable for spending time in the garden, sailing, or leisure. The trend went on into the 1930s, before declining rapidly in the post-war period, to rise from oblivion in the 1970s in a new mode, the palazzo pant, looking like a maxi skirt with two legs and whose name originated from the palazzo pyjamas designed in the early 1960s by Georgian Princess Irene Galitzine. The nearly century-old garment managed another comeback at the end of the 2010s, where it was spotted on several catwalks.

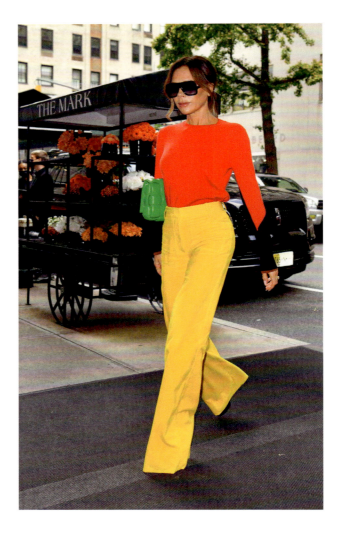

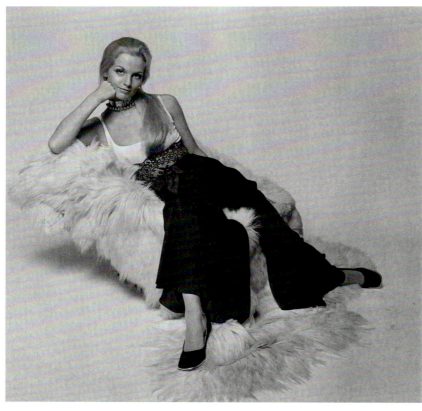

Trousers, shorts, overalls, jumpsuits, and tracksuits / Hosen, Shorts, Latzhosen, Overalls und Trainingsanzüge

In den 1920er-Jahren lag der Orientalismus in der westlichen Mode sehr im Trend. Unter den Frauen der gehobenen Gesellschaft verbreitete sich die Mode, bestickte Kimonos zu Hause zu tragen, und mit ihr die Gewohnheit, seidene Kleidung, die an Pyjamas angelehnt war, als Loungewear anzuziehen. Diese Hose mit weitem Bein erinnert an den ersten Strandpyjama von Coco Chanel, der 1918 auf den Markt kam und nach den damaligen gesellschaftlichen Normen als gewagt galt. Die weiten Beine gaben ihm jedoch das Aussehen eines Kleides und dies war akzeptabel für den Aufenthalt im Garten, beim Segeln oder in der Freizeit. Der Trend setzte sich bis in die 1930er-Jahre fort, bevor er in der Nachkriegszeit rapide zurückging, um in den 1970er-Jahren mit einem neuen Trend der Vergessenheit zu entkommen: der Palazzo-Hose, die wie ein Maxirock mit zwei Beinen aussieht und deren Name von den Palazzo-Pyjamas stammt, die Anfang der 1960er-Jahre von der georgischen Prinzessin Irene Galitzine entworfen wurden. Ende der 2010er-Jahre erlebte das fast hundert Jahre alte Kleidungsstück ein weiteres Comeback und wurde auf mehreren Laufstegen gesichtet.

Hose mit weitem Bein

Low-rise jeans

With low-rise jeans, fashion seems to have fun with defying gravity. One cannot help but imagine that any moment the pants will slide down the body, and yet, nothing of the sort happens. They cling tightly to the hips, or just below them, exposing the navel, the midriff, and sometimes the top of the underwear, or perhaps an intimate tattoo. Beware cold winds! This unisex – yet highly sexualized – fashion trend was born in the 1990s, under the influence of rappers who took up the dress code of American jails where inmates, deprived of belts for security reasons, wear their pants below the waist. The first designer to include low-rise pants in his collections was Alexander McQueen, in 1993, although their popularity owes much to Tom Ford and his maverick sense of aesthetics. When their appeal began to decline in the late 2000s, no one would have bet on their comeback - but here we are, barely twenty years later, revisiting the same old trend!

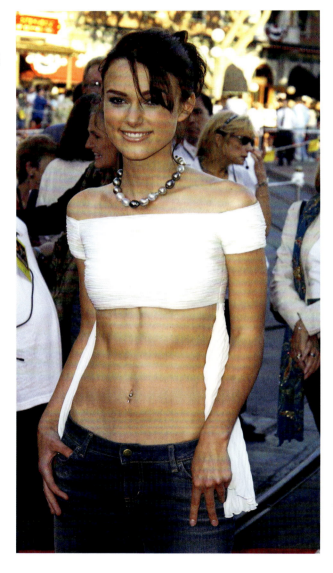

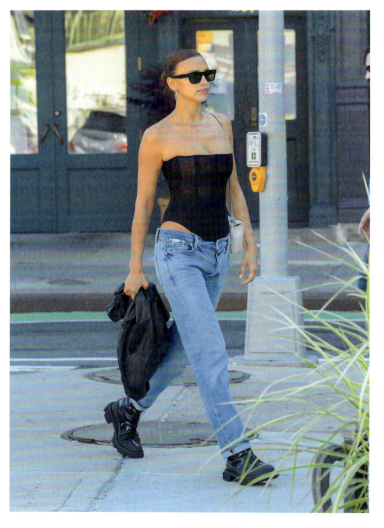

80 **Trousers, shorts, overalls, jumpsuits, and tracksuits / Hosen, Shorts, Latzhosen, Overalls und Trainingsanzüge**

The enfant terrible of 1990s fashion

Das Enfant terrible der 90er-Jahre-Mode

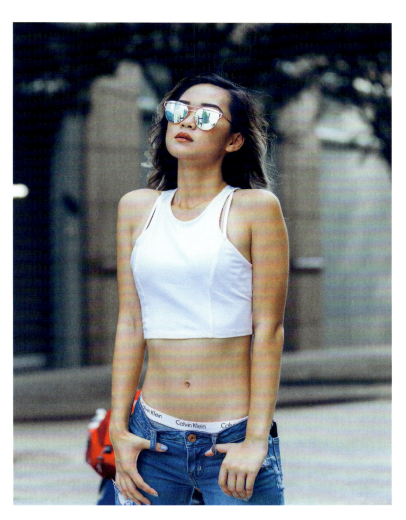

Mit sogenannten *Low Rise Jeans* scheint die Mode, der Schwerkraft trotzen zu wollen. Man kommt nicht umhin, sich vorzustellen, dass die Hose jeden Moment den Körper hinunterrutschen wird, aber nichts dergleichen passiert. Sie liegt eng an den Hüften oder knapp darunter an und enthüllt den Bauchnabel, die Taille und manchmal auch den oberen Teil der Unterwäsche oder eine intime Tätowierung. Hüten Sie sich vor kaltem Wind! Dieser geschlechtsneutrale, aber stark sexualisierte Modetrend entstand in den 1990er-Jahren unter dem Einfluss von Rappern, die die Kleiderordnung US-amerikanischer Gefängnisse aufgriffen, in denen die Insassen, die aus Sicherheitsgründen keine Gürtel tragen dürfen, ihre Hosen unterhalb der Taille tragen. Der erste Designer, der Jeanshosen mit niedrigem Bund in seine Kollektionen aufnahm, war Alexander McQueen 1993. Doch ihre Popularität verdanken sie vor allem Tom Ford und seinem eigenwilligen Sinn für Ästhetik. Als ihre Beliebtheit in den späten 2000er-Jahren abnahm, hätte niemand auf ihr Comeback gewettet – aber kaum zwanzig Jahre später erleben wir denselben Trend noch einmal!

Jeans mit niedrigem Bund

Baggy pants

As a fashion expert once noted, "baggy jeans have always felt intrinsically rebellious, a kind of overtly casual pushback against stuffiness."[10] In the 1990s, these ultra-loose pants were popular with members of the hip hop and skate scenes, two communities where the freedom of movement the pants offered was highly appreciated. No matter how you twist and turn, you will always feel comfortable in them. True, aesthetically baggy pants belong in the "anti-fashion" category, and are often associated with grunge, but sometimes comfort and functionality prevail over elegance. In the 180-degree turn that fashion is known for, baggy pants have resurfaced in 2021 as if to conclusively dismiss the rather uncomfortable skinny jeans, their perfect opposite. Celebrities such as Rihanna, Bella Hadid, Emily Ratajkowski and even Victoria Beckham were spotted in baggy jeans and crop tops, as if they had just escaped from a time capsule.

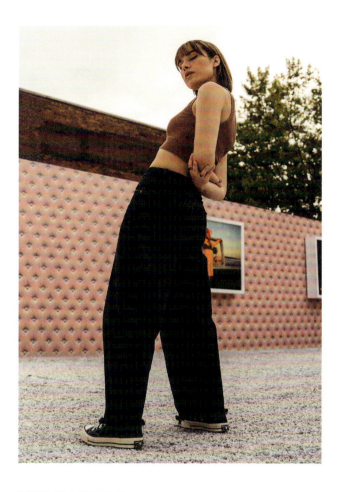

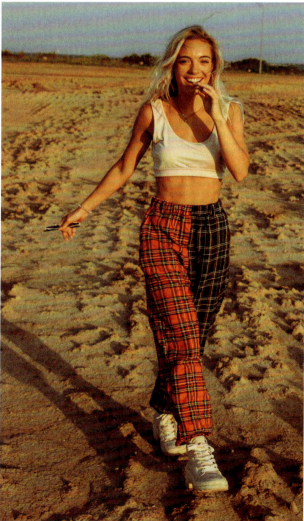

Rebellious trousers that let you move freely

Hosen, die für Rebellion stehen und Beinfreiheit bieten

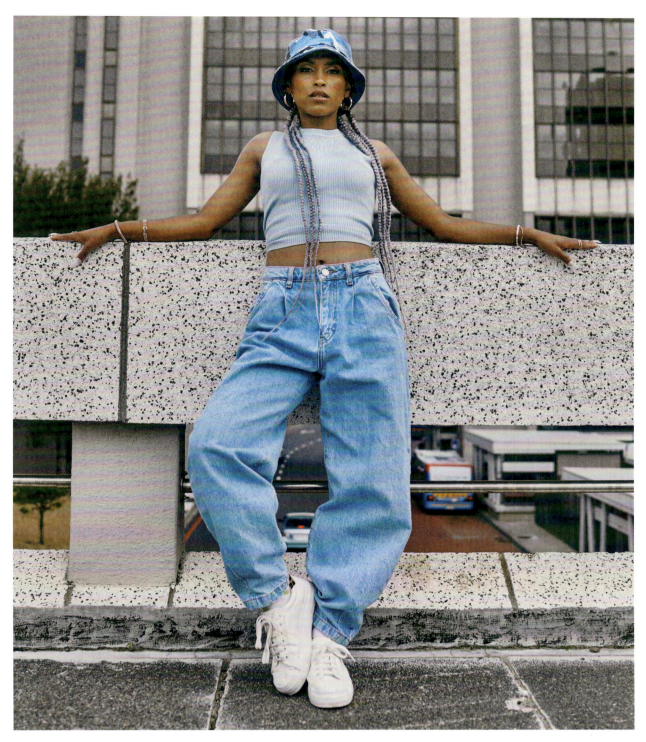

Ein Modeexperte bemerkte einmal: „Baggy-Jeans haben sich schon immer rebellisch angefühlt. Sie sind eine Art offenkundig lässiger Widerstand gegen die Spießigkeit."[10] In den 1990er-Jahren waren diese ultralockeren Hosen bei Mitgliedern der Hip-Hop- und Skate-Szene beliebt – zwei Gemeinschaften, in denen die Bewegungsfreiheit, die die Hosen boten, sehr geschätzt wurde. Egal, wie man sich dreht und wendet, man wird sich in ihnen immer wohl fühlen. Ästhetisch gesehen gehören weite Hosen zwar in die Kategorie „Anti-Mode" und werden oft mit dem *Grunge Style* assoziiert, aber manchmal siegen Komfort und Funktionalität über Eleganz. Die Mode hat wieder einmal eine 180-Grad-Wende vollzogen: Baggy-Hosen sind 2021 wieder aufgetaucht, als wollten sie die unbequemen *Skinny Jeans* – ihr perfektes Gegenstück – endgültig loswerden. Prominente wie Rihanna, Bella Hadid, Emily Ratajkowski und sogar Victoria Beckham wurden in Baggy-Jeans und verkürzten Tops gesichtet, als wären sie gerade aus einer Zeitkapsel gestiegen.

Cargo pants (aka Combat pants)

The current Y2K fashion trend brought back to life one of the most iconic pieces of casual urban wear: cargo pants. While they may arguably not be the most sophisticated and elegant outfit ever – some use the adjective "daggy" to describe them – cargo pants are quite practical thanks to the additional square pockets placed at the side of each leg. This functionality is at the core of their origins, back in 1938, when they were designed as a part of the battle dress uniform for British soldiers. Combat pants were also quickly adopted by the US army. For decades, they were available in beige, camouflage, and khaki at army surplus shops before making it into the fashion stores, in the aftermath of the Cold War, as the unisex attire for young urbans – with cargo shorts offering a great summer variant.

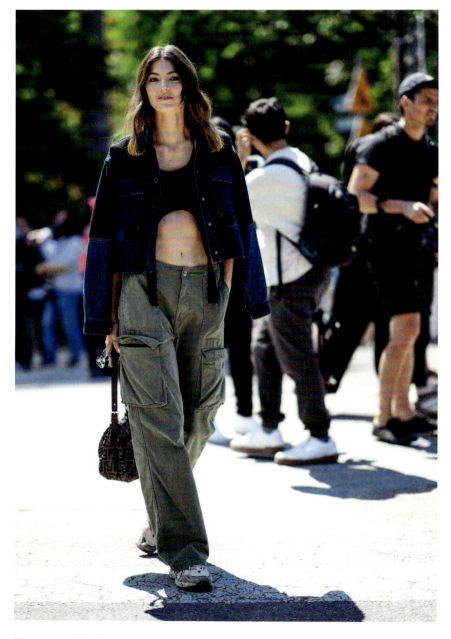

When life looks like a battlefield

Wenn das Leben wie ein Schlachtfeld aussieht

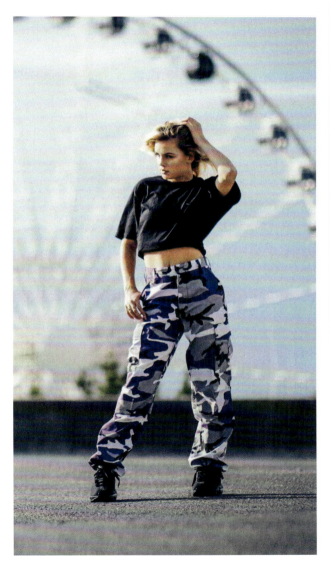

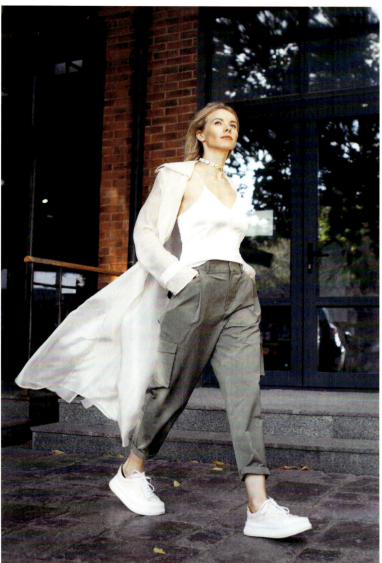

Der aktuelle *Y2K*-Trend, der die Mode der 2000er-Jahre wiederaufgreift, hat eines der kultigsten Kleidungsstücke der urbanen Freizeitkleidung wieder zum Leben erweckt: die Cargohose. Auch wenn sie wohl nicht zu den raffiniertesten und elegantesten Kleidungsstücken überhaupt gehört – manche bezeichnen sie als „schäbig" –, ist diese Hose dank der zusätzlichen quadratischen Taschen an den Seiten der Beine recht praktisch. Diese Funktionalität geht auf ihre Ursprünge zurück, als sie 1938 als Teil der britischen Kampfanzüge entworfen wurde. Cargohosen wurden auch von der US-Armee schnell übernommen. Jahrzehntelang waren sie in Geschäften für Armeerestposten in Beige, Camouflage und Khaki erhältlich, bevor sie nach dem Ende des Kalten Krieges als Unisexkleidung für junge Großstädter in die Kaufhäuser kamen – mit Cargoshorts als tolle Sommervariante.

Velvet tracksuits

If not for September 11 and the subprime mortgage crisis, the world would remember the beginning of the millennium as a new *Belle Époque*, an era of growth, optimism and excess when booming e-commerce and bling-bling were everywhere. And yet, despite the euphoric atmosphere prevalent in Y2K, it took a good dose of audacity for LA-based fashion entrepreneurs, Gela Nash-Taylor and Pamela Skaist-Levy, to launch high-end, colourful velvet tracksuits with the name of their young start-up, *Juicy*, emblazoned on the buttocks of those who wore the track pants. Even those who liked a bit of provocation wondered, quite rightly, if fashion had not gone a bit too far... However, it was to be a resounding, albeit relatively short-lived success: by 2008, the brand was making $605 million in sales, just before the financial crisis, and market saturation dragged the company down. The success story could have ended abruptly, but luckily for all fans of cosy clothing, the velour tracksuit craze is back in the 2020s. Say thank you to teleworking...

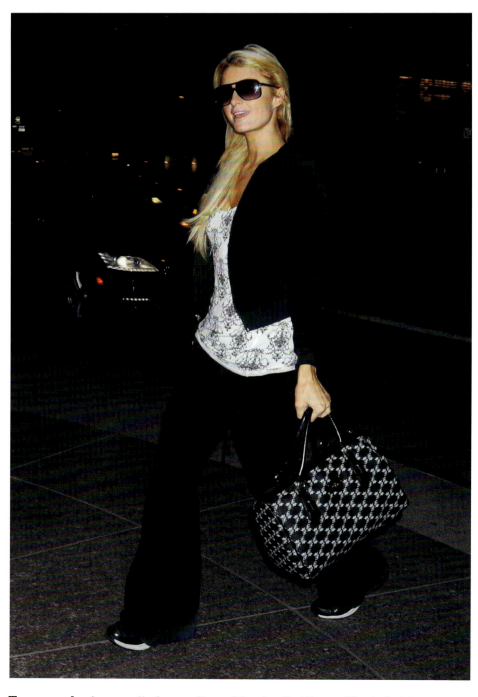

Hyper-comfortable clothing that you never want to take off

Ein superbequemes Kleidungsstück, das man am liebsten nie mehr ausziehen würde

Wären da nicht der 11. September und die Weltfinanzkrise gewesen, würde sich die Welt an den Beginn des Jahrtausends als eine neue *Belle Époque* erinnern – eine Ära des Wachstums, des Optimismus und des Exzesses, als der boomende E-Commerce und der Bling-Bling allgegenwärtig waren. Doch trotz der euphorischen Stimmung, die in den Zweitausendern herrschte, bedurfte es einer gehörigen Portion Kühnheit, damit die in Los Angeles ansässigen Modeunternehmerinnen Gela Nash-Taylor und Pamela Skaist-Levy hochwertige Trainingsanzüge aus farbenfrohem Samt auf den Markt brachten, auf denen der Name ihres jungen Unternehmens – *Juicy* – auf dem Gesäß der Trägerin prangte. Selbst diejenigen, die ein wenig Provokation mochten, fragten sich zu Recht, ob die Mode nicht ein wenig zu weit gegangen war ... Es sollte jedoch ein durchschlagender, wenn auch relativ kurzlebiger Erfolg werden: 2008 machte die Marke einen Umsatz von 605 Millionen US-Dollar kurz vor der Finanzkrise, aber die Marktsättigung zog das Unternehmen nach unten. Die Erfolgsgeschichte hätte abrupt enden können, aber zum Glück für alle Fans von kuscheliger Kleidung ist der Trainingsanzug aus Nicki in den 2020er-Jahren wieder angesagt. Das haben wir wohl der Telearbeit zu verdanken ...

Trainingsanzüge aus Samt

Suits

4

Anzüge und Kostüme

Pantsuit

Women's fashion in the 20th century has constantly expanded its range of possibilities by appropriating clothing once strictly reserved for men, such as trousers, neckties, or elements of the military uniform, such as field jackets, but above all the suit, which was a symbol of male power. In the 1920s, some fearless avant-garde women adopted a masculine style of clothing as a challenge to a society that relegated women to secondary roles. German-born American actress, Marlene Dietrich, personified this trend in a pantsuit designed by Coco Chanel, which she regularly complemented with a tie and a beret. In the film *Morocco* (1930), she was seen wearing a tuxedo and a top hat, which was revolutionary for the time. The idea of creating a ladies' tuxedo was taken up by *enfant terrible* of French *haute couture*, Yves Saint-Laurent, in 1966. One year later, building on that success, the designer launched the first pantsuit truly designed for the female form, just as women's liberation was ushering in a generation of women determined to share power with men. The pantsuit has since then become a staple of executive women in banks, media, industrial groups, and of course politics. Both Hillary Clinton and Angela Merkel have made it the signature garment for the most influential female politicians. Although their era is now over, the baton has been taken up by the Vice President of the United States, Kamala Harris, by Sanna Marin, Finland's young Prime Minister, and by Annalena Baerbock, Germany's Minister of Foreign Affairs.

US Vice President Kamala Harris in a pantsuit, the standard garment for women who mean business

US-Vizepräsidentin Kamala Harris im Hosenanzug, dem Standardkleidungsstück für einflussreiche Frauen

Die Damenmode des 20. Jahrhunderts hat ihre Möglichkeiten ständig erweitert, indem sie sich Kleidungsstücke aneignete, die einst strikt den Männern vorbehalten waren, wie Hosen, Krawatten und Elemente von Militäruniformen wie Feldjacken. Vor allen Dingen wurde aber der Anzug – ein Symbol männlicher Macht – aus der Herrenmode übernommen. In den 1920er-Jahren legten einige unerschrockene Avantgardistinnen einen maskulinen Kleidungsstil an den Tag, um eine Gesellschaft herauszufordern, die Frauen in eine untergeordnete Rolle verwies. Die deutschstämmige US-Schauspielerin Marlene Dietrich verkörperte diesen Trend in einem von Coco Chanel entworfenen Hosenanzug, den sie regelmäßig mit einer Krawatte und einer Baskenmütze abrundete. In dem Film *Marokko* (1930) war sie im Smoking und mit Zylinder zu sehen, was für die damalige Zeit revolutionär war. Die Idee, einen Smoking für Damen zu entwerfen, wurde 1966 von

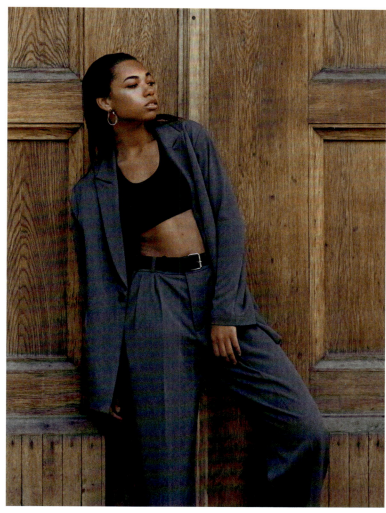

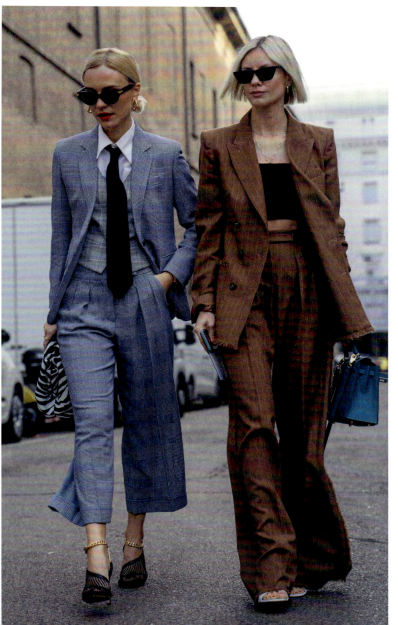

Yves Saint-Laurent, dem *Enfant terrible* der französischen *Haute Couture*, aufgegriffen. Aufbauend auf den Erfolg brachte der Designer ein Jahr später den ersten Hosenanzug auf den Markt, der wirklich auf die weibliche Form zugeschnitten war und zwar genau zu dem Zeitpunkt, als die weibliche Emanzipation eine Generation von Frauen hervorbrachte, die entschlossen war, die Macht mit den Männern zu teilen. Seitdem ist der Hosenanzug zu einem festen Bestandteil der weiblichen Führungskräfte in Banken, Medien, Industriekonzernen und natürlich der Politik geworden. Sowohl Hillary Clinton als auch Angela Merkel haben ihn zum Markenzeichen der einflussreichsten Politikerinnen gemacht. Ihre Ära ist zwar vorbei, aber die US-Vizepräsidentin Kamala Harris, die junge finnische Ministerpräsidentin Sanna Marin und die deutsche Außenministerin Annalena Baerbock haben den Staffelstab übernommen.

Hosenanzug

Tweed suit

In 1954, at the age of seventy-one, Coco Chanel, who had been absent from *Haute Couture* shows for more than fifteen years, returned to the forefront of the fashion world to cross swords with supporters of Christian Dior's *New Look*, and reintroduce a style aimed at liberating the female body. A tweed ensemble consisting of a straight, soft, square jacket and a knee-length pencil skirt was the centrepiece of the new collection. It was both classically elegant and deliberately at odds with the trends of the day. The idea was to create a suit that could be worn throughout the day and evening and for any occasion, thus simplifying the wardrobe of busy women. While the French and European press gave the Chanel suit a lukewarm reception, the American fashion press was immediately enthusiastic ensuring its success on that side of the Atlantic. It was a decade later that it gained similar recognition in France and other Western countries. Its popularity suffered during the anti-conformist atmosphere of the post-1968 years, but it returned to fashion in the 1980s after Karl Lagerfeld took over the artistic direction of Chanel and revisited the suit that had become such a classic. His interpretation of the iconic garment was recently adopted by some of the Gen Z celebrities such as singer Olivia Rodrigo and actress Zoey Deutch.

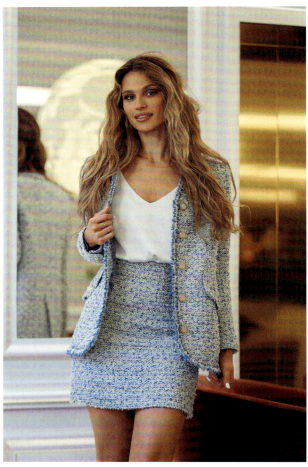

Since the days of Coco Chanel, tweed suits have defined feminine elegance

Coco Chanel hat das Tweed-Kostüm zum Inbegriff weiblicher Eleganz gemacht

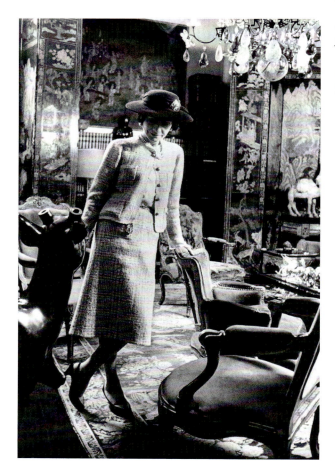

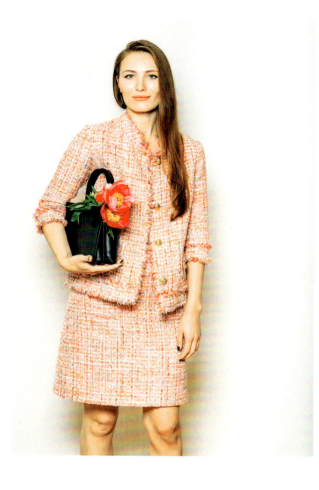

1954 kehrte Coco Chanel nach einer mehr als 15-jährigen Pause von *Haute-Couture*-Schauen im Alter von 71 Jahren an die Spitze der Modewelt zurück, um sich mit den Anhängern des *New Look* von Christian Dior zu messen und einen Stil erneut populär zu machen, der den weiblichen Körper befreit. Ein Tweedensemble aus einer geraden, weichen, quadratischen Jacke und einem knielangen Bleistiftrock war das Herzstück der neuen Kollektion. Es war sowohl klassisch-elegant als auch bewusst gegen den Trend der Zeit gerichtet. Die Idee bestand darin, ein Kostüm zu kreieren, das sowohl tagsüber als auch abends und zu jedem Anlass getragen werden kann und so die Garderobe viel beschäftigter Frauen vereinfacht. Während die französische und europäische Presse das Chanel-Kostüm nur mäßig begeistert aufnahm, waren die US-amerikanischen Modemagazine sofort angetan und sorgten für dessen Erfolg auf der anderen Seite des Atlantiks. Erst ein Jahrzehnt später wurde es auch in Frankreich und anderen westlichen Ländern ähnlich gut aufgenommen. Seine Popularität litt unter der antikonformistischen Atmosphäre der Jahre nach 1968, aber in den 1980er-Jahren kehrte es in die Mode zurück, nachdem Karl Lagerfeld die künstlerische Leitung von Chanel übernommen hatte und das Kostüm, das zu einem Klassiker geworden war, neu interpretierte. Seine Interpretation des kultigen Kleidungsstücks wurde vor Kurzem von einigen Prominenten der Generation Z wie der Sängerin Olivia Rodrigo und der Schauspielerin Zoey Deutch übernommen.

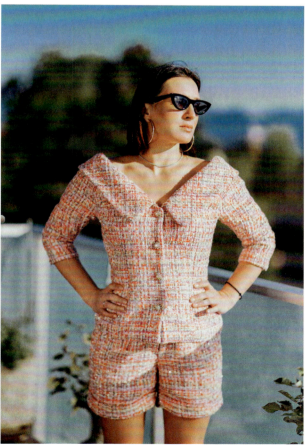

Tweed-Kostüm

Coats and jackets

5

Mäntel und Jacken

Denim jacket

The denim jacket has been so widely worn by all the young urban tribes throughout the second half of the 20th century, that one would have considered it timeless. And yet, it underwent an eclipse of nearly ten years between the late 1990s and the early 2010s when it resurfaced as a versatile, informal garment, delivering a message of coolness rather than making a non-conformist statement, which was the case from the 1950s to the 1970s. Back then, wearing denim was banned from most of the schools, as it was perceived as a sign of rebellion and anarchy. As such, it was endorsed by supporters of the women's liberation movement of the 1960s as a piece of unisex clothing that rejected gender discrimination. Customized with patches, embroidery, pins or badges, the denim jacket was the armour of rebellious teenagers. In contrast, the denim jacket of the 2020s is worn without decoration and with the sleeves slightly rolled up.

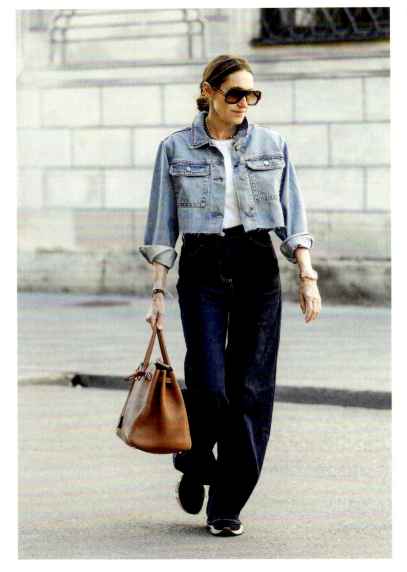

There are a thousand and one ways to style a denim jacket

Es gibt tausendundeine Möglichkeit, eine Jeansjacke zu tragen

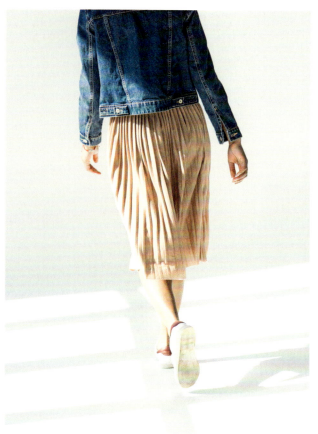
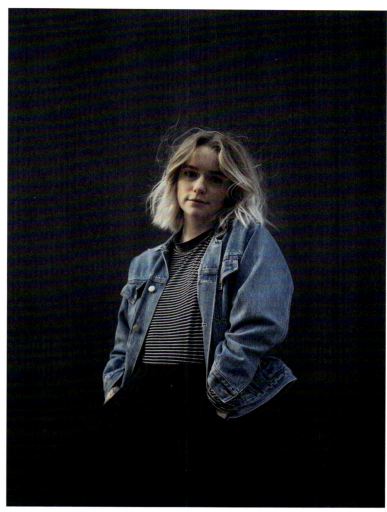
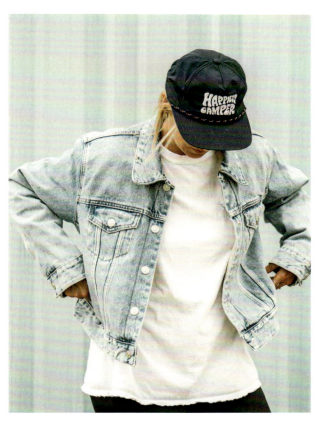

Die Jeansjacke wurde in der zweiten Hälfte des 20. Jahrhunderts von allen jungen Städtern so häufig getragen, dass man sie für zeitlos halten könnte. Doch zwischen den späten 1990er- und den frühen 2010er-Jahren war sie fast verschwunden und tauchte dann als vielseitiges, informelles Kleidungsstück wieder auf, das eher eine Botschaft von Coolness vermittelt als ein nonkonformistisches Statement abzugeben, wie es von den 1950er- bis zu den 1970er-Jahren der Fall war. Damals war das Tragen von Denim in den meisten Schulen verboten, da es als Zeichen von Rebellion und Anarchie angesehen wurde. Als solches wurde die Jeansjacke von Anhängern der Frauenbewegung der 1960er-Jahre als Unisexkleidungsstück befürwortet, das Diskriminierungen aufgrund des Geschlechts entgegenwirkte. Mit Aufnähern, Stickereien, Anstecknadeln und Abzeichen symbolisierte die Jeansjacke den Panzer der rebellischen Teenager. Im Gegensatz dazu wird die Jeansjacke der 2020er-Jahre ohne Verzierung und mit leicht hochgekrempelten Ärmeln getragen.

Jeansjacke

Capes and ponchos

Far from being limited to super-heroes (remember *Wonder Woman*?), femmes fatales, and guests of gala evenings, capes have been finding their way back onto the catwalks since the middle of the 2010s. This frequently underrated, versatile garment offers more freedom of arm movement than a coat, and its amplitude means several layers can be piled on underneath on cold days without feeling overwhelmed. While it was strictly ankle length until the 1920s, today's cape can also be waist length to be styled with pants and short skirts, thanks to avant-garde fashion designers of the 1930s such as Jeanne Lanvin and Elsa Schiaparelli who envisioned the modern-day cape. Similar in shape, but with a less formal and more bohemian look, the poncho, originally from Peru, goes with all styles and body types. Its South American origins seduced young protesters in the United States and Europe in the 1970s, turning it into a symbol of non-conformism and revolutionary dreams.
Its recent comeback is more about comfort, timeless elegance, and the ease of putting it on.

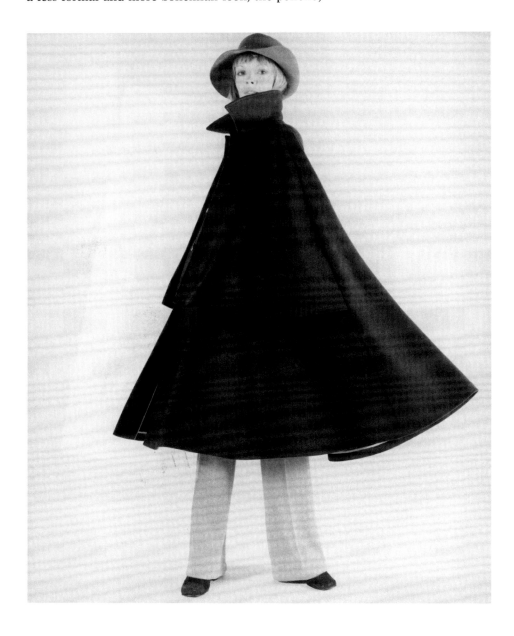

Coats and jackets / Mäntel und Jacken

Umhänge, die nicht nur für Superhelden wie Wonder Woman, Femmes fatales und Gästen von Galaabenden stehen, finden seit Mitte der 2010er-Jahre ihren Weg zurück auf die Laufstege. Dieses häufig unterschätzte, vielseitige Kleidungsstück bietet mehr Bewegungsfreiheit für die Arme als ein Mantel und dank seiner Weite können an kalten Tagen mehrere Schichten darunter getragen werden, ohne dass man sich erdrückt fühlt. Während das Cape bis in die 1920er-Jahre ausschließlich knöchellang war, kann es heute auch hüftlang sein und mit Hosen und kurzen Röcken kombiniert werden. Dies ist den avantgardistischen Modeschöpfern der 1930er-Jahre wie Jeanne Lanvin und Elsa Schiaparelli zu verdanken, die das moderne Cape erfanden.

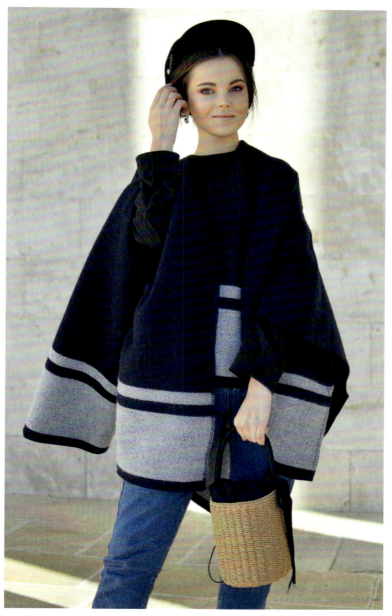

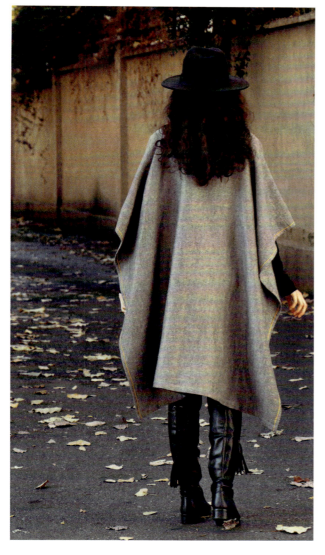

Der ursprünglich aus Peru stammende Poncho hat eine ähnliche Form, ist aber weniger förmlich und sieht mehr nach Boheme aus. Er passt zu allen Stilen und Körpertypen. Seine südamerikanischen Ursprünge verführten in den 1970er-Jahren junge Demonstranten in den USA und Europa und machten ihn zu einem Symbol für Nonkonformismus und revolutionäre Träume. Ihr Comeback in jüngster Zeit ist jedoch eher auf den Komfort, die zeitlose Eleganz und die Leichtigkeit des Anziehens zurückzuführen.

Cape und Poncho

Long coats

The long coats worn by Trinity (Carrie-Anne Moss) and her companions in *The Matrix* (1999) seemed to be a nod to those seen in the spaghetti westerns of the 1970s. However, twenty years later, one wonders if they weren't anticipating the comeback of a fashion classic that had long been deserted in favour of shorter coats or oversized jackets. You only need to watch the fashion competition between Kate Middleton and Meghan Markle, however, to understand that the long coat is back in style. It's the ideal cocoon of style and warmth you need to get through the winter. The long coat of the 2020s embraces the look of those envisioned exactly a century ago by the designers of the 1920s, with simple lines, huge pockets, and large buttons. It is slightly looser than necessary to give an air of fragility to the wearer, and also to support the use of a belt that will enhance the figure.

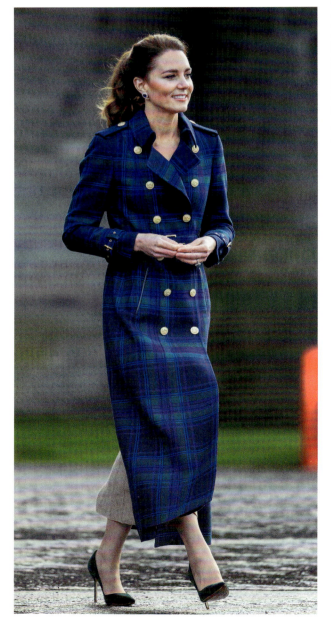

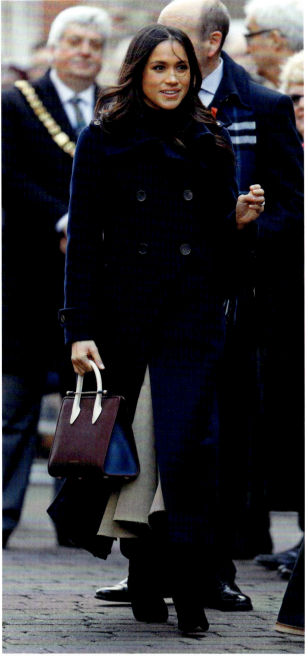

A fashion classic that still makes the headlines

Ein Modeklassiker, der es immer noch in die Schlagzeilen schafft

100 **Coats and jackets / Mäntel und Jacken**

Die langen Mäntel, die Trinity (Carrie-Anne Moss) und ihre Mitstreiter in *The Matrix* (1999) tragen, scheinen eine Anspielung auf die Italowestern der 1970er-Jahre zu sein. Zwanzig Jahre später fragt man sich jedoch, ob sie nicht das Comeback eines Modeklassikers vorweggenommen haben, der lange Zeit zugunsten kürzerer Mäntel und übergroßer Jacken ins Hintertreffen geraten war. Man muss sich nur den Modewettstreit zwischen Kate Middleton und Meghan Markle ansehen, um zu verstehen, dass der lange Mantel wieder im Trend liegt. Er ist die ideale Verbindung zwischen Stil und Wärme, die Sie brauchen, um durch den Winter zu kommen. Der lange Mantel der 2020er-Jahre erinnert an die Modelle, die die Designer der 1920er-Jahre vor genau einem Jahrhundert entworfen haben: einfache Linien, riesige Taschen und große Knöpfe. Er ist etwas lockerer als nötig, um der Trägerin einen Hauch von Zerbrechlichkeit zu verleihen und auch die Verwendung eines Gürtels anzuregen, der die Figur betont.

Langer Mantel

Peacoat

This short double-breasted coat, made of thick wool, has long been a staple for sailors, offering the best defence against cold, wind and wet. For this reason, it is part of the uniform of many national navies, and this military use has contributed to perfecting its functional yet elegant look, with vertical pockets, large buttons that are easy to fasten even when your fingers are freezing, and an oversized collar that protects the neck. Associated originally with a very masculine universe, the peacoat came to women's fashion fairly late, in 1962, thanks to Yves Saint-Laurent who feminized its cut, and lengthened it to mid-thigh. He also equipped the sleeves with buttons to narrow the cuff and prevent the wind from rushing in. In the wake of the *marinière*, the peacoat has made a lasting comeback to the streets in recent years. Whether styled with a dress, a skirt, or pants, it will always give a dynamic look to the silhouette.

Functional elegance is at the core of the peacoat

Funktionelle Eleganz ist der Kern der Cabanjacke

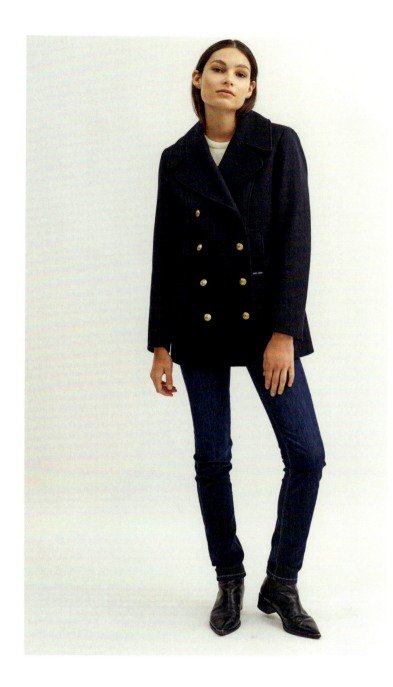

Diese kurze, doppelreihige Jacke aus dicker Wolle ist schon seit langem sehr beliebt bei Seglern und bietet den besten Schutz vor Kälte, Wind und Nässe. Aus diesem Grund gehört sie zur Uniform vieler nationaler Marinen. Ihre Verwendung beim Militär hat dazu beigetragen, den funktionalen und zugleich eleganten Look der Jacke zu perfektionieren: vertikale Taschen, große Knöpfe, die sich auch mit eisigen Fingern leicht schließen lassen, und ein übergroßer Kragen, der den Hals schützt. Ursprünglich wurde die Cabanjacke nur mit maskulinen Aspekten assoziiert und kam erst 1962 bei den Damen in Mode – dank Yves Saint-Laurent, der den Schnitt feminisierte und ihn bis zur Mitte des Oberschenkels verlängerte. Außerdem versah er die Ärmel mit Knöpfen, um sie zu verengen und zu verhindern, dass der Wind hineinbläst. Durch das Aufkommen der *Marinière* hat die Cabanjacke in den letzten Jahren ein nachhaltiges Comeback auf den Straßen erlebt. Egal, ob sie mit einem Kleid, einem Rock oder einer Hose kombiniert wird, diese Jacke verleiht der Silhouette immer einen dynamischen Look.

Cabanjacke

Trench coat

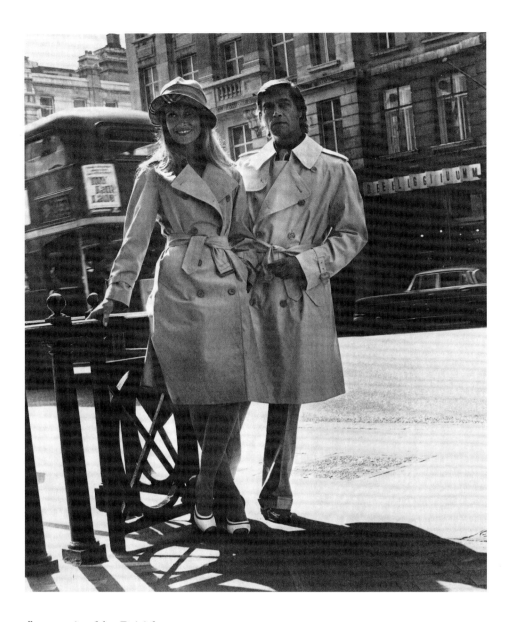

While the term "trench coat" was coined by British journalists in 1916, as the Battle of the Somme was raging, this waterproof coat actually originated in 19th century Scotland. Chemist and inventor, Charles Macintosh, is credited for inventing the first rubberized-cotton fabric, which he used for rainproof coats worn by upper-class hunters. In the late 1870s, a young Basingstoke-based draper, Thomas Burberry, improved the waterproof quality of the fabric and patented his innovation under the name of gabardine. The qualities of the new fabric attracted the attention of the British War Office, and the manufacturer was soon asked to design a lightweight coat for officers, with very precise specifications: the coat had to be double-breasted for more warmth, the belt was to be equipped with D-shaped rings on which to hook accessories, deep pockets were de rigueur, as were epaulettes that indicated the officer's rank.

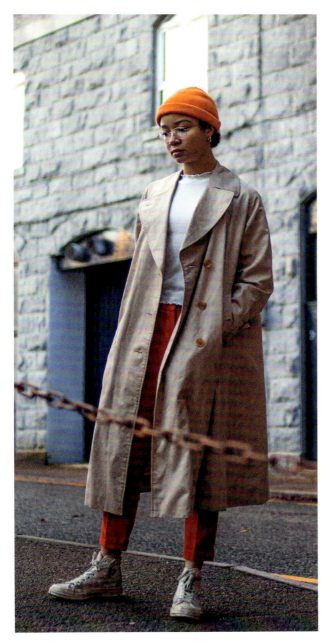

The trench coat is too classy to wear only on rainy days

Der Trenchcoat ist zu edel, um ihn nur an Regentagen zu tragen

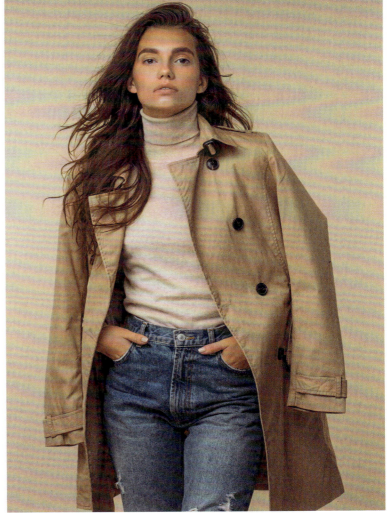

The trench coat soon became a symbol of courage, bravery, and resilience. In the aftermath of the war, veterans-turned-civilians continued to wear it, as the coat had proved quite practical and elegant. While everyone remembers Humphrey Bogart's trench coat in *Casablanca* (1942), few people are aware that Marlene Dietrich was the first woman to wear one on screen in *A Foreign Affair* (1948), followed by Audrey Hepburn in *Breakfast at Tiffany's* (1961). The beige trench coat has, since then, become a woman's wardrobe staple, but is regularly adapted to follow the trends. However, the design is so timeless that you can wear yours for decades and never look out of fashion.

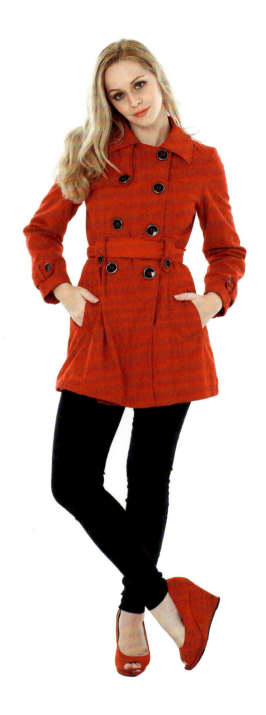

Der Begriff „Trenchcoat" wurde zwar 1916 von britischen Journalisten geprägt, als die Schlacht an der Somme tobte, aber eigentlich stammt dieser wasserdichte Mantel aus dem Schottland des 19. Jahrhunderts. Dem Chemiker und Erfinder Charles Macintosh wird die Erfindung des ersten gummierten Baumwollstoffs zugeschrieben, den er für regenfeste Mäntel der gehobenen Jägerschaft verwendete. In den späten 1870er-Jahren verbesserte der junge Tuchhändler Thomas Burberry aus Basingstoke die Wasserdichtigkeit des Stoffes und ließ seine Innovation unter dem Namen Gabardine patentieren. Die Qualitäten des neuen Stoffes erregten die Aufmerksamkeit des britischen Kriegsministeriums und der Hersteller wurde bald gebeten, einen leichten Mantel für Offiziere mit sehr präzisen Spezifikationen zu entwerfen: Der Mantel musste zweireihig sein, um wärmer zu sein, der Gürtel sollte mit D-förmigen Ringen ausgestattet sein, an denen Ausrüstungsteile eingehängt werden konnten, tiefe Taschen waren *de rigueur*, ebenso wie Epauletten, die den Rang des Offiziers anzeigten. Der Trenchcoat wurde bald zu einem Symbol für Mut, Tapferkeit und Durchhaltevermögen. Veteranen trugen den Mantel auch nach dem Krieg, da er sich als praktisch und elegant erwiesen hatte. Jeder erinnert sich an Humphrey Bogarts Trenchcoat in *Casablanca* (1942), aber nur wenige wissen, dass Marlene Dietrich in *Eine auswärtige Affäre* (1948) die erste Frau war, die einen solchen Mantel auf der Leinwand trug, gefolgt von Audrey Hepburn in *Frühstück bei Tiffany* (1961). Der beigefarbene Trenchcoat hat sich seitdem zu einem festen Bestandteil der Damenmode entwickelt, wird aber regelmäßig an die aktuellen Trends angepasst. Das Design ist jedoch so zeitlos, dass man es jahrzehntelang tragen kann und damit nie unmodisch aussieht.

Trenchcoat

Shoulder pads

The 1980s were a decade of extravagance and exuberance in fashion: big shoulders and baroque hairdos were typical of the time, both signalling power and self-confidence. Women, be they in real life – Nancy Reagan, Margaret Thatcher, Lady Diana or in TV series such as *Dynasty's* Krystle Carrington (Linda Evans) and Alexis Carrington (Joan Collins) – wore clothes enhanced by shoulder pads, which also had the advantage of making the waist look smaller. This accessory, often associated with American football players, was initially used in men's clothing, but gradually became a symbol of gender equality and female power. From this point of view, their return to the catwalk (Balenciaga, Burberry, Givenchy, Gucci) and to the clothing of celebrities (Hailey Bieber, Megan Fox) in the early 2020s is an interesting sociological phenomenon. Even Melania Trump occasionally tries to display broader shoulders than her burly husband!

Die 1980er-Jahre waren ein Jahrzehnt der Extravaganz und Überschwänglichkeit in der Mode: Breite Schultern und barocke Frisuren waren typisch für diese Zeit und signalisierten Macht und Selbstbewusstsein. Ob Nancy Reagan, Margaret Thatcher und Lady Diana im wirklichen Leben oder Krystle Carrington (Linda Evans) und Alexis Carrington (Joan Collins) in der Serie *Der Denver-Clan*, Frauen trugen Kleider mit Schulterpolstern, die auch den Vorteil hatten, die Taille schmaler erscheinen zu lassen. Dieses Accessoire, das oft mit American-Football-Spielern in Verbindung gebracht wird, wurde zunächst für Männerkleidung verwendet, entwickelte sich aber allmählich zu einem Symbol für die Gleichstellung der Geschlechter und die Macht der Frau. Unter diesem Gesichtspunkt ist ihre Rückkehr auf die Laufstege (Balenciaga, Burberry, Givenchy, Gucci) und in die Bekleidung von Prominenten (Hailey Bieber, Megan Fox) in den frühen 2020er-Jahren ein interessantes soziologisches Phänomen. Sogar Melania Trump versucht gelegentlich, breitere Schultern zu zeigen als ihr stämmiger Mann!

Schulterpolster

Leather jacket

The leather jacket is to contemporary fashion what the Rolling Stones are to rock music: a miracle of longevity. Like the legendary British band, it has gone from a provocative and scandalous image to public recognition. While the first fashionable leather jacket, called the *Perfecto motorcycle* jacket was designed by Irvin Schott in 1928, and launched the same year, its appeal was initially limited to Harley-Davidson fans. As often in fashion, it was the cult film *The Wild One* (1953) that popularized the Perfecto and propelled Marlon Brando into a symbol of rebellious youth. A year later in 1954, the *Ladies Companion jacket*, the first one envisioned for women, was marketed. But for a young woman, wearing a black leather jacket meant being ostracized from polite society: only "bad girls", by the standard of the time, would dare to show up in such outerwear. The protest spirit of the 1960s, the rock craze, the emergence of subcultures such as the greasers and the punks, as well as the influence of cinema would, together, overcome the prejudice. By the end of the 1970s, the leather jacket had become a stylish outfit associated with urban youth, and fashion quickly offered alternatives to the two colours that had dominated until then, black, and brown. The current craze for cycling, skateboarding, and scootering makes it a practical, protective, and stylish garment.

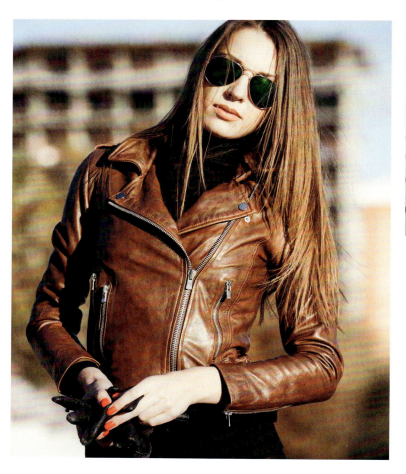

108 Coats and jackets / Mäntel und Jacken

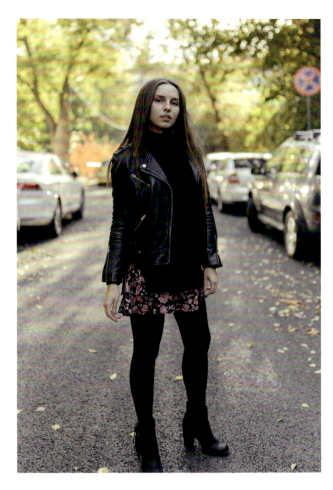

Die Lederjacke ist für die zeitgenössische Mode das, was die Rolling Stones für die Rockmusik sind: ein Wunder der Beständigkeit. Wie das der legendären britischen Band hat sich ihr provokantes und skandalöses Image zu öffentlicher Anerkennung gewandelt. Die erste modische Lederjacke – die Motorradjacke *Perfecto* – wurde 1928 von Irvin Schott entworfen und noch im selben Jahr auf den Markt gebracht, war aber zunächst nur für Harley-Davidson-Fans interessant. Wie so oft in der Mode war es der Kultfilm *Der Wilde* (1953), der die *Perfecto* populär machte und Marlon Brando zu einem Symbol der rebellischen Jugend werden ließ. Ein Jahr später – 1954 – kam die Jacke *Ladies Companion* auf den Markt. Sie war die erste Lederjacke, die für Frauen gedacht war. Doch für eine junge Frau bedeutete das Tragen einer schwarzen Lederjacke die Ächtung durch die anständige Gesellschaft: Nur „schlechte Mädchen" würden es nach den damaligen Maßstäben wagen, sich in solcher Oberbekleidung zu zeigen. Der Protestgeist der 1960er-Jahre, die Begeisterung für Rockmusik, das Aufkommen von Subkulturen wie den Punks sowie der Einfluss des Kinos haben allesamt zur Überwindung dieser Vorurteile beigetragen. Ende der 1970er-Jahre war die Lederjacke zu einem trendigen Outfit der urbanen Jugend geworden und die Mode bot schnell Alternativen zu den beiden bis dahin dominierenden Farben Schwarz und Braun. Der aktuelle Trend zum Fahrradfahren, Skateboarden und Rollerfahren macht sie zu einem praktischen, schützenden und modischen Kleidungsstück.

Lederjacke

Military jacket

Many clothes and accessories of everyday life are taken from the military uniform and – while retaining the functionality that characterizes them – are reshaped for civilian life by fashion designers. Some, on the other hand, keep their original appearance – including the camouflage hues - and are worn for the military look they offer, including its eye-catching effect: the *army style* is deemed attractive by both sexes (yes, the charm of the uniform works both ways). Military jackets first became a trend in the 1960s-70s, at a time of protest when civilians appropriated military clothing to subvert it and to use it as a symbol of rebellion against society. Its adoption by women signalled their stand for equal rights and for their emancipation. The return of the military jacket to the forefront in the late 2010s has nothing to do with the anarchistic spirit of the previous era: as a unisex and utilitarian garment, it is now valued for its practicality and the dynamic, assertive look it conveys.

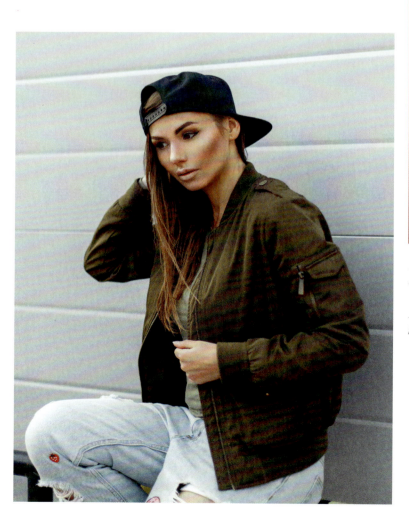

Lightweight and robust, a military jacket can be paired with almost anything

Die leichte und robuste Militärjacke lässt sich mit fast allem kombinieren

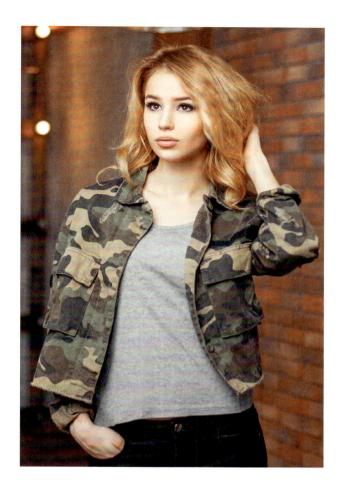

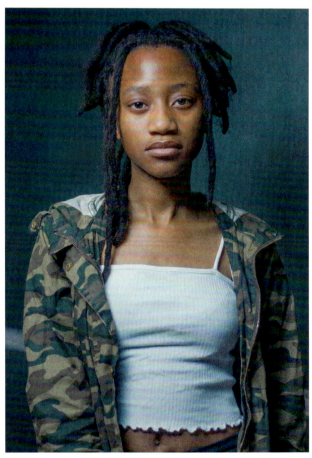

Viele Kleidungsstücke und Accessoires des täglichen Lebens haben ihren Ursprung in Militäruniformen und wurden von Modedesignern – unter Beibehaltung der für sie charakteristischen Funktionalität – für das zivile Leben umgestaltet. Andere wiederum behalten ihr ursprüngliches Aussehen, einschließlich der Tarnfarben, bei und werden wegen ihres militärischen Aussehens getragen, das auch ein Blickfang ist: Der *Military Style* wird von beiden Geschlechtern als attraktiv empfunden (ja, der Charme einer Uniform wirkt in beide Richtungen). Militärjacken kamen erstmals in den 1960er- und 1970er-Jahren in Mode, als sich Zivilisten militärische Kleidung aneigneten, um ihren eigentlichen Zweck zu unterwandern und als Symbol der Rebellion gegen die Gesellschaft zu verwenden.
Mit der Übernahme dieses Kleidungsstücks setzten Frauen ein Zeichen für ihre Gleichberechtigung und Emanzipation. Die Rückkehr der Militärjacke in den späten 2010er-Jahren hat nichts mit dem anarchistischen Geist der vorherigen Ära zu tun: Als Unisexgebrauchskleidung wird sie heute wegen ihrer Zweckmäßigkeit und ihres dynamischen, selbstbewussten Looks geschätzt.

Militärjacke

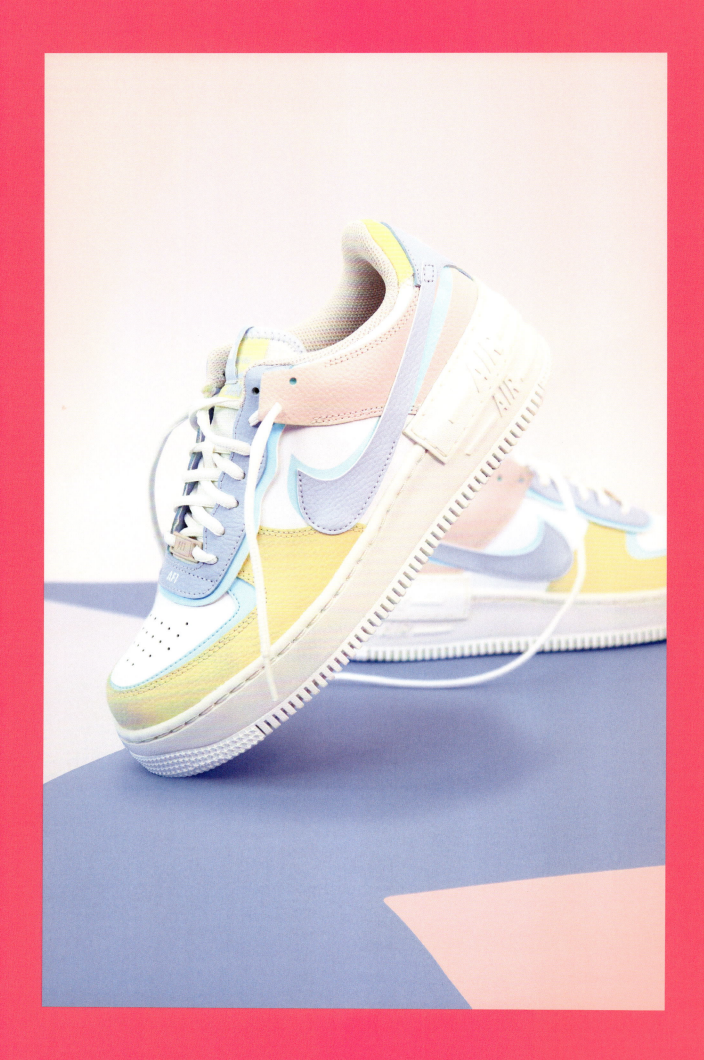

Shoes and boots

6

Schuhe und Stiefel

Ankle boots

Even at the venerable age of 220 years, the ankle boot remains as fashionable as it was when it was first introduced in 1804. The ankle-high boot combines the comfort of a shoe with the practicality of a boot, especially in rainy weather, while adding touches of feminine grace to the silhouette thanks to a raised heel or a more pointed toe. It enjoyed lasting success from its beginning to the 1870s, gradually fell out of fashion after the 1880s and resurfaced in the 1960s as a companion to the mini-dress and mini-skirt, then in the 1990s a grunge version offered a stylish alternative to heavy-looking platform shoes. Ankle boots have been on the radar since the early 2010s, with luxury variants by Christian Louboutin, Gucci, and Valentino Garavani to name but a few. In recent seasons, black ankle boots are a must-have.

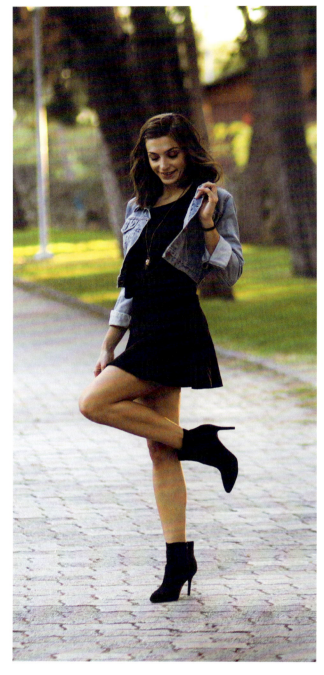

Blending the comfort of shoes with the elegance of boots

Der Komfort von Schuhen und die Eleganz von Stiefeln in einem

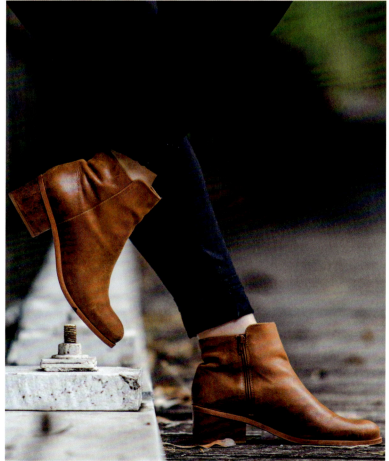

114 **Shoes and boots / Schuhe und Stiefel**

Auch im ehrwürdigen Alter von 220 Jahren ist die Stiefelette noch so modern wie bei ihrer Einführung im Jahr 1804. Die knöchelhohe Stiefelette verbindet den Komfort eines Schuhs mit der Zweckmäßigkeit eines Stiefels, vor allem bei Regenwetter, und verleiht der Silhouette dank des erhöhten Absatzes oder der spitzen Zehenpartie einen Hauch von femininer Anmut. Sie war von ihren Anfängen bis in die 1870er-Jahre hinein beliebt, kam nach den 1880er-Jahren allmählich aus der Mode und tauchte in den 1960er-Jahren in Kombination mit Minikleidern und Miniröcken wieder auf, um dann in den 1990er-Jahren in einer Grunge-Version eine modische Alternative zu den schwer wirkenden Plateauschuhen zu bieten. Stiefeletten sind seit den frühen 2010er-Jahren populär und auch als Luxusvarianten von Christian Louboutin, Gucci, Valentino Garavani und vielen anderen erhältlich. In den letzten Saisons waren schwarze Stiefeletten ein Must-have.

Stiefelette

Ballet flats

"Flat is beautiful" could be a catchphrase for these simple, but chic, lightweight, and comfortable shoes. They give the wearer the sensation of dancing, not walking. The city version of these shoes designed for ballet dancers owes its existence to an Australian shoemaker of Lithuanian origin, Jacob Bloch, who improved the comfort and quality of ballet shoes in the 1930s, and to his Italian American colleague Salvatore Capezio, whose New York boutique was popular with dancers from the Metropolitan Opera and performers in Broadway musicals. Capezio's designs caught the attention of fashion designer Claire McCardell, the creator of the American sportswear style, who decided, in the late 1930s, to commission the shoemaker to produce a new model of these shoes with a rubber sole. The success of ballet flats in North America spread to Europe in the late 1940s, thanks to Rose Repetto, the founder of the famous dance accessory brand, and to René Caty, a renowned French shoe manufacturer who launched a mass-market model in 1950. Six years later, the ballet flat had a starring role in Roger Vadim's film *And God Created Woman*. Brigitte Bardot, the lead actress, wore bright red ballerinas created especially for her by Rose Repetto. As befitted a star, Bardot insisted that the beginning of her toes be shown because she felt this detail to be very sensual. On the other side of the Atlantic, Audrey Hepburn opted for iconic black ballet flats by Salvatore Ferragamo. While their popularity had somewhat faded by the end of the 20th century, Parisian fashion queen Inès de la Fressange brought back the trend at the beginning of the new millennium. The style has regained its status as an easy-going, elegant shoe that can be worn comfortably from morning to night.

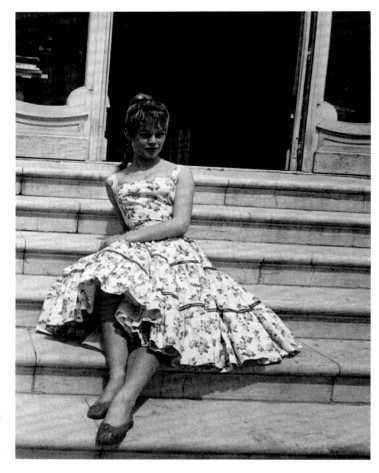

Brigitte Bardot in her legendary ballet flats

Brigitte Bardot in ihren legendären Ballerinas

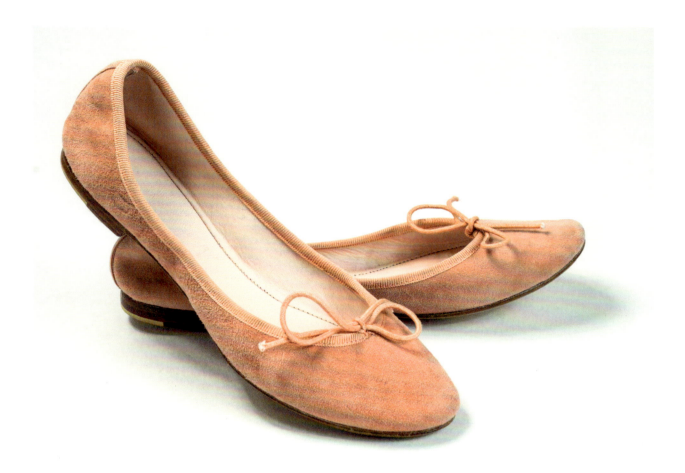

„Flat is beautiful" könnte ein Slogan für diese einfachen, aber schicken, leichten und bequemen Schuhe sein. Sie geben der Trägerin das Gefühl zu tanzen und nicht bloß zu gehen. Die Stadtversion dieser Schuhe für Balletttänzer verdankt ihre Existenz einem australischen Schuhmacher litauischer Herkunft namens Jacob Bloch, der in den 1930er-Jahren den Komfort und die Qualität von Ballettschuhen verbesserte, und seinem italienisch-amerikanischen Kollegen Salvatore Capezio, dessen New Yorker Boutique bei Tänzern der Metropolitan Opera und Musicaldarstellern des Broadways beliebt war. Die Entwürfe von Capezio erregten die Aufmerksamkeit der Modedesignerin Claire McCardell, der Erfinderin des US-amerikanischen *Sportswear Style*, die Ende der 1930er-Jahre beschloss, den Schuhmacher mit der Herstellung eines neuen Modells dieser Schuhe mit Gummisohle zu beauftragen. Der Erfolg der Ballerinas in Nordamerika schwappte in den späten 1940er-Jahren nach Europa – zum einen wegen Rose Repetto, der Gründerin der berühmten Marke für Tanzzubehör, und zum anderen wegen René Caty, einem renommierten französischen Schuhhersteller, der 1950 ein Massenmodell auf den Markt brachte. Sechs Jahre später hatte ein Paar Ballerinas eine Hauptrolle in Roger Vadims Film *Und immer lockt das Weib*. Brigitte Bardot, die Hauptdarstellerin, trug leuchtend rote Ballerinas, die Rose Repetto speziell für sie entworfen hatte. Wie es sich für einen Star gehört, bestand Bardot darauf, dass der Anfang ihrer Zehen gezeigt wird, da sie dies als sehr sinnlich empfand. Auf der anderen Seite des Atlantiks entschied sich Audrey Hepburn für die ikonischen schwarzen Ballerinas von Salvatore Ferragamo. Obwohl ihre Popularität Ende des 20. Jahrhunderts etwas nachgelassen hatte, brachte die Pariser Modekönigin Inès de la Fressange den Trend zu Beginn des neuen Jahrtausends zurück. Das Modell hat seinen Status als lässiger und doch eleganter Schuh zurückgewonnen, der von morgens bis abends bequem getragen werden kann.

Ballerinas

Brogues

Before becoming elegant and popular city shoes, brogues served as utilitarian footwear for Scottish and Irish farmers throughout the 19th century: the perforations decorating the leather allowed any water that seeped inside from walks through swamps or muddy fields to drain out. The addition of a higher heel to ladies' brogues in the early 20th century changed the shoe's fortunes: the sound the heel produced syncopated well with Gaelic music, and the brogue became the favourite shoe of Irish and Scottish dancing enthusiasts. Thanks to the large Irish diaspora in the United States, brogues were quickly adopted in North America. In the 1930s, they became the fashionable shoe worn around the globe by jazz musicians, bankers, and gangsters. Even the Prince of Wales wore a pair for playing golf. The first women who took up the androgynous look inspired by men's fashion promptly adopted the stylishly ornamented shoes. Brogues enjoyed renewed popularity in women's fashion around the 1960s and 1970s when stars of the day such as the actress Katharine Hepburn, model Twiggy and singer Patti Smith made them one of their signature styles. After a hiatus in the 1990s when brogues were considered old-fashioned, interest in shoes that combined comfort and chic returned in the 2010s, where brogues took on a preppy, *gamine* look.

Bevor die Brogues zu eleganten und beliebten Stadtschuhen wurden, dienten sie den schottischen und irischen Landwirten im 19. Jahrhundert als Gebrauchsschuhe: Durch die Perforationen im Leder konnte das Wasser, das bei Spaziergängen durch Sümpfe oder schlammige Felder ins Innere drang, abfließen. Mit der Einführung eines höheren Absatzes bei den Brogues für Damen zu Beginn des 20. Jahrhunderts änderte sich das Schicksal des Schuhs: Der Klang, den der Absatz erzeugte, passte gut zur gälischen Musik und der Brogue wurde zum Lieblingsschuh der Tanzbegeisterten Irlands und Schottlands. Dank der großen irischen Diaspora in den USA wurden die Brogues schnell in Nordamerika übernommen. In den 1930er-Jahren wurden sie zum modischen Schuh, der von Jazzmusikern, Bankern und Gangstern rund um den Globus getragen wurde. Selbst der Prinz von Wales trug ein Paar zum Golfspielen. Die ersten Frauen, die den von der Herrenmode inspirierten androgynen Look aufgriffen, übernahmen prompt die stilvoll verzierten Schuhe. In den 1960er- und 1970er-Jahren erfreuten sich Brogues bei den Damen erneut großer Beliebtheit, als Stars wie die Schauspielerin Katharine Hepburn, das Model Twiggy und die Sängerin Patti Smith sie zu einem ihrer Markenzeichen machten. Nach einer Phase in den 1990er-Jahren, als Brogues als altmodisch galten, kehrte das Interesse an Schuhen, die Komfort und Chic verbinden, in den 2010er-Jahren zurück. Brogues nahmen zu dieser Zeit einen adretten, verspielten Look an.

Cowboy boots (aka Texas boots)

Cowboy boots are much more than just ordinary leather footwear: they carry with them nostalgia for the lifestyle of the American plains, of adventure, of the Wild West and iconic Westerns. In fact, it was Hollywood and then the country music craze that gave this footwear its credentials. Its main features are higher heels known as Cuban heels for the stirrups, a height that covers the calves without hindering knee movement, hard leather to protect against snake bites and beautifully engraved ornamental patterns on the surface. Cowboy boots can have a bit of a sexy pin-up vibe, a style embodied at various times by Marilyn Monroe, Nancy Sinatra, Catherine Bach, Raquel Welch, Pamela Anderson, and Beyoncé, among others. The boots work equally well with a pair of jeans, shorts, or a sundress. And, good news, as a piece of maximalist aesthetic, they are very much in style these days.

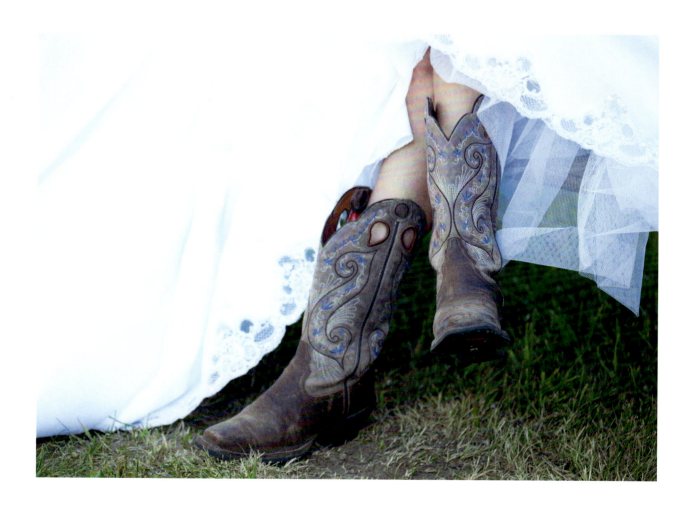

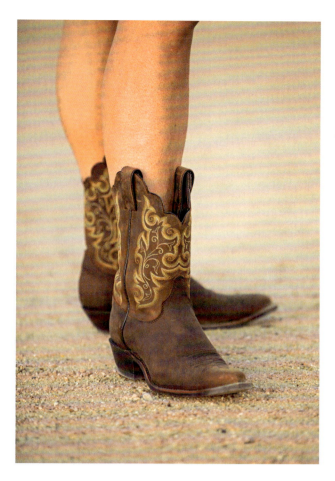

The boots for contemporary adventurers

Die Stiefel für moderne Abenteurerinnen

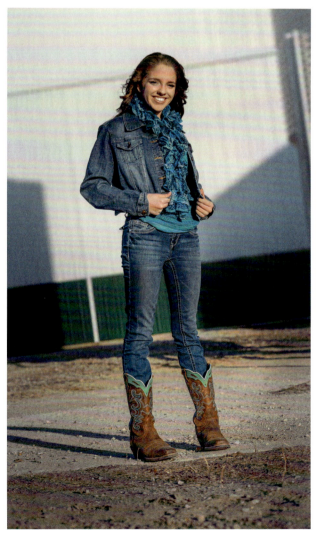

Cowboystiefel sind viel mehr als nur gewöhnliche Lederschuhe: Sie wecken die Sehnsucht nach einem Leben in der amerikanischen Prärie, nach Abenteuer, nach dem Wilden Westen und den legendären Western. In der Tat war es Hollywood und dann der Hype um Countrymusik, der diesen Schuh erfolgreich machte. Seine Hauptmerkmale sind die sogenannten kubanischen Absätze für die Steigbügel, die Länge bis zu den Waden, die Kniebewegungen nicht einschränkt, das harte Leder zum Schutz vor Schlangenbissen und wunderschön geprägte Ziermuster auf der Oberfläche. Cowboystiefel zeichnen sich durch einen leicht sexy Pin-up-Touch aus – ein Stil, der unter anderem von Marilyn Monroe, Nancy Sinatra, Catherine Bach, Raquel Welch, Pamela Anderson und Beyoncé verkörpert wurde bzw. wird. Die Stiefel passen gut zu Jeans, Shorts oder Sommerkleidern. Und die gute Nachricht ist, dass sie im Zuge des *Maxi-Style*-Trends heutzutage sehr angesagt sind.

Cowboystiefel

Flip-flops

Basically, flip-flops are sandals without a heel strap. However, unlike sandals, which can be made of various materials, real flip-flops are always produced from rubber. While their shape was known to ancient Egyptians about 4,000 years ago, the modern-day flip-flop originates from the traditional Japanese *zori*, a thong sandal, manufactured in Japan during WWII using rubber sourced in occupied South-East Asia. Although Japan lost its direct access to rubber plantations at the end of the war, production resumed in the late 1940s, and American soldiers stationed in the archipelago adopted the traditional zori or its rubber variant as their casual footwear, especially as they were easy to slip on or off. In the 1950s, veteran GIs brought the rubber sandal back to the United States where it became known as the "flip-flop" in the 1960s, the time when it established itself as the standard unisex summer shoe on Californian beaches. A low-priced shoe, it also enjoyed enormous success among the middle class in Brazil, where the Alpargatas brand introduced a version called *Havaianas* (Hawaiian) in 1962. The Brazilian flip-flops became cult items in 1998 when the brand reissued them in the colour of the Brazilian flag to support the football team that had made it to the World Cup final against France. Brazil may have lost the game, but the Brazilian flip-flop has conquered the world ever since.

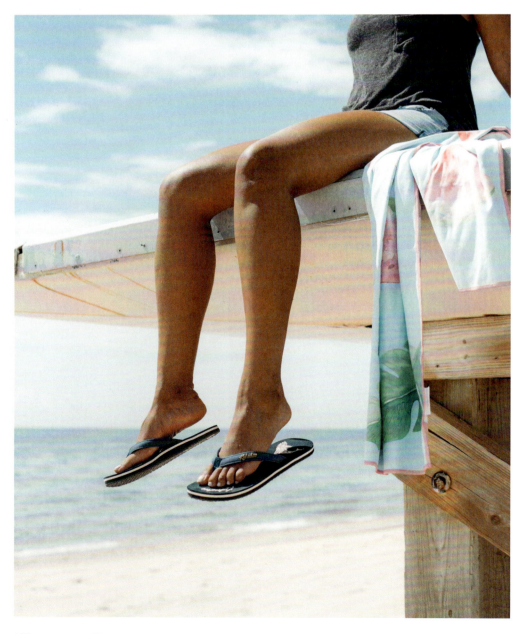

The symbol of carefree summers

Das Symbol des unbeschwerten Sommers

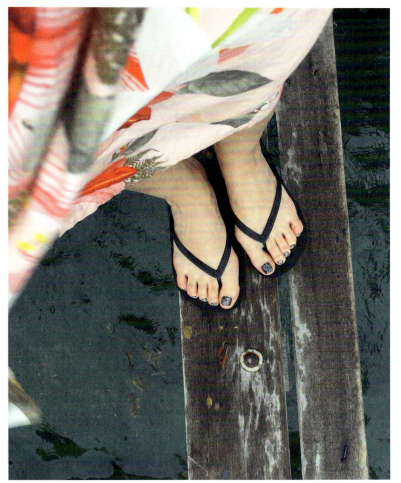
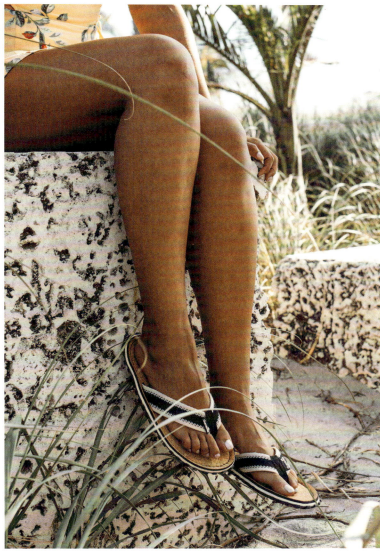

Im Grunde sind Flipflops Sandalen ohne Fersenriemen. Im Gegensatz zu Sandalen, die aus verschiedenen Materialien gefertigt werden können, werden echte Flipflops jedoch immer aus Gummi hergestellt. Während ihre Form schon den alten Ägyptern vor etwa 4000 Jahren bekannt war, hat der moderne Flipflop seinen Ursprung in den japanischen *Zōri*, einer traditionellen Zehenstegsandale. Während des Zweiten Weltkriegs wurde der Schuh in Japan aus Gummi hergestellt, der aus dem besetzten Südostasien stammte. Obwohl Japan nach Kriegsende den direkten Zugang zu den Kautschukplantagen verlor, wurde die Produktion in den späten 1940er-Jahren wieder aufgenommen und die auf dem Archipel stationierten US-Soldaten übernahmen die traditionellen *Zōri* oder ihre Gummivariante als Freizeitschuhe, da sie sich besonders leicht an- und ausziehen ließen. In den 1950er-Jahren brachten GI-Veteranen die Gummisandale mit in die USA, wo sie in den 1960er-Jahren unter dem Namen *Flip-Flop* bekannt wurde und sich an den Stränden Kaliforniens als Unisexbadeschuh etablierte. Als preisgünstiger Schuh war er auch in der brasilianischen Mittelschicht sehr erfolgreich, wo die Marke Alpargatas 1962 eine Version namens *Havaianas* (hawaiisch) einführte. Die brasilianischen Flipflops wurden 1998 zum Kultobjekt, als die Marke sie in den Farben der brasilianischen Flagge neu auflegte, um die Fußballmannschaft zu unterstützen, die es bis ins Finale der Weltmeisterschaft gegen Frankreich geschafft hatte. Brasilien mag das Spiel verloren haben, aber der brasilianische Flipflop hat seitdem die Welt erobert.

Flipflops

Long boots (aka Over-the-knee boots)

While equestrians have been wearing over-the-knee boots since the Renaissance, women only started to enjoy these elongated boots as fashion items in the early 1960s. In 1962, Cristóbal Balenciaga's autumn collection featured, for the first time, over-the-knee boots designed by the French-Italian shoemaker René Mancini. Yves Saint-Laurent followed suit the following year, with even taller boots designed by stylist and shoemaker to the stars, Roger Vivier. Unsurprisingly, the rise of over-the-knee boots coincided with the rapid shortening of skirt lengths. The pairing of the miniskirt and long boots was ready to lead the fashion of the sixties and seventies. In 1971, Jane Fonda enshrined the sexy side of these boots by playing a New York call girl and wore a pair of over-the-knee boots in Alan J. Pakula's *Klute*. In the decades that followed, the success of over-the-knee boots varied, with lulls linked to the appearance of leggings and thigh-high stockings worn with shorts or a miniskirt. The boots made a meteoric comeback thanks to Julia Roberts and her unforgettable performance in *Pretty Woman* (1990). The early 2010s marked their lasting return to the spotlight, and the long list of celebrities wearing them includes actresses Emma Watson and Zendaya Coleman, singers Gwen Stefani, Jennifer Lopez and Taylor Swift, top model Kylie Jenner and former First Lady Michelle Obama.

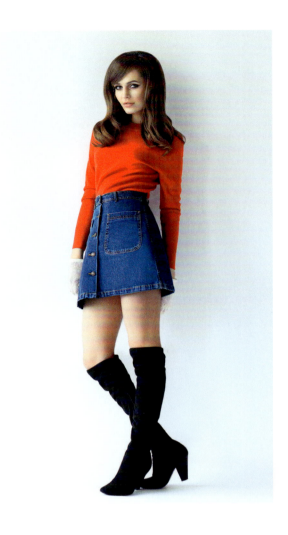

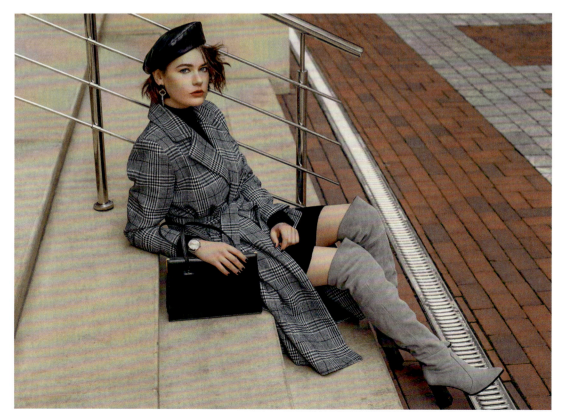

Combining style and allure

Die perfekte Verbindung aus Stil und Verlockung

Während Reiter schon seit der Renaissance Overknee-Stiefel trugen, kamen Frauen erst in den frühen 1960er-Jahren in den Genuss dieser länglichen Stiefel. In der Herbstkollektion 1962 präsentierte Cristóbal Balenciaga zum ersten Mal Overknee-Stiefel, die von dem französisch-italienischen Schuhmacher René Mancini entworfen wurden. Yves Saint-Laurent folgte im nachfolgenden Jahr mit noch höheren Stiefeln, die von Roger Vivier, einem bei den Stars beliebten Stylisten und Schuhmacher, entworfen wurden. Es ist nicht überraschend, dass das Aufkommen der Overknee-Stiefel mit der rapiden Verkürzung der Rocklängen zusammenfiel. Die Kombination von Minirock und langen Stiefeln prägte die Mode der sechziger und siebziger Jahre. 1971 zeigte Jane Fonda die sexy Seite dieser Stiefel, indem sie ein New Yorker Callgirl mit einem Paar Overknee-Stiefeln in Alan J. Pakulas *Klute* spielte. In den folgenden Jahrzehnten schwankte der Erfolg von Overknee-Stiefeln. Es gab Flauten, die mit dem Aufkommen von Leggings und oberschenkelhohen Strümpfen zusammenhingen, die zu einer kurzen Hose oder einem Minirock getragen wurden. Dank Julia Roberts und ihrer unvergesslichen Darstellung in *Pretty Woman* (1990) erlebten die Stiefel ein kometenhaftes Comeback. Anfang der 2010er-Jahre kehrten sie dauerhaft ins Rampenlicht zurück. Auf der langen Liste der prominenten Trägerinnen stehen die Schauspielerinnen Emma Watson und Zendaya Coleman, die Sängerinnen Gwen Stefani, Jennifer Lopez und Taylor Swift, das Topmodel Kylie Jenner und die ehemalige First Lady Michelle Obama.

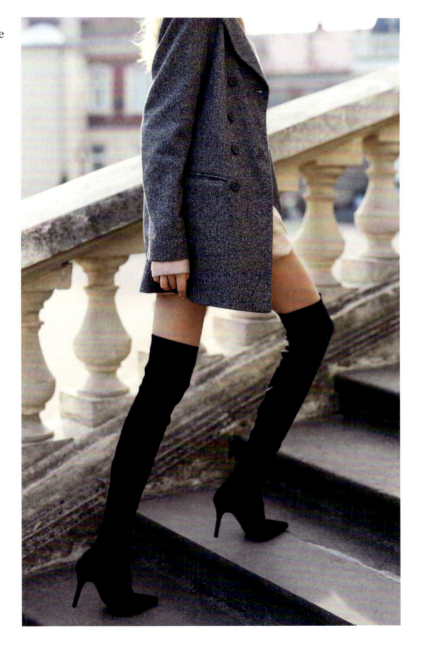

Overknee-Stiefel

Platform shoes

It's odd, but most of us feel that we are 2 or 3 centimetres (1 inch) short of the ideal height. High heels make up for this, however not everyone feels comfortable with permanently stretched ankles, as happens with heeled shoes or ankle boots. Platform shoes are therefore a very useful option, as they make their wearers taller and are available in countless variations, from platform flip-flops to gothic-style combat boots. Although ancient Greek actors wore *cothurnus*, heavy-heeled laced boots during performances, and Renaissance ladies put wooden platforms under their shoes to prevent their long dresses from dragging on the floor and getting dirty, the paternity of contemporary platform shoes is attributed to Salvatore Ferragamo, a very talented Italian shoemaker, who also designed wedge shoes. Ferragamo's platform sandal, designed in 1938, has lost none of its originality with its different layers of cork painted in bright rainbow colours. In the 1970s, platform shoes were seen both on the streets – they came in handy to keep long bell-bottoms from dragging on the floor — and in Yves Saint-Laurent's *haute couture* shows, before hitting the disco dance floors thanks to ABBA in the early 1980s. They successfully kept pace with a new generation of pop singers in the 1990s as the Spice Girls made platform shoes their signature footwear, while star designer Vivienne Westwood has given a new lease of life to this mythical shoe, and platform boots are still part of grunge and gothic fashion. It is therefore surprising that platform shoes only came back into the limelight in the 2010s, but this time, the trend seems to be here to stay.

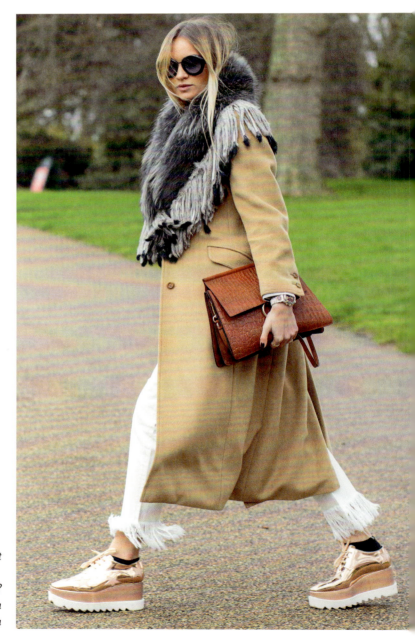

Adding height without sacrificing comfort

Wollten Sie schon immer größer sein? Diese Schuhe machen es möglich und sind dabei auch noch bequem

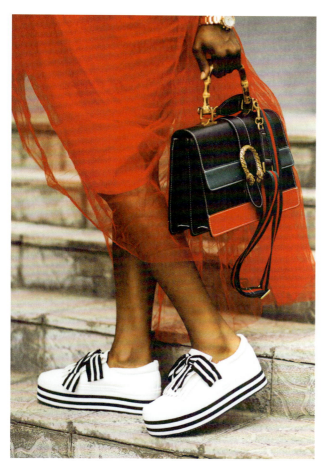

bemalten Korkschichten nichts von ihrer Originalität verloren. In den 1970er-Jahren sah man Plateauschuhe sowohl auf der Straße – sie waren praktisch, um zu verhindern, dass lange Schlaghosen auf dem Boden schleiften – als auch bei den *Haute-Couture*-Schauen von Yves Saint-Laurent, bevor man sie Anfang der 1980er-Jahre dank ABBA auf den Tanzflächen der Diskotheken fand. In den 1990er-Jahren hielten sie erfolgreich mit einer neuen Generation von Popsängerinnen Schritt, als die Spice Girls Plateauschuhe zu ihrem Markenzeichen machten, während Stardesignerin Vivienne Westwood diesem mythischen Schuh neues Leben einhauchte und Plateaustiefel noch immer Teil des *Grunge* und *Gothic Style* waren. Es ist daher verwunderlich, dass Plateauschuhe erst in den 2010er-Jahren wieder ins Rampenlicht zurückkehrten, aber dieses Mal scheint der Trend von Dauer zu sein.

Es ist seltsam, aber die meisten von uns haben das Gefühl, dass wir zwei oder drei Zentimeter von der idealen Größe entfernt sind. Hohe Absätze gleichen dies zwar aus, doch nicht jeder fühlt sich mit dauerhaft gestreckten Füßen wohl, wie es bei hochhackigen Schuhen oder Stiefeletten der Fall ist. Plateauschuhe sind daher eine sehr nützliche Option, weil sie ihre Trägerinnen größer machen und in unzähligen Varianten erhältlich sind – von Plateauflipflops bis hin zu Springerstiefeln im *Gothic Style*. Obwohl die griechischen Schauspieler der Antike bei ihren Auftritten *Kothurne*, Schnürstiefel mit dicken Sohlen, trugen und die Damen der Renaissance hölzerne Plateauschuhe unter ihre Schuhe legten, damit ihre langen Kleider nicht auf dem Boden schleiften und schmutzig wurden, wird die Erfindung der heutigen Plateauschuhe Salvatore Ferragamo zugeschrieben, einem sehr talentierten italienischen Schuhmacher, der auch Schuhe mit Keilabsatz erfand. Die 1938 entworfene Plateausandale von Ferragamo hat mit ihren in leuchtenden Regenbogenfarben

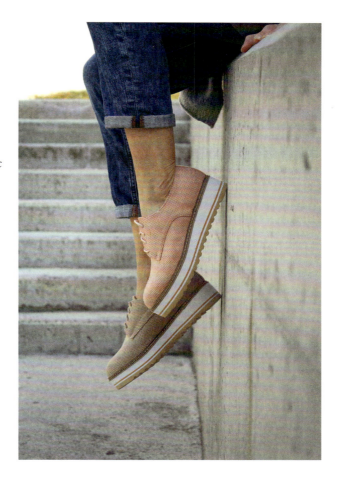

Plateauschuhe

Wedge shoes

If you want to look taller and chic while wearing comfortable footwear, opt for wedge shoes. More stylish than platform shoes, they flatter your silhouette while also being much more stable than high-heeled shoes: as body weight is evenly distributed across the shoe, there is little risk of losing your balance with the wedge style. Launched by luxury shoemaker Salvatore Ferragamo in the 1930s, wedge shoes are suitable for everyday use in the city as well as for holidays at the seaside. The heightened soles were originally made of cork, due to a shortage of imported rubber in Mussolini's Italy, and they rapidly became popular around the globe during WWII, when restrictions limited the availability of other materials. Although rubber soles are now common, cork is still the first choice for this type of shoe. Its advantage is that it adapts perfectly to the shape of the foot, acts as a shock absorber when walking, as well as adapting well to the humidity, thus making wedges nearly orthopaedic shoes. Their natural look appealed to the protesting youth of the 1970s, and the fashion even extended to men. In a similar desire to return to simple, natural materials and in a quest for comfort, wedges came back into favour in the mid-2000s. They are a favourite among celebrities who are often photographed in their wedges: Jennifer Lopez, Jessica Alba, Michelle Obama, Heidi Klum, Jennifer Aniston, Meghan Markle and her sister-in-law Kate Middleton appreciate the refined comfort of the shoe.

The Dolce Vita in a shoe

Für das besondere Dolce-Vita-Gefühl

Wenn Sie größer wirken und schick aussehen möchten, aber auch bequeme Schuhe tragen wollen, entscheiden Sie sich für Schuhe mit Keilabsatz. Sie sind eleganter als Plateauschuhe, schmeicheln der Silhouette und bieten gleichzeitig viel stabileren Halt als hochhackige Schuhe: Da das Körpergewicht gleichmäßig auf den Schuh verteilt wird, besteht bei Schuhen mit Keilabsatz kaum die Gefahr, das Gleichgewicht zu verlieren. Die vom Luxusschuhmacher Salvatore Ferragamo in den 1930er-Jahren eingeführten Schuhe eignen sich sowohl für den Alltag in der Stadt als auch für den Strandurlaub. Die erhöhten Sohlen wurden ursprünglich aus Kork hergestellt, da im Italien Mussolinis ein Mangel an importiertem Kautschuk herrschte. Während des Zweiten Weltkriegs wurden sie schnell weltweit populär, da die Verfügbarkeit anderer Materialien eingeschränkt war. Obwohl Gummisohlen heute üblich sind, ist Kork immer noch die erste Wahl für diese Art von Schuhen. Der Vorteil von Korksohlen besteht darin, dass sie sich perfekt an die Fußform anpassen, beim Gehen stoßdämpfend wirken und sich gut an die Feuchtigkeit anpassen, wodurch Schuhe mit Keilabsatz fast zu orthopädischen Schuhen werden. Ihr natürlicher Look gefiel der protestierenden Jugend der 1970er-Jahre und der Trend schwappte auch auf Männer über. Mit dem Wunsch, zu einfachen, natürlichen Materialien und zu mehr Bequemlichkeit zurückzukehren, kamen Mitte der 2000er-Jahre Keilabsätze wieder in Mode. Sie werden von folgenden Prominenten für ihren raffinierten Komfort geschätzt, die oft in ihren sogenannten Wedges fotografiert werden: Jennifer Lopez, Jessica Alba, Michelle Obama, Heidi Klum, Jennifer Aniston, Meghan Markle und ihre Schwägerin Kate Middleton.

Schuhe mit Keilabsatz

Chucks (aka Converse, All Star, Chuck Taylor)

If not for the basketball shoe that bears his name, Charles "Chuck" H. Taylor might not have become a part of modern history, notwithstanding his talent as a player. If not for Chuck, the sneaker might have been just one basketball player's shoe among many. For the legend of the *Converse All Star Chuck Taylor* is a double success story: one of perfection in design backed by exceptional marketing flair. When the young semi-professional player walked into the Converse shop in 1921, four years after the launch of the *All Star* shoe, he certainly didn't expect to be hired as the brand's marketing director. He probably didn't know that Marquis Mill Converse, the founder of the brand, had decided to develop rubber and canvas shoes after falling down a staircase in 1908. The light and comfortable Converse shoes quickly found their way into stadiums and sports fields. The fabric, which covered and protected the ankle without reducing flexibility, was ideal for basketball players, a sport where players must run, jump, and turn all the time. The challenge was to combine these qualities with the image of a sporty and fast-moving lifestyle, where elegance and a casual attitude go hand in hand. The on-going success of the sneaker, which has stood the test of time, is all about this philosophy of life.

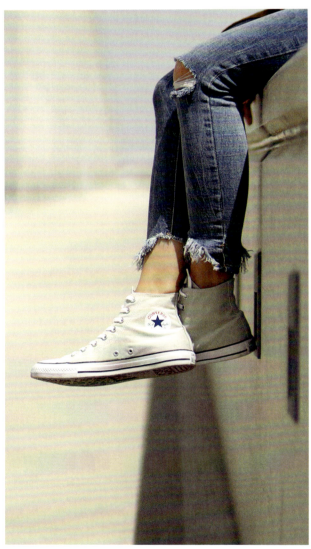

The perfect cool city shoe

Perfekte Alltagsbegleiter

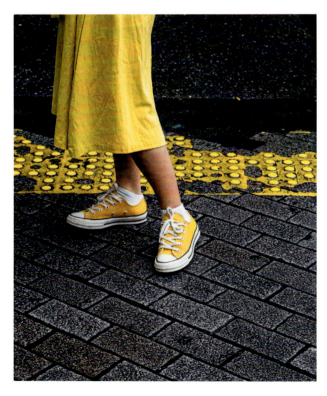

Ohne den Basketballschuh, der seinen Namen trägt, wäre Charles „Chuck" H. Taylor trotz seines Talents als Spieler vielleicht nicht in die moderne Geschichte eingegangen. Hätte es Chuck nicht gegeben, wäre der Sneaker vielleicht nur ein Basketballschuh unter vielen gewesen. Denn die Legende des Converse All Star Chuck Taylor ist eine doppelte Erfolgsgeschichte: ein perfektes Design mit einem außergewöhnlichen Marketing. Als der junge semiprofessionelle Spieler 1921 – vier Jahre nach der Einführung des *All-Star*-Schuhs – das Converse-Geschäft betrat, rechnete er sicher nicht damit, als Marketingdirektor der Marke eingestellt zu werden. Er wusste wahrscheinlich nicht, dass Marquis Mill Converse, der Gründer der Marke, nach einem Treppensturz 1908 beschlossen hatte, Schuhe aus Gummi und Segeltuch zu entwickeln. Die leichten und bequemen Converse fanden schnell ihren Weg in die Stadien und auf die Sportplätze. Das Material, das den Knöchel bedeckt und schützt, ohne die Bewegungsfreiheit einzuschränken, war ideal für Basketballspieler. Die Herausforderung bestand darin, diese Qualitäten mit dem Image eines sportlichen und schnelllebigen Lebensstils zu verbinden, bei dem Eleganz und Lässigkeit Hand in Hand gehen. Der ungebrochene Erfolg des Sneakers, der die Zeit überdauert hat, steht ganz im Zeichen dieser Lebensphilosophie.

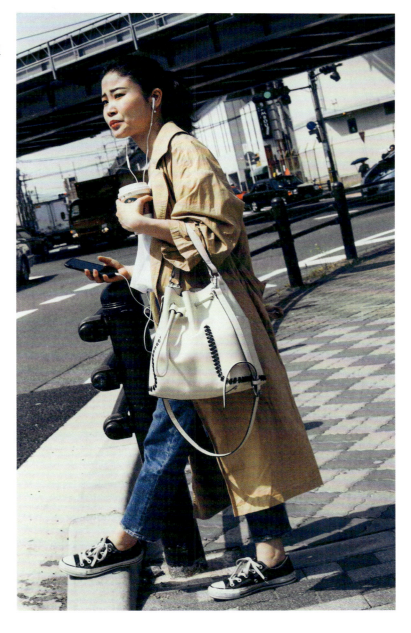

Chucks (auch als Converse bekannt)

Dr Martens 1460

The rigid, somewhat massive look of Dr Martens 1460 shoes and their reputation as a footwear for tough guys can be disconcerting, but this first impression is deceptive: despite their intimidating aspect, they are extremely comfortable shoes. They were originally devised by a young Bavarian doctor, Klaus Märtens, while he was recovering from an ankle injury following a skiing accident in early 1946. Märtens came up with the idea of equipping leather boots with an air-cushioned sole that made walking less painful and a rigid leather structure that surrounded and supported the ankle. In the 1950s, the boot was primarily successful as an orthopaedic shoe, particularly among the seniors, before an English manufacturer specialising in work boots, Griggs, uncovered its potential as a safe and comfortable footwear. The brand promptly acquired the license from Klaus Märtens, and the boot was relaunched under the anglicised name Dr Martens on the 1st of April 1960 (1.4.60). The utilitarian boot of the working class met the rebellious protest of the 1960s and became the footwear of two rather antagonistic groups, the skinheads, and the punks, who both proclaimed their proletarian origins. The combination of Dr Martens and rolled-up-to-the-calf trousers also appealed to rock singers accustomed to acrobatic stage performances, such as Joe Strummer of The Clash and Pete Townsend of The Who – a style that would be taken up by the grunge generation twenty years later. These days, Olivia Rodrigo, who embraces nostalgic references to the 1990s, regularly wears them, as does Megan Fox. Rihanna, who is known for her eclectic wardrobe, has also made headlines with pink Dr Martens.

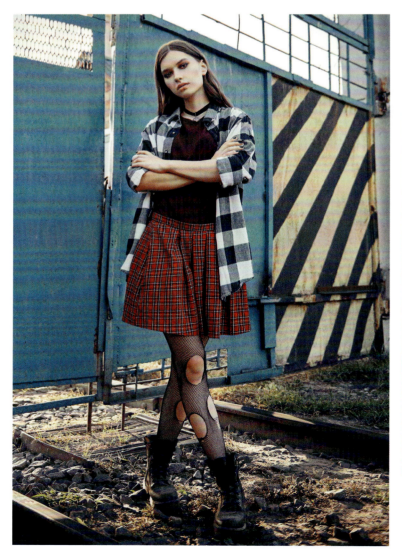

Hard on the outside, amazingly comfortable on the inside, and supremely durable

Außen hart, innen erstaunlich bequem und dabei völlig verschleißfrei

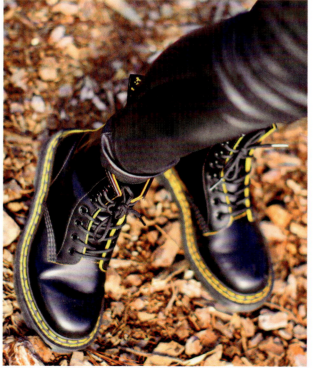

Shoes and boots / Schuhe und Stiefel

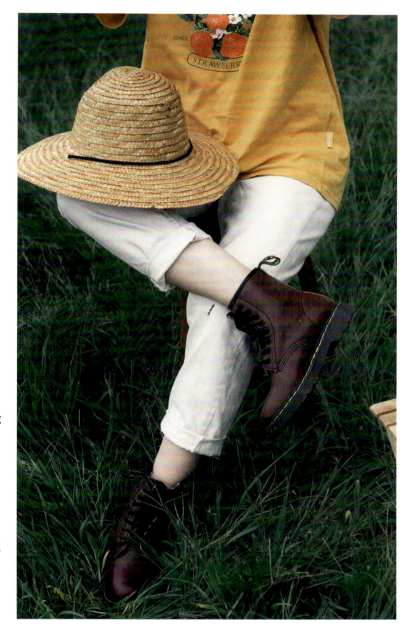

Der starre, etwas wuchtige Look der Dr. Martens 1460 Schuhe und ihr Ruf als Schuhwerk für harte Kerle kann beunruhigend sein, aber dieser erste Eindruck täuscht: Trotz ihres einschüchternden Aussehens sind sie äußerst bequeme Schuhe. Ursprünglich wurden sie von einem jungen bayerischen Arzt namens Klaus Märtens erfunden, als er sich Anfang 1946 von einer Knöchelverletzung nach einem Skiunfall erholte. Märtens kam auf die Idee, Lederstiefel mit einer luftgepolsterten Sohle auszustatten, die das Gehen weniger schmerzhaft macht, und mit einer starren Lederstruktur, die den Knöchel umschließt und stützt. In den 1950er-Jahren war der Stiefel vor allem als orthopädischer Schuh, insbesondere bei Senioren, erfolgreich, bevor der auf Arbeitsstiefel spezialisierte englische Hersteller Griggs sein Potenzial als sicheres und bequemes Schuhwerk entdeckte. Prompt erwarb die Marke die Lizenz von Klaus Märtens und am 1. April 1960 wurde der Stiefel unter dem anglisierten Namen Dr. Martens neu aufgelegt. Der Gebrauchsstiefel der Arbeiterklasse traf auf den rebellischen Protest der 1960er-Jahre und wurde zum Schuhwerk von zwei eher antagonistischen Gruppen – den Skinheads und den Punks –, die beide ihre proletarische Herkunft beteuerten. Die Kombination aus Dr. Martens und hochgekrempelten Hosen gefiel auch Rocksängern, die Gefallen an akrobatischen Bühnenauftritten fanden, wie Joe Strummer von The Clash und Pete Townsend von The Who – ein Stil, der zwanzig Jahre später von der Grunge-Generation aufgegriffen werden sollte. Heutzutage trägt Olivia Rodrigo, die nostalgische Anspielungen auf die 1990er-Jahre pflegt, sie regelmäßig, ebenso wie Megan Fox. Rihanna, die für ihre eklektische Garderobe bekannt ist, hat auch schon mit rosa Dr. Martens Schlagzeilen gemacht.

Dr. Martens 1460

Moccasins

The origins of the moccasin are rooted in the snowy plains of Canada, where the Algonquian tribes made these traditionally heelless shoes from animal hide sewn together and wore them for winter walks. The word *makisin*, common to many Algonquian dialects, translates loosely as "footwear". Its modern version was created by George H. Bass, a shoemaker from Wilton, Maine, who had already made a name for himself by designing the official boots of the young US Air Force (Charles Lindbergh wore a pair when he flew across the Atlantic). Designed in 1936, his *Weejun* leather moccasins borrowed from both the Algonquian shoe as well as from traditional Norwegian leather slippers (*Weejun* is the abbreviation of Norwegian). The lightweight, easy-to-put-on shoe was so popular with young American students that it became a symbol of Ivy League style in the late 1930s. The moccasin entered women's fashion in the 1940s and had its heyday in the 1960s when Grace Kelly and Audrey Hepburn popularised wearing moccasins sockless, a trend taken up by all the preppy students and the beat generation. After a comeback in the 1990s in the wake of boat shoes, which were similar in style, the moccasin has recently resurfaced as a chic alternative to sneakers. Combining comfort and year-round wearability, the shoe remains popular; even though its reputation as a somewhat bourgeois style of footwear has stuck with it.

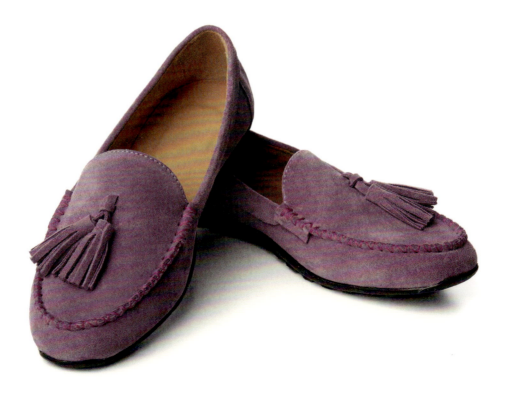

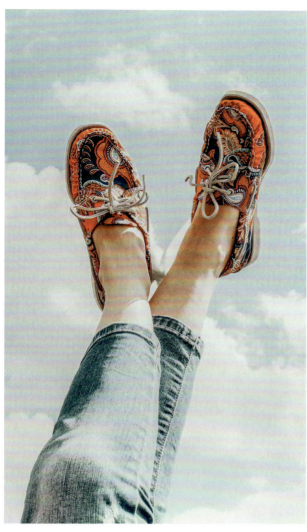

You always look and feel good in loafers

In Mokassins sieht man immer schick aus

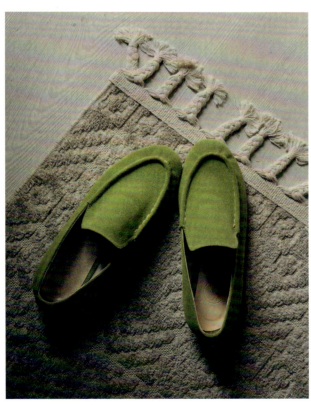

Die Ursprünge des Mokassins liegen in den verschneiten Ebenen Kanadas, wo die Algonkin-Stämme diese traditionell absatzlosen Schuhe aus zusammengenähten Tierhäuten herstellten und sie bei Winterspaziergängen trugen. Das Wort *Makisin*, das in vielen Algonkin-Dialekten vorkommt, bedeutet frei übersetzt „Schuhwerk". Seine moderne Version wurde von George H. Bass entworfen, einem Schuhmacher aus Wilton im US-Bundesstaat Maine, der sich bereits einen Namen gemacht hatte, indem er die offiziellen Stiefel der jungen US Air Force entwarf (Charles Lindbergh trug ein Paar, als er den Atlantik überflog). Seine 1936 entworfenen Ledermokassins *Weejun* lehnen sich sowohl an den Algonkin-Schuh als auch an die traditionellen norwegischen Lederslipper an (*Weejun* ist die Abkürzung vom englischen *Norwegian*, also „norwegisch"). Der leichte und einfach anzuziehende Schuh war bei jungen US-amerikanischen Studenten so beliebt, dass er in den späten 1930er-Jahren zu einem Symbol für den Stil der Ivy League wurde. Der Mokassin hielt in den 1940er-Jahren Einzug in die Damenmode und erlebte seine Blütezeit in den 1960er-Jahren, als Grace Kelly und Audrey Hepburn das Tragen von Mokassins ohne Socken populär machten – ein Trend, der von *Preppy*-Studenten und der *Beat Generation* aufgegriffen wurde. Nach einem Comeback in den 1990er-Jahren zusammen mit Bootsschuhen, die einen ähnlichen Stil hatten, ist der Mokassin in letzter Zeit als schicke Alternative zu Sneakers wieder aufgetaucht. Mit seiner Kombination aus Komfort und ganzjähriger Tragbarkeit ist der Schuh nach wie vor beliebt, auch wenn ihm der Ruf von Spießigkeit anhaftet.

Mokassin

Accessories

7

Accessoires

John Lennon glasses

The round granny-style glasses worn by John Lennon throughout his artistic career have become a recognised design icon reaching far beyond the circle of his fans. They are a symbol of the 1960s' pacifist zeitgeist, a significance accentuated by their resemblance to Mahatma Gandhi's spectacles. However, vanity wasn't the reason that the Beatles' singer wore them: suffering from severe myopia, he was unable to see beyond his guitar, and the world would have looked blurry to him without them. The lenses, tinted in blue, orange, green or red, matched the brightly coloured outfits he sported during his hippie days and protected his eyes from flashbulbs. These wire-rim glasses have enjoyed resurging popularity thanks to the Harry Potter films, in which the hero wears them. More recently, Lady Gaga has made them a part of her signature look.

A gentle nod to John Lennon

Nicht nur für Fans von John Lennon geeignet

138 **Accessories / Accessoires**

Die runde Brille im Oma-Stil, die John Lennon während seiner künstlerischen Laufbahn trug, ist zu einem anerkannten Designklassiker geworden. Die Begeisterung für das ikonische Accessoire reicht weit über den Kreis seiner Fans hinaus. Sie sind ein Symbol für den pazifistischen Zeitgeist der 1960er-Jahre – eine Bedeutung, die durch ihre Ähnlichkeit mit der Brille von Mahatma Gandhi noch unterstrichen wird. Der Sänger der Beatles trug sie jedoch nicht aus Eitelkeit: Er litt an starker Kurzsichtigkeit und konnte nicht über seine Gitarre hinaussehen. Ohne sie wäre ihm die Welt verschwommen erschienen. Die blau, orange, grün und rot getönten Gläser passten zu den farbenfrohen Outfits seiner Hippiezeit und schützten seine Augen vor Blitzlichtgewitter. Diese Nickelbrille erfreut sich dank der Harry-Potter-Filme, in denen der Held sie trägt, wieder wachsender Beliebtheit. In jüngster Zeit gehört sie auch zu dem typischen Look von Lady Gaga.

John-Lennon-Brille

XXL glasses

It is simply impossible to go unnoticed wearing a pair of oversized glasses! Their surreal proportions catch the eye of every passerby and have a truly mesmerizing effect. Following a trend set by Jackie Kennedy, the stars of the 1960s played cat-and-mouse with the paparazzi by wearing these XXL-sized glasses, often adorned with eccentric frames to ensure they would stand out. Sophia Loren, Brigitte Bardot, and Françoise Hardy contributed to the fame of the oversized glasses at that time. After decades of restraint, XXL glasses with metal frames have resurfaced during fashion weeks in the early 2020s. Their revival seems to mean more than a mere nostalgic nod to the swinging sixties.

Es ist einfach unmöglich, mit einer übergroßen Brille nicht aufzufallen! Ihre surrealen Proportionen ziehen jeden Passanten in ihren Bann und haben eine wahrhaft hypnotisierende Wirkung. Nach dem Vorbild von Jackie Kennedy spielten die Stars der 1960er-Jahre Katz und Maus mit den Paparazzi, indem sie diese Brillen im XXL-Format trugen, die oft auch exzentrische Gestelle hatten, um sicherzugehen, dass sie auffielen. Sophia Loren, Brigitte Bardot und Françoise Hardy trugen damals zum Ruhm der übergroßen Brillen bei. Nach jahrzehntelanger Zurückhaltung sind XXL-Brillen mit Metallrahmen auf den Fashion Weeks der frühen 2020er-Jahre wieder aufgetaucht. Ihre Wiederbelebung scheint mehr zu bedeuten als nur eine nostalgische Anspielung auf die *Swinging Sixties*.

XXL-Brille

Aviator glasses

The design of the first aviator glasses in the 1930s was a direct consequence of booming air travel for both commercial and military purposes. Pilots had to fly longer and higher, facing the effects of the rising or setting sun and the dazzling light at high altitude. The issue was serious enough for the US Army, in 1936, to join forces with the optical company Bausch & Lomb to develop a model of glasses that would effectively protect pilots from the sun's rays without impairing their field of vision or their perception of distance and terrain. It was also imperative that the glasses be impact-resistant and fit tightly on the aviator's face, even in turbulent conditions. A year later, the first Ray-Ban glasses were launched. Their teardrop-shaped lenses and double bridge provided ideal visibility and functionality. Their look, which was quite original at the time, guaranteed them a rapid success well beyond the circle of pilots: motorists and holidaymakers were among the first civilian users. Hollywood actresses in the late 1950s and rock stars in the 1970s, also adopted them to protect their eyes from the crackling flashes of cameras. More recently, aviator glasses have been adopted by contemporary socialites such as Kendall Jenner and Eva Longoria for the same reason.

Glasses to feel like a living legend

Eine Brille, um sich wie eine lebende Legende zu fühlen

Das Design der ersten Fliegerbrille in den 1930er-Jahren war eine direkte Folge des boomenden Luftverkehrs, sowohl für kommerzielle als auch für militärische Zwecke. Die Piloten mussten länger und höher fliegen und waren den Auswirkungen der auf- oder untergehenden Sonne und dem blendenden Licht in großer Höhe ausgesetzt. Das Problem war so gravierend, dass sich die US-Armee 1936 mit dem Optikhersteller Bausch & Lomb zusammentat, um ein Brillenmodell zu entwickeln, das Piloten wirksam vor den Sonnenstrahlen schützte, ohne ihr Sichtfeld oder ihre Wahrnehmung von Entfernungen und Gelände zu beeinträchtigen. Außerdem musste die Brille stoßfest sein und auch bei Turbulenzen fest auf der Nase des Piloten sitzen. Ein Jahr später wurde die erste Ray-Ban-Brille auf den Markt gebracht. Ihre tropfenförmigen Gläser und der doppelte Steg bieten ideale Sicht und Funktionalität.

Ihr für die damalige Zeit recht originelles Aussehen garantierte der Brille einen schnellen Erfolg weit über den Kreis der Piloten hinaus: Autofahrer und Urlauber gehörten zu den ersten zivilen Nutzern. Auch Hollywood-Schauspielerinnen in den späten 1950er-Jahren und Rockstars in den 1970er-Jahren trugen sie, um ihre Augen vor dem Blitzlichtgewitter der Kameras zu schützen. In jüngerer Zeit wurde die Pilotenbrille aus dem gleichen Grund auch von aktuellen Berühmheiten wie Kendall Jenner und Eva Longoria getragen.

Fliegerbrille

Choker necklace

One could easily write a fascinating book on the choker necklace, since its history has been intertwined for more than 5,000 years with the strangest and most contradictory social phenomena. It was a symbol of power and aristocratic lifestyle in ancient Egypt, Byzantium, Renaissance Europe and even during the Victorian era. But the choker necklace was taken over by the punks in the 1990s, in the form of a metal chain, or a spiked collar, as a sign of rebellion and defiance (By the way, Mathilda, the young killer played by Natalie Portman in *Leon: The Professional* (1993), wears a choker necklace adorned with a stone). It is also an accessory associated with *femmes fatales*, at least in paintings such as *Olympia*, the famous and scandalous nude by Édouard Manet, or *Salome* by Franz von Stuck. The choker necklace of the 2020s is made of metal or pearls, and is simply meant to highlight a graceful neck. It can be styled with any type of clothing.

The ideal accessory to highlight a slender neck

Das ideale Accessoire zur Betonung eines schlanken Halses

144 **Accessories / Accessoires**

Über den Choker könnte man ein faszinierendes Buch schreiben, denn seine Geschichte ist seit mehr als 5000 Jahren mit den seltsamsten und widersprüchlichsten sozialen Phänomenen verwoben. Im alten Ägypten, in Byzanz, im Europa der Renaissance und sogar im viktorianischen Zeitalter war sie ein Symbol für Macht und einen aristokratischen Lebensstil. Aber in den 1990er-Jahren wurde der Choker in Form einer Metallkette oder eines Stachelhalsbandes von den Punks als Zeichen der Rebellion und des Trotzes übernommen. (Übrigens, die junge Killerin Mathilda, die von Natalie Portman in *Léon – Der Profi* (1993) gespielt wird, trägt eine mit einem Stein besetzte Choker-Halskette). Sie ist auch ein Accessoire, das mit Femmes fatales assoziiert wird, zumindest in Gemälden wie *Olympia*, dem berühmten und skandalösen Aktgemälde von Édouard Manet, oder *Salome* von Franz von Stuck. Der Choker der 2020er-Jahre ist aus Metall oder Perlen gefertigt und soll einfach nur einen anmutigen Hals betonen. Er kann mit jeder Art von Kleidung kombiniert werden.

Choker

145

Square neck scarf

A fabric version of the choker necklace, the square neck scarf adds a touch of elegance and softness – especially if it is made of silk – while protecting the neck from wind and cold. It is also a clever way to hide some love bites. Popular in the 1950s under the name "chiffon neck scarf", it was either tied around the neck or rolled up and used as a hairband. Riding on the popularity of bandanas in the 1990s, the square neck scarf made a major comeback at the end of the 20th century, and it makes sense that it is resurfacing in the wake of the current Y2K fashion trend.

Simply cool and stylish

Einfach cool und stilvoll

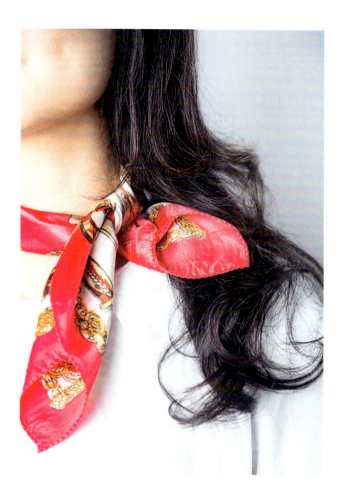

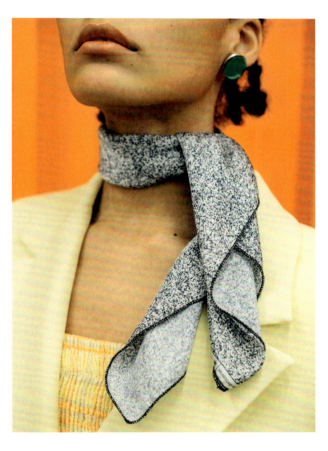

Das quadratische Halstuch ist eine Stoffvariante des Chokers und verleiht dem Hals einen Hauch von Eleganz und Zartheit – vor allem, wenn es aus Seide gefertigt ist – und schützt ihn vor Wind und Kälte. Mit Halstüchern lassen sich auch Knutschflecken clever verstecken. In den 1950er-Jahren wurde das unter dem Namen Chiffonschal bekannte Accessoire entweder um den Hals gebunden oder gerollt und als Haarband getragen. Als Folge der Popularität von Bandanas in den 1990er-Jahren erlebte das quadratische Halstuch Ende des 20. Jahrhunderts ein großes Comeback und es macht Sinn, dass es im Zuge des aktuellen *Y2K*-Trends um die Mode der 2000er-Jahre wieder auftaucht.

Quadratisches Halstuch

Scrunchie

In 1986, nightclub singer and pianist, Rommy Revson, was looking for a softer alternative to metal hair ties. By her own admission, she was inspired by her pyjama waistband to envision a circular elastic tie covered with fabric, which she called *Scunci* after her beloved pet toy poodle, a name quickly transformed into "scrunchie" by users, quite logically, since the accessory scrunches. The invention, patented in 1987, was a resounding success. It instantly replaced the barrettes, headbands, and other plastic clips up until the early 2000s. From Madonna to female astronaut, Col. Pamela Melroy, every woman owned a scrunchie. In 2003, the French actress Emmanuelle Béart created a buzz by posing naked on a beach for *Elle* magazine, wearing only a scrunchie. And yet, the same year, Carrie Bradshaw, the heroine of *Sex and the City* ridiculed the accessory that had become too ubiquitous to be fashionable, thus announcing its inevitable decline. With the current wave of 1990s nostalgia, the scrunchie has just as inevitably climbed back to the top of the ponytail. First Lady of the US, Dr Jill Biden, sports one regularly, as do Hailey Bieber and Selena Gomez.

In a bun or as a casual bracelet, the scrunchie has become a fashion essential

Ob am Dutt oder als lässiger Armreif, das Stoff-Haargummi ist ein modisches Must-have

Accessories / Accessoires

1986 suchte die Nachtclubsängerin und Pianistin Rommy Revson nach einer sanfteren Alternative zu Haargummis aus Metall. Nach eigener Aussage ließ sie sich von ihrem Pyjamabund inspirieren und stellte sich ein rundes, elastisches und mit Stoff überzogenes Band vor, das sie nach ihrem geliebten Zwergpudel *Scunci* benannte. Der Name wurde von den Nutzern schnell in *Scrunchie* umgewandelt – was Sinn ergab, denn das Accessoire sieht aus wie zusammengeknüllt (das Englische *scrunch* bedeutet „zerknüllen"). Die Erfindung, die 1987 patentiert wurde, war ein durchschlagender Erfolg. Bis Anfang der 2000er-Jahre ersetzte es Haarspangen, Haarbänder und andere Plastikclips. Von Madonna bis zur Astronautin Pamela Melroy besaß jede Frau ein stoffbezogenes Haargummi. 2003 sorgte die französische Schauspielerin Emmanuelle Béart für Aufsehen, als sie für die Zeitschrift *Elle* nackt am Strand posierte und dabei nur ein Scrunchie trug. Doch im selben Jahr machte sich Carrie Bradshaw, die Heldin von *Sex and the City*, über das Accessoire lustig, das zu allgegenwärtig geworden war, um modisch zu sein, und kündigte damit seinen unvermeidlichen Niedergang an. Mit der aktuellen Nostalgiewelle der 1990er-Jahre wird das Haargummi unweigerlich wieder für das Zusammenhalten von Pferdeschwänzen genutzt. Dr. Jill Biden, die First Lady der USA, trägt es regelmäßig, ebenso wie Hailey Bieber und Selena Gomez.

Haargummi aus Stoff

Fanny pack (aka bum bag, belt bag, hip pack, waist bag)

The idea of attaching a small pouch to a belt is not new: one was even found among Ötzi the iceman's belongings. However, the actual idea of a banana-shaped bag that opens with a zipper dates back to 1954. It was designed and intended for skiers who wore it on their backs. This had the advantage of not impeding their movements. The practical sportswear accessory emerged as a ubiquitous piece of streetwear in the 1980s, switching quite naturally from hikers, cyclists, and joggers to holidaymakers and tourists, to shoppers and sellers on the markets, to mothers and children. In short, everyone carried a fanny pack adapted to their needs. This overexposure was to prove fatal, as in the following decade the rather inelegant waist bag fell into the "has been" category and was promptly replaced by brightly coloured backpacks and shoulder bags. The sudden resurgence of the fanny pack in recent years is all the more surprising as it is supported by luxury brands such as Louis Vuitton, Prada and Gucci that have appropriated the "ugly duckling" to make it a sophisticated and chic accessory with a lovely vintage touch.

From utilitarian sportswear to a catwalk icon: the bum bag's success story

Vom praktischen Sportaccessoire zur Laufsteg-Ikone: die Erfolgsgeschichte der Bauchtasche

Accessories / Accessoires

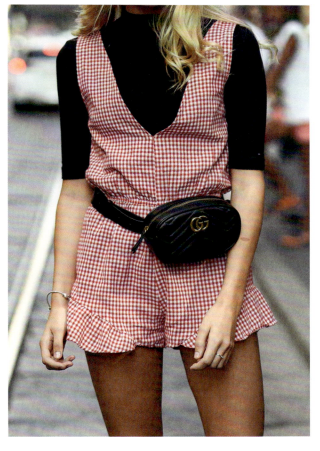

Die Idee, eine kleine Tasche am Gürtel zu befestigen, ist nicht neu: Eine solche Tasche wurde sogar bei den Habseligkeiten der Eismumie Ötzi gefunden. Die eigentliche Idee für eine bananenförmige Tasche, die sich mit einem Reißverschluss öffnen lässt, stammt jedoch aus dem Jahr 1954. Sie wurde für Skifahrer entworfen, die sie auf dem Rücken trugen. Dies hatte den Vorteil, dass ihre Bewegungen nicht eingeschränkt wurden. Das praktische und sportliche Accessoire wurde in den 1980er-Jahren zu einem allgegenwärtigen Kleidungsstück, das von Wanderern, Radfahrern und Joggern über Urlauber und Touristen bis hin zu Einkäufern und Verkäufern auf den Märkten sowie von Müttern und Kindern ganz selbstverständlich getragen wurde. Kurz gesagt: Jeder trug eine seinen Bedürfnissen angepasste Gürteltasche.
Diese Allgegenwärtigkeit sollte sich jedoch als fatal erweisen, denn im folgenden Jahrzehnt fiel die eher unelegante Hüfttasche in die Kategorie „das war einmal" und wurde prompt durch bunte Rucksäcke und Umhängetaschen ersetzt.
Das plötzliche Wiederaufleben der Gürteltasche in den letzten Jahren ist umso überraschender, da dies von Luxusmarken wie Louis Vuitton, Prada und Gucci unterstützt wird, die sich das „hässliche Entlein" zu eigen gemacht und es zu einem raffinierten und schicken Accessoire mit einem schönen Vintage-Touch umgestaltet haben.

Gürteltasche (auch Bauchtasche oder Hüfttasche genannt)

Suspenders (aka braces)

In the early 2000s, suspenders belonged to the sartorial dress of old-fashioned gentlemen, halfway between grandpas, pot-bellied bankers, and the eccentric American TV host Larry King. True, Sigourney Weaver had worn some in *Aliens* (1986), but as cartridge belts, and in *Titanic* (1997), Leonardo DiCaprio as Jack Dawson drowned wearing suspenders. But it was not until the hipster wave, in the middle of the 2000s, that this accessory found its way back into streetwear. Although they are not very well adapted to the female form, the straps conveniently do not squeeze the belly as a belt would. Suspenders can be worn as a colourful, original adornment providing a fancy androgenous look if, for example, combined with skinny jeans.

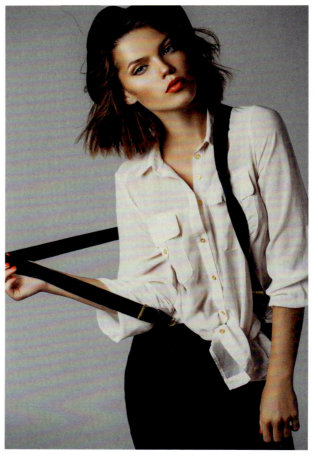

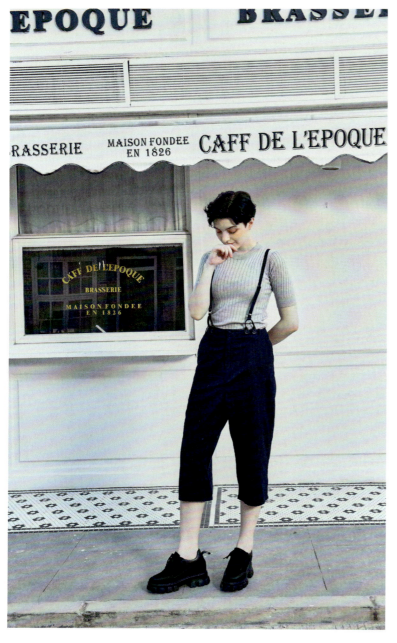

The retro accessory with a new appeal

Das ultimative Retro-Accessoire mit Stil

Accessories / Accessoires

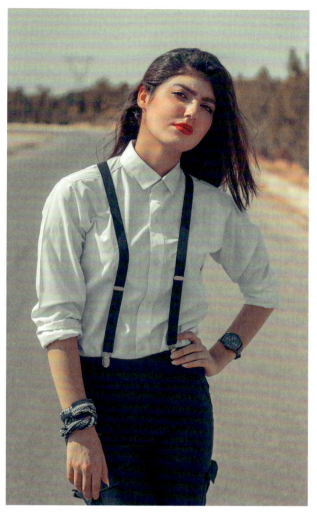

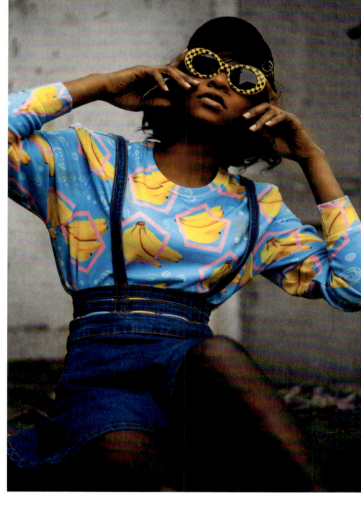

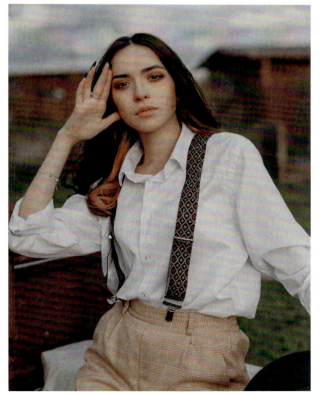

In den frühen 2000er-Jahren gehörten Hosenträger zur Garderobe altmodischer Herren, die zwischen Opas, dickbäuchigen Bankern und dem exzentrischen US-amerikanischen Fernsehmoderator Larry King angesiedelt waren. Sigourney Weaver hatte zwar in *Aliens* (1986) welche getragen, aber als Patronengürtel. In *Titanic* (1997) ertrank Leonardo DiCaprio als Jack Dawson zwar mit Hosenträgern, doch erst mit der Hipster-Welle Mitte der 2000er-Jahre fand das Accessoire seinen Weg zurück in die Streetwear. Obwohl sie nicht sehr gut an die weibliche Form angepasst sind, drücken die Träger den Bauch nicht wie ein Gürtel zusammen. Hosenträger können als farbenfrohes, originelles Accessoire getragen werden und sorgen für einen ausgefallenen, androgynen Look, wenn sie zum Beispiel mit *Skinny Jeans* kombiniert werden.

Newsboy cap

If you enjoy a boyish look and all things oversized, then the newsboy cap is for you! Director François Truffaut's choice to have French actress Jeanne Moreau wear one in his film *Jules and Jim* (1962) was somewhat transgressive, but it was perfectly within the spirit of the plot, which was about a triangular love relationship. By the end of the 1960s, the newsboy cap had become the headgear of emancipated, bohemian women like Brigitte Bardot and Jane Birkin, a tradition that has continued with Kate Moss, Jennifer Lopez, and Rihanna. With Anne Hathaway in *The Devil Wears Prada* (2006), the cap became a fashionable accessory, and it has made regular appearances on the catwalks since then.

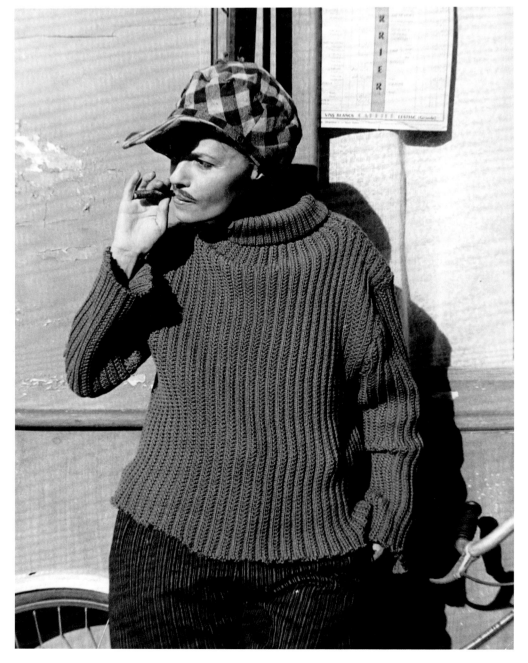

French actress Jeanne Moreau in Jules and Jim (1962)

Die französische Schauspielerin Jeanne Moreau in Jules und Jim (1962)

Wenn Sie einen jungenhaften Look und alles, was übergroß ist, mögen, dann ist die Ballonmütze genau das Richtige für Sie! Die Entscheidung des Regisseurs François Truffaut, die französische Schauspielerin Jeanne Moreau in seinem Film *Jules und Jim* (1962) ein solches Kleidungsstück tragen zu lassen, war zwar etwas gewagt, passte aber perfekt zur Handlung, in der es um eine Dreiecksbeziehung ging. Ende der 1960er-Jahre wurde die Ballonmütze zur Kopfbedeckung emanzipierter, unkonventioneller Frauen wie Brigitte Bardot und Jane Birkin – eine Tradition, die von Kate Moss, Jennifer Lopez und Rihanna fortgesetzt wird. Mit Anne Hathaway in *Der Teufel trägt Prada* (2006) wurde die Mütze zum modischen Accessoire, das seitdem regelmäßig auf den Laufstegen zu sehen ist.

Ballonmütze

Bucket hat

All hats and caps have one major drawback in common: they are not easy to store when not in use. However, there is a notable exception, a hat that can be easily stored in a pants pocket or in a backpack without losing its shape: the bucket hat. This quality probably explains why it has become a wardrobe essential for all weather conditions: just like an umbrella, it offers equal protection from sun, rain, snow, and wind. Deriving from the Irish walking hat, the bucket hat, also known as the fisherman's hat, has been used for outdoor leisure activities since the early 20th century. If firmly placed on the head, it won't blow away at the first gust of wind or sudden movement, unlike most of its peers. This contributed to making this hat popular in the hip-hop scene and streetwear in the early 1980s, before it was propelled to the catwalks a decade later. Without ever really fading away, it has enjoyed a robust revival since the end of the 2010s, thanks in particular to the Kangol brand and to celebrities such as Rihanna, the Hadid sisters, Kourtney Kardashian, and top models.

Alle Hüte und Mützen weisen einen großen Nachteil auf: Sie sind nicht leicht zu verstauen, wenn sie nicht in Gebrauch sind. Es gibt jedoch eine bemerkenswerte Ausnahme – den Fischerhut, der sich leicht in der Hosentasche oder im Rucksack verstauen lässt, ohne seine Form zu verlieren. Diese Eigenschaft erklärt wahrscheinlich, warum er zu einem unverzichtbaren Kleidungsstück für alle Wetterbedingungen geworden ist: Wie ein Regenschirm bietet er gleichermaßen Schutz vor Sonne, Regen, Schnee und Wind. Der vom irischen Wanderhut abgeleitete Fischerhut, der auch als Eimerhut bekannt ist, wird seit dem frühen 20. Jahrhundert für Outdooraktivitäten genutzt. Wenn er fest auf dem Kopf sitzt, wird er nicht beim ersten Windstoß oder einer plötzlichen Bewegung weggeblasen, wie die meisten anderen Hüte.
Dies trug dazu bei, dass der Hut Anfang der 1980er-Jahre in der Hip-Hop-Szene und als Streetwear-Accessoire beliebt war, bevor er ein Jahrzehnt später auf die Laufstege kam. Ohne jemals wirklich zu verschwinden, hat er seit Ende der 2010er-Jahre ein starkes Revival erlebt, vor allem dank der Marke Kangol und Prominenten wie Rihanna, den Hadid-Schwestern, Kourtney Kardashian und einigen Topmodels.

Fischerhut

Styles and trends

8

Stile und Trends

Punk

When the Sex Pistols launched their "no future" slogan in 1977, it became the mantra of the punk counterculture at the time. Fashion, however, had other ideas and The Exploited's first studio album, *Punks Not Dead*, was more accurate: punk style did indeed have a future. Five decades on, colourful spikes, grungy leather jackets, black combat boots and safety pins as earrings – if not studs or paper clips – continue to haunt the streets and defy convention. The only difference is that, now, elements of punk style are also showing up on the catwalk, which is a paradox when you consider that the punk movement is first and foremost a rebellion against the establishment, including fashion. But after all, neither fashion nor punks have ever shied away from contradiction.

The punk attitude never dies

Die Punk-Attitüde stirbt nie

160 **Styles and trends** / **Stile und Trends**

Als die Sex Pistols 1977 ihren Slogan „no future" veröffentlichten, wurde er zum Mantra der damaligen Punk-Gegenkultur. Die Mode hatte jedoch andere Vorstellungen und das erste Studioalbum von The Exploited – *Punks Not Dead* – war genauer: Der *Punk Style* hatte tatsächlich eine Zukunft. Fünf Jahrzehnte später geistern bunte Spikes, schäbige Lederjacken, schwarze Springerstiefel und Sicherheitsnadeln oder Büroklammern als Ohrringe weiterhin durch die Straßen und widersetzen sich den Konventionen. Der einzige Unterschied besteht darin, dass Elemente des *Punk Styles* jetzt auch auf den Laufstegen zu sehen sind, was paradox ist, wenn man bedenkt, dass die Punkbewegung in erster Linie eine Rebellion gegen das Establishment ist und sich damit auch gegen die Mode richtet. Aber weder die Mode noch die Punks haben sich jemals vor Widersprüchen gescheut.

Punk

Western style (aka cowgirl style)

While a total western-style look may be too much of a costume outside of the American Southwest, it is again cool and fashionable to add some country-style elements to your everyday wardrobe: maybe a jacket with fringes, cowboy boots, a Stetson or gaucho hat, or a belt with an extra-large buckle, all of which go perfectly with a pair of jeans and a checked shirt. You could opt for a prairie dress with a straw hat and deerskin moccasins, or explore more subtle cowboy-style accessories, such as a red bandana, cowboy gloves, and a bolo tie clasp. Whatever you decide, western-style articles of clothing will add a touch of originality to your outfit, and make you feel part of the legend of the West.

Styles and trends / Stile und Trends

Während ein kompletter Westernlook außerhalb des Südwestens der USA wohl zu sehr nach einer Verkleidung aussieht, ist es wieder cool und modisch, einige Elemente des Stils in die Alltagsgarderobe einfließen zu lassen, wie eine Jacke mit Fransen, Cowboystiefel, einen Stetson- oder Gaucho-Hut oder einen Gürtel mit einer extragroßen Schnalle. All das passt natürlich perfekt zu einer Jeans und einem karierten Hemd. Entscheiden Sie sich für ein Präriekleid mit Strohhut und Mokassins aus Hirschleder oder entdecken Sie subtilere Accessoires im *Cowboy Style*, wie ein rotes Halstuch, Cowboyhandschuhe oder ein *Bolo Tie*. Wie auch immer Sie sich entscheiden, Kleidungsstücke im *Western Style* verleihen Ihrem Outfit einen Hauch von Originalität und geben Ihnen das Gefühl, Teil des wilden Westens zu sein.

Western Style (auch Cowgirl Style genannt)

Rastafari look

Even if you don't adopt it for yourself, you can still agree that the rasta style is really cool and fun. Dreadlocks, rasta tam caps, and Bob Marley t-shirts have conquered the world, as have the colours associated with the Rastafari movement: yellow, red, green, and black, which combine the colours of the Ethiopian and Jamaican flags. Whether you're a reggae aficionado or a fan of Rihanna - who played a Rasta hacker in the film *Ocean's 8* (2018) - you'll always have a reason to borrow some elements of rasta-style clothing. Just remember that the true Rasta's dress code excludes any clothing made from animal materials.

Styles and trends / Stile und Trends

*"Love the life you live.
Live the life you love."*
– Bob Marley

„Liebe das Leben, das du lebst.
Lebe das Leben, das du liebst."
– Bob Marley

Auch wenn Sie ihn nicht für sich selbst übernehmen, können Sie den *Rasta Style* trotzdem cool finden. Dreadlocks, Rastamützen und Bob-Marley-T-Shirts haben die Welt erobert, ebenso wie die Farben der Rastafaribewegung: Gelb, Rot, Grün und Schwarz – eine Kombination aus den Farben der äthiopischen und der jamaikanischen Flagge. Egal, ob Sie Reggaemusik lieben oder ein Fan von Rihanna sind, die im Film *Ocean's 8* (2018) eine Hackerin mit Rastalocken spielt, Sie werden immer einen Grund haben, sich einige Elemente des *Rasta Styles* anzueignen. Denken Sie nur daran, dass ein echter Rasta keine Kleidung tragen würde, die aus tierischen Materialien hergestellt wurde.

Rastafarilook

Ethnic look (Tie Dye, Dutch wax, African wax prints)

The hippie style of the 1970s introduced the western world to decorative traditions from across the globe that eventually shaped the fashions of the time. The tie-dye technique, known in China, parts of Africa and South America for millennia, suddenly blossomed in the West in the late 1960s. With its bright colours, blurred shapes, and some traditional patterns (sun rays, spiral rainbows, mandalas), it was appealing to hippies and had a resonance with the psychedelic visions they had experienced. Tie-dye enjoyed a comeback in the 1990s and has been hot yet again in the latest seasons, particularly for athleisure garments, with even such fashion icons as Anna Wintour and Heidi Klum occasionally wearing dresses with tie-dye motifs.

For fans of a more radical ethnic look, Dutch wax, a technique developed in the early 19th century and derived from Javanese batik, enabled young rebels of the 1970s to wear colourful, cheerful, and original ornamental patterns from West African, Indian, or Hawaiian traditions. The technique consisted of applying wax resin to parts of the fabric before submerging it in dye, and then repeating the process, waxing different parts to dip into other colours and create interlaced patterns. Popular until the early 1980s, this technique has benefited from the renewed interest in fair trade in recent years, which has favoured African manufacturers. The fabric has been a regular guest on the catwalk since 2015.

Styles and trends / Stile und Trends

Der *Hippie Style* der 1970er-Jahre führte die westliche Welt in dekorative Traditionen aus aller Welt ein, die schließlich die Mode dieser Zeit prägten. Eine Färbetechnik, die im englischen Sprachraum als *Tie Dye* bezeichnet wird und in China, Teilen Afrikas und Südamerikas seit Jahrtausenden bekannt ist, erlebte in den späten 1960er-Jahren eine plötzliche Blüte im Westen. Mit ihren leuchtenden Farben, verschwommenen Formen und traditionellen Mustern (Sonnenstrahlen, spiralförmige Regenbögen, Mandalas) war sie für die Hippies attraktiv und passte zu den psychedelischen Visionen, die sie erlebt hatten. Das *Tie-Dye*-Verfahren erlebte in den 1990er-Jahren ein Comeback und ist auch in den letzten Saisons wieder angesagt, vor allem für *Athleisure*-Kleidung. Sogar Modeikonen wie Anna Wintour und Heidi Klum tragen gelegentlich Kleider mit *Tie-Dye*-Motiven.

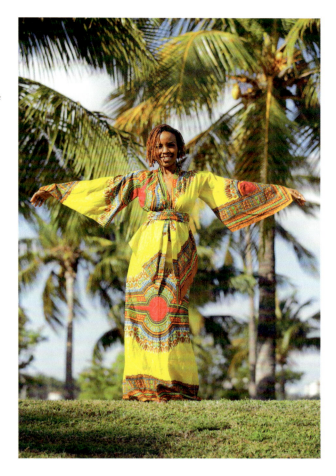

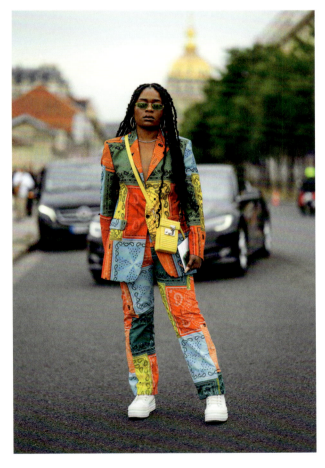

Den Fans eines radikaleren Ethnolooks unter den jungen Rebellen der 1970er-Jahre ermöglichte die sogenannte *Dutch-Wax*-Technik, die im frühen 19. Jahrhundert entwickelt wurde und von der javanischen Batiktechnik abgeleitet ist, farbenfrohe, fröhliche und originelle Ornamentmuster aus westafrikanischen, indischen und hawaiianischen Traditionen zu tragen. Die Technik besteht darin, Teile des Stoffs mit Harz zu bestreichen, bevor der Stoff in die Farbe getaucht wird, und dann den Prozess zu wiederholen, wobei andere Stellen gewachst werden, um sie in andere Farben zu tauchen und verschlungene Muster zu kreieren. Diese bis Anfang der 1980er-Jahre beliebte Technik hat in den letzten Jahren von dem wiedererwachten Interesse am fairen Handel profitiert, der afrikanische Hersteller begünstigt hat. Derart bearbeitete Stoffe sind seit 2015 regelmäßig auf Laufstegen zu sehen.

Ethnolook (Tie Dye, Dutch Wax, afrikanische Waxprints)

Safari

In their early colonial expeditions to Africa and India, British soldiers – and later those of other European powers – quickly became aware that their uniforms were poorly suited to the climate of subtropical countries. Instead, they adopted lightweight cotton jackets, trousers and shorts in hues that blended with the surrounding savannah or jungle, between beige and khaki, and later on the colonial helmet, which came to symbolise the ruthless Western domination over the conquered territories. In the wake of the colonial armies, civilian safari hunters and explorers took up these practical and comfortable garments which became associated with exotism and epic tales – unsurprisingly, Ernest Hemingway chose the safari jacket as his signature. This trend was amplified through Hollywood movies, where adventurers of both sexes, including Grace Kelly and Clark Gable wore immaculate tropical outfits in the middle of deserts or hostile rainforests. Interestingly, the fashion world waited until the end of decolonisation in the 1960s to appropriate the dress codes of the safari style: Yves Saint-Laurent was the first to design a safari jacket, *la saharienne*, which he launched on the catwalk in 1967. A year later, *Vogue* magazine devoted a photo feature to the *saharienne*, bringing it fully into the spotlight. Despite arguments about its colonial origins and its association with hunting, the safari style remains a chic trend for women of action.

Bei ihren frühen kolonialen Expeditionen nach Afrika und Indien stellten die britischen Soldaten – und später auch die anderer europäischer Mächte – schnell fest, dass ihre Uniformen für das Klima der subtropischen Länder nicht gut geeignet waren. Stattdessen trugen sie leichte Baumwolljacken, Hosen und Shorts in Farben, die mit der Savanne oder dem Dschungel verschmolzen und zwischen Beige und Khaki angelegt waren. Diese Farben fanden sich später auch auf dem Kolonialhelm wieder, der zum Symbol für die rücksichtslose Herrschaft westlicher Mächte über die eroberten Gebiete wurde.
Im Gefolge der Kolonialarmeen griffen zivile Safarijäger und Entdecker zu diesen praktischen und bequemen Kleidungsstücken, die mit Exotik und epischen Geschichten assoziiert wurden. Daher überraschte es nicht, dass Ernest Hemingway die Safarijacke zu seinem Markenzeichen machte. Verstärkt wurde dieser Trend durch Hollywood-Filme, in denen Abenteurer beider Geschlechter wie Grace Kelly und Clark Gable in Wüsten oder lebensfeindlichen Regenwäldern makellose tropische Outfits trugen. Interessanterweise wartete die Modewelt bis zum Ende der Entkolonialisierung in den 1960er-Jahren, um sich die Kleiderordnung des *Safari Style* anzueignen: Yves Saint-Laurent war der Erste, der eine Safarijacke – die *Saharienne* – entwarf und 1967 auf dem Laufsteg präsentierte. Ein Jahr später widmete die Zeitschrift *Vogue* der *Saharienne* eine Fotostrecke und rückte sie damit noch mehr ins Rampenlicht. Trotz der Diskussionen über seine kolonialen Ursprünge und seine Assoziation mit der Jagd bleibt der *Safari Style* ein schicker Trend für tatkräftige Frauen.

Safarilook

Grunge

The depressive offspring of rock and punk, grunge emerged as a musical movement in the late 1980s in the northwest United States, specifically in the Seattle area. The resounding success of *Nevermind*, the second album by the mythical band Nirvana in 1991, helped propel this alternative trend into the global spotlight and transformed singers Kurt Cobain and his wife Courtney Love into symbols of grunge. One advantage of the grunge style is that the more worn and battered a garment looks, the more authentically grunge it is: jeans should be ripped, and fishnet stockings should be frayed. A crumpled t-shirt with an undone hem and a pair of dusty converse trainers will complete the look. In short, to be truly grunge, simply don't give a damn about fashion. Except that, of course, fashion couldn't resist the pleasure of swallowing up this delirious style for itself by creating a chic grunge version. In 1992, Marc Jacobs launched a resolutely grunge collection for Perry Ellis in a show that resulted in him being fired from the brand and launched his reputation as an avant-garde fashion designer. Today, *Twilight* actress Kristen Stewart, Rihanna, Cara Delevingne, and media queen Alexa Chung occasionally pay homage to the style in grunge outfits.

Als depressiver Ableger von Rock- und Punkmusik entstand Grunge als musikalische Bewegung in den späten 1980er-Jahren im Nordwesten der USA, insbesondere in der Gegend um Seattle. Der durchschlagende Erfolg von *Nevermind*, dem zweiten Album der legendären Band Nirvana von 1991, trug dazu bei, diesen alternativen Trend in das Interesse der Weltöffentlichkeit zu rücken, und machte die Sänger Kurt Cobain und seine Frau Courtney Love zu Symbolen des Grunge. Ein Vorteil des *Grunge Style* besteht darin, dass ein Kleidungsstück umso authentischer wirkt, je abgenutzter und ramponierter es aussieht: Jeans sollten zerrissen und Netzstrümpfe ausgefranst sein. Ein zerknittertes T-Shirt mit offenem Saum und ein Paar verstaubte Converse-Turnschuhe komplettieren den Look. Kurz gesagt: Um wirklich Grunge zu sein, sollte man sich einfach nicht um Mode scheren. Aber natürlich konnte die Mode dem Vergnügen nicht widerstehen, diesen wahnsinnigen Stil für sich zu vereinnahmen und eine schicke Version des Grunge zu kreieren. 1992 präsentierte Marc Jacobs für Perry Ellis eine konsequente Grungekollektion, die dazu führte, dass er von der Marke gefeuert wurde und einen Ruf als avantgardistischer Modedesigner erlangte. Heute huldigen die *Twilight*-Darstellerin Kristen Stewart, Rihanna, Cara Delevingne und die Medienkönigin Alexa Chung dem Stil gelegentlich in ihren Outfits.

Ugly made beautiful. The miracle of grunge

Abgenutztes kann auch schick sein. Das Wunder des Grunge

Oversized

The most fascinating thing about fashion is that it constantly breaks its own rules. One might have taken it for granted that clothes should be sized to fit the body, a simple matter of common sense and elegance. Deviations from this rule were more likely to be laughed at, such as Charlie Chaplin's too-wide trousers and too-tight jacket. The idea of wearing oversized clothing originated in the rap music circles of the late 1980s with rapper MC Lyte experimenting with oversized shoulder pads, jacket, and pants on the cover of her second album, *Eyes on This* (1989). This was the time when baggy trousers and hoodies were born, which naturally encouraged the fashion for oversized clothing. From streetwear, oversized style has made its way onto the catwalk. These days there are countless oversized coats, jackets, and dresses by established brands.
If you want to experiment with the oversized look, try a loose jumper or coat and play with how the contrast works with other clothes.

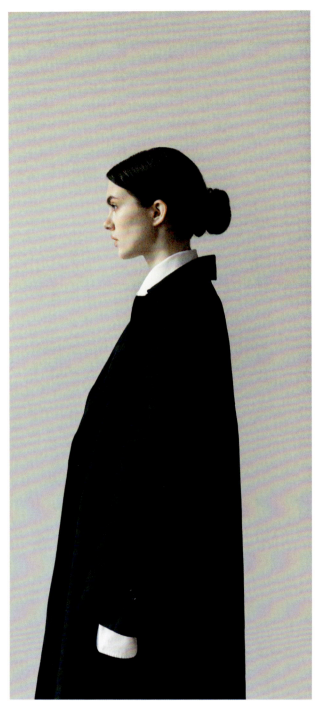

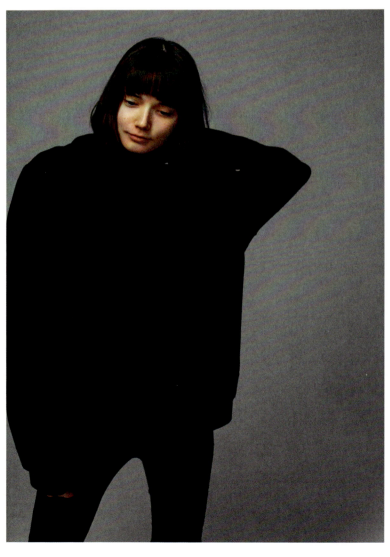

Styles and trends / Stile und Trends

Das Faszinierendste an der Mode ist, dass sie ständig ihre eigenen Regeln bricht. Man hätte annehmen können, dass die Größe der Kleidung an den Körper angepasst sein sollte – diese Annahme entspricht dem gesunden Menschenverstand und der Eleganz. Abweichungen von dieser Regel wurden eher belächelt, wie z. B. Charlie Chaplins zu weite Hosen und sein zu enges Jackett. Die Idee, übergroße Kleidung zu tragen, entstand in der Rapszene der späten 1980er-Jahre, als die Rapperin MC Lyte auf dem Cover ihres zweiten Albums *Eyes on This* (1989) mit übergroßen Schulterpolstern sowie einer übergoßen Jacke und Hose experimentierte. Dies war die Zeit, in der Baggy-Hosen und Kapuzenpullover aufkamen, was natürlich der Mode für übergroße Kleidung Aufwind gab. Von der Streetwear hat der *Oversized*-Look seinen Weg auf die Laufstege gefunden. Heutzutage gibt es unzählige Mäntel, Jacken und Kleider im übergroßen Stil von etablierten Marken. Wenn Sie den *Oversized*-Look ausprobieren möchten, versuchen Sie es mit einem lockeren Pullover oder Mantel und spielen Sie mit dem Kontrast zu anderen Kleidungsstücken.

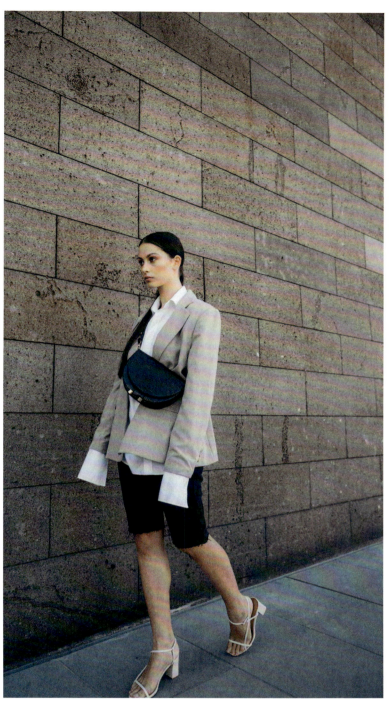

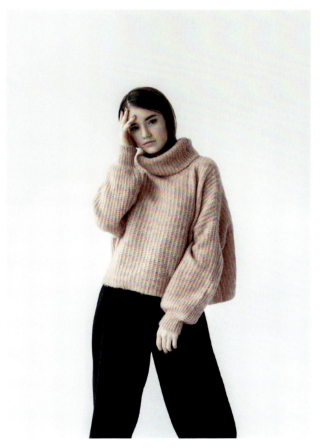

Hippie

In the 1960s and 1970s, people did not "dress up" as hippies, they adopted a way of life, a philosophy, that included music, some psychotropic substances, and a vision of the world that broke away from consumer society. All this was without taking themselves too seriously, because, above all, the hippie had to be cool. Hippie fashion was so iconoclast that you could not ignore it, especially in contrast to the conservative 1950s that preceded it. The style was a mix of utilitarian – to show solidarity with the working class – and psychedelic – embroidered ornaments that alluded to acid hallucinations. The hippie look was a funny anti-fashion, quite eclectic in style, as it blended motifs such as flower power, tie dye, African and Indian graphics in a joyful expression of pacifism and universal love. The trend leaned towards traditional textiles, such as linen, wool, cotton, crochet, and velvet, making hippies early pioneers in eco-responsible and sustainable consumption. They liked to buy their clothes from second-hand or surplus shops. Clogs and flip-flops were popular, but walking barefoot was even cooler. Last but not least, accessories such as headbands, coloured bead necklaces, and the inevitable peace symbols were de rigueur. After all, we can only be delighted to see the hippie style flourish again in an age as narrow-minded by populism and social media as ours.

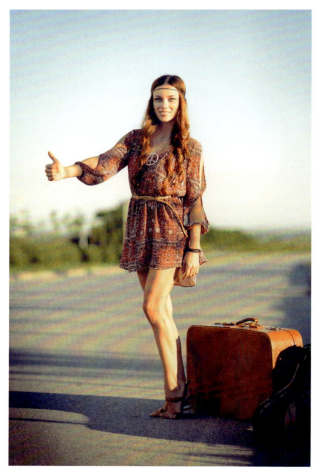

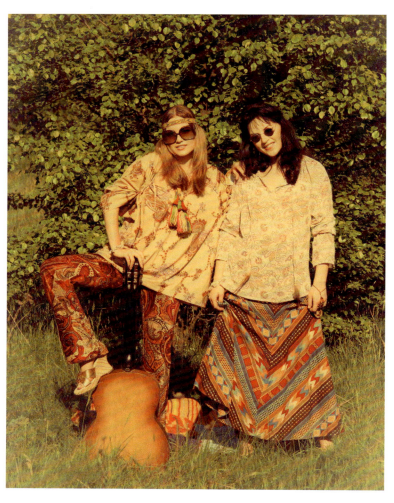

In den 1960er- und 1970er-Jahren „verkleideten" sich die Menschen nicht als Hippies, sondern nahmen eine Lebensphilosophie an, die Musik, einige psychotrope Substanzen und eine Weltanschauung umfasste, die sich von der Konsumgesellschaft absetzte. Und das alles, ohne sich selbst zu ernst zu nehmen, denn als Hippie musste man vor allem cool sein. Die Hippiemode war so ikonoklastisch, dass man sie nicht ignorieren konnte, besonders weil sie einen Kontrast zur konservativen Mode der 1950er-Jahre, die ihr vorausging, bildete. Der Stil war eine Mischung aus Praktikabilität als Zeichen der Solidarität mit der Arbeiterklasse und Psychedelik in Form von bestickten Ornamenten, die an durch LSD hervorgerufene Halluzinationen erinnerten. Der Hippielook war eine witzige Anti-Mode mit einem ziemlich eklektischen Stil, da er Flower-Power und *Tie-Dye*-Motive sowie afrikanische und indianische Grafiken in einem fröhlichen Ausdruck von Pazifismus und universeller Liebe vermischte. Der Trend ging zu traditionellen Textilien wie Leinen, Wolle, Baumwolle, Gehäkeltes und Samt und machte die Hippies zu frühen Vorreitern eines umweltbewussten und nachhaltigen Konsums. Sie kauften ihre Kleidung gerne in Secondhand- oder Restpostenläden. Clogs und Flipflops waren beliebt, aber barfuß zu laufen, war noch cooler. Und nicht umsonst waren Accessoires wie Stirnbänder, bunte Perlenketten und die obligatorischen Friedenssymbole unverzichtbar. Schließlich können wir uns nur darüber freuen, dass der *Hippie Style* in einer von Populismus und sozialen Medien geprägten Zeit wie der unseren wieder aufblüht.

Hippie

Boyfriend

Coco Chanel often borrowed men's clothes from her lovers and male friends. This allowed her to test shapes and materials, and then integrate them into her designs for the woman's wardrobe. In a famous photograph, she is seen wearing the tweed jacket of the Duke of Westminster, with whom she had a long-lasting affair, and this inspired her to use tweed for her iconic suit. Chanel's habit could also qualify her as being the inventor of the boyfriend style, which consists of choosing articles of your boyfriend's clothes and appropriating them to achieve a slightly boyish or androgynous look. Two Hollywood film icons, Marilyn Monroe and Grace Kelly, donned men's jeans on screen as early as the beginning of the 1950s. Boyfriend jeans have remained the most common style piece, although jackets, t-shirts, and shirts have joined them in the boyfriend panoply – mannish jackets were hot in the 1980s, for example. Although ready-to-wear clothing is becoming increasingly unisex, the boyfriend style has been a constant for the last ten years, not so much as a claim for equal status, but more as a play on the codes that define masculine and feminine.

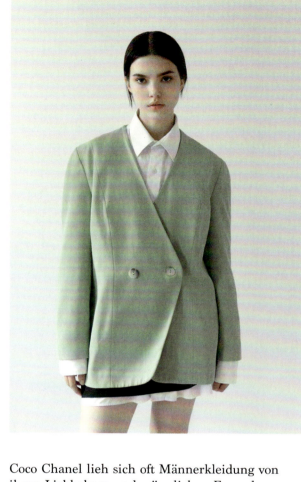

Coco Chanel lieh sich oft Männerkleidung von ihren Liebhabern und männlichen Freunden. So konnte sie Formen und Materialien testen und in ihre Entwürfe für Damenmode einfließen lassen. Auf einem berühmten Foto ist sie in der Tweedjacke des Herzogs von Westminster zu sehen, mit dem sie eine lange Affäre hatte, was sie zu ihrem ikonischen Tweedkostüm inspirierte. Chanels Angewohnheit könnte sie auch als Erfinderin des *Boyfriend Style* qualifizieren, der dadurch gekennzeichnet ist, Kleidungsstücke des Freundes zu nehmen und sich anzueignen, um einen leicht jungenhaften oder androgynen Look zu kreieren. Die Hollywood-Ikonen Marilyn Monroe und Grace Kelly trugen bereits Anfang der 1950er-Jahre Herrenjeans auf der Leinwand. *Boyfriend Jeans* sind nach wie vor das am häufigsten getragene Kleidungsstück, obwohl auch Jacken, T-Shirts und Hemden inzwischen zu dem Stil gehören. In den 1980er-Jahren waren zum Beispiel Männerjacken angesagt. Obwohl die Konfektionskleidung zunehmend unisex wird, ist der *Boyfriend Style* seit zehn Jahren konstant beliebt. Er ist nicht so sehr als Forderung nach Gleichberechtigung zu verstehen, sondern eher als Spiel mit den Codes, die männlich und weiblich definieren.

Boyfriend

Athleisure

The term "athleisure" was coined in March 1979 in an article of the *Nation's Business* magazine to describe the growing influence of sportswear in leisurewear – it was an interesting contraction of two words depicting contrasting activities – athletics and leisure. The coinage of the word also marked one hundred years of innovation in sportswear and its full acceptance as a component of ready-to-wear fashion. Nowadays, no one thinks of polo shirts, sneakers or tracksuit jackets as strictly sportswear anymore, quite the opposite, they are part of everyday casual wear. While fashion trends come and go, athleisure has never actually gone out of fashion over the last 50 years, but instead it has constantly crossed new thresholds of popularity thanks to numerous innovations in design, material, and style. The global athleisure market size was valued at a whopping US$ 306.62 billion in 2021[11] and is expected to continue expanding at a fast pace over the coming years. High-tech fibres and increasing comfort are now the hallmarks of athleisure clothing, which builds on two strong phenomena: the cult of the body and the aspiration for optimal cosiness.

Always comfy

Gemütlich zu jeder Zeit

Styles and trends / Stile und Trends

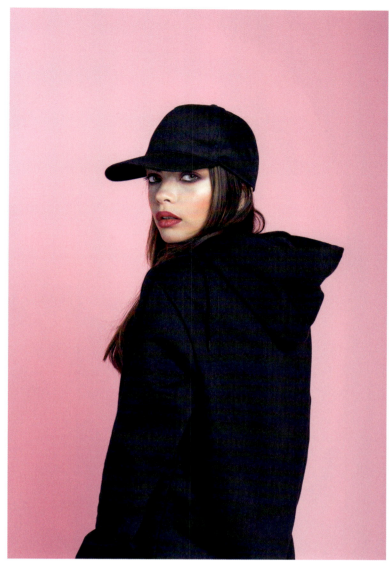

Der Begriff *Athleisure* wurde im März 1979 in einem Artikel des Magazins *Nation's Business* geprägt, um den wachsenden Einfluss der Sportbekleidung auf die Freizeitbekleidung zu beschreiben. Er stellt eine interessante Verbindung zweier Wörter dar, die gegensätzliche Aktivitäten beschreiben: *Athletics* und *Leisure*, also Athletik und Freizeit. Die Prägung des Wortes markiert auch einhundert Jahre voller Innovationen in der Sportbekleidung und ihre Akzeptanz als Bestandteil der Konfektionsmode. Poloshirts, Turnschuhe und Trainingsjacken gelten heute nicht mehr als reine Sportbekleidung, sondern sind Teil der Alltagskleidung geworden. Während Modetrends kommen und gehen, ist *Athleisure* in den letzten 50 Jahren nie wirklich aus der Mode gekommen, sondern ist dank zahlreicher Innovationen in Bezug auf Design, Material und Stil immer beliebter geworden. Die Größe des globalen *Athleisure*-Markts wurde 2021 auf satte 306,62 Milliarden US-Dollar geschätzt und es wird erwartet, dass er in den kommenden Jahren weiter rasant wachsen wird. Hightechfasern und zunehmender Komfort sind heute die Markenzeichen der *Athleisure*-Bekleidung, die auf zwei Phänomenen aufbaut: dem Körperkult und dem Streben nach optimaler Behaglichkeit.

Athleisure

Materials and handicrafts

9

Stoffe und Handarbeiten

Crochet

The millennials' fondness for handicrafts and slow fashion has led to the recent revival of crochet both as a hobby and as a fabric for summer clothing. Once popular in the 1970s, crochet had fallen into oblivion and had been seen primarily in lovingly crocheted baby clothes. Much stronger than lace, the crochet technique allows for the creation of lightweight garments and original patterns, with the added advantage that handmade crochet clothing is also environmentally friendly. Nicely sophisticated and with a lovely bohemian feel, it carries on an ancient tradition that derived from knitting. You can create almost anything with crochet: bucket hats, dresses, tops, shorts, beachwear, even handbags or blankets. Any colour choice or combination is permitted, from strictly monochrome to joyfully multicoloured elements.

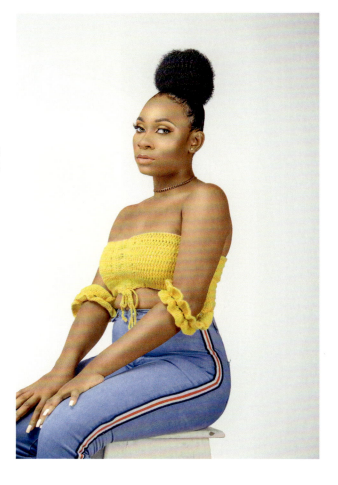

Materials and handicrafts / Stoffe und Handarbeiten

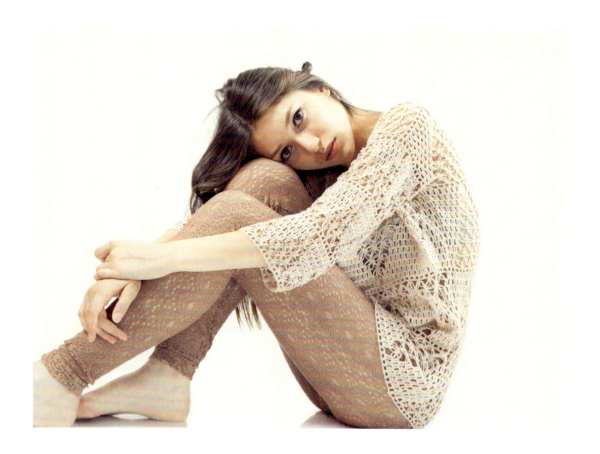

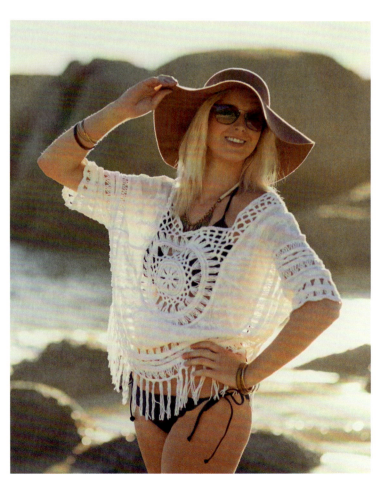

Die Vorliebe der Millennials für Handarbeit und Slow Fashion hat dazu geführt, dass Häkeln in letzter Zeit als Hobby wiederbelebt und auch Gehäkeltes für Sommerkleidung immer beliebter wurde. Häkeln war einst in den 1970er-Jahren populär, geriet dann aber in Vergessenheit und wurde fast nur noch für liebevoll gestaltete Babykleidung genutzt. Häkelmaterialien sind viel stabiler als Spitze. Außerdem kann man damit leichte Kleidungsstücke und originelle Muster herstellen. Der Herstellungsprozess bietet zudem den Vorteil, dass handgehäkelte Kleidung umweltfreundlich ist. Solche Teile sehen sehr raffiniert aus, versprühen ein angenehmes Boho-Flair und führen eine alte Tradition fort, die vom Stricken herrührt. Man kann fast alles häkeln: Hüte, Kleider, Oberteile, Shorts, Strandbekleidung und sogar Handtaschen und Decken. Jede Farbauswahl bzw. -kombination ist erlaubt – von einfarbig bis knallbunt.

Häkelstoffe

Knitwear

While crochet is a perfect summer textile, knitwear is mainly associated with cooler days of autumn. Over the past few seasons, knitted wool has been making a comeback on the catwalks in the wake of vintage trends and environmental concerns. Fashion designers and fashionistas are rediscovering the comfy-chic look that a knitted polo dress or cardigan provides to their wearers. Organic wools not only bring warmth, but their elegant, muted hues enhance every skin complexion. To add a little bit of fantasy and fun, patterns can be woven into the knit or embroidered onto it – geometric shapes, floral ornaments, animals – can decorate a jumper, a cardigan, or a sweater vest.

Embracing authentic, natural materials

Für alle, die authentische und natürliche Stoffe bevorzugen

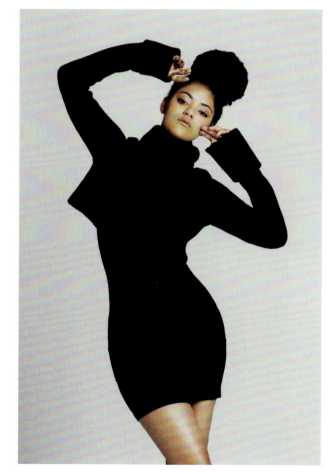

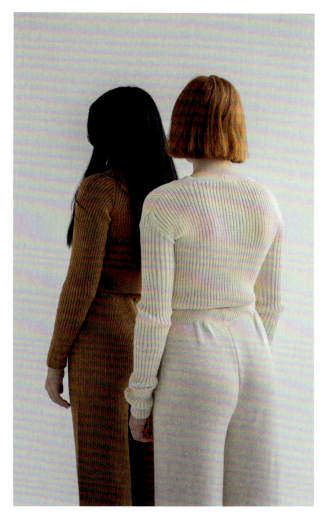
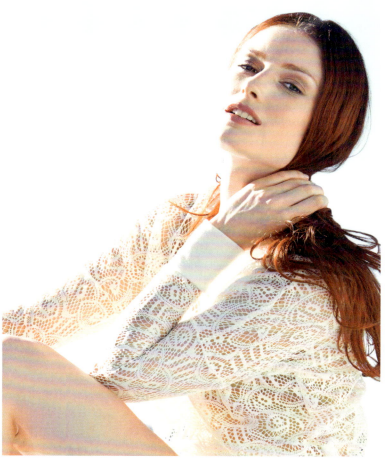

Während Gehäkeltes perfekt für die Sommergarderobe ist, wird Strick hauptsächlich mit den kühleren Herbsttagen in Verbindung gebracht. In den letzten Saisons ist Strickwolle im Zuge von Vintage-Trends und Umweltbewusstsein ein Comeback auf die Laufstege gelungen. Modedesigner und Fashionistas entdecken den bequemen und zugleich schicken Look wieder, den ein gestricktes Polokleid oder ein Cardigan seinen Trägern verleiht. Bio-Wolle spendet nicht nur Wärme, sie unterstreicht mit ihren eleganten, gedeckten Farbtönen auch jeden Hautton. Für ein bisschen Fantasie und Spaß können Muster in den Strick eingewebt oder aufgestickt werden. So können geometrische Formen, florale Ornamente oder Tiere Pullover, Strickjacken und Pullunder zieren.

Strickstoffe

Denim

From the heavy-duty workwear devised by Jacob Davis and Levi Strauss in 1853, denim trousers have conquered the world and all ages. Denim jeans are so ubiquitous that it is hard to believe that they were banned from schools in the 1950s because they were linked to Jim Stark's character played by James Dean in *Rebel without a Cause*. Stark's insurgent look included a pair of Lee 101Z Rider denim jeans, which became a fashion staple for the younger generation of the time. By the 1960s, jeans had become the uniform of the counterculture, and wearing a denim jacket, blouse, or skirt was cool. In 1976, Calvin Klein was the first fashion designer to put denim garments on the runway. Oddly enough, although originally worn by the working class, denim was disliked by the authorities in the Soviet Union until the mid-1980s, because it represented Western decadence in the eyes of the communist regime. Jeans were among the most sought-after items on the black market. A very versatile fabric, denim has easily adapted to our viral culture by offering new weaves and colours. The latest fashion is for cuffed, patchwork, or two-toned jeans, with embroidered patterns on the fabric.

You can never own too much denim

Man kann nie zu viel Denim besitzen

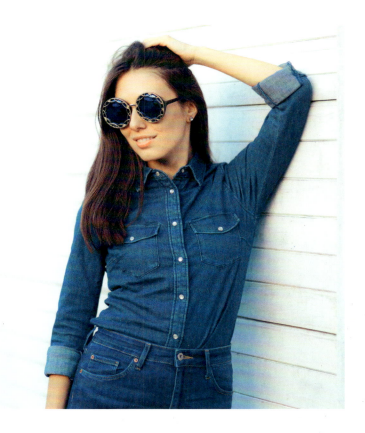

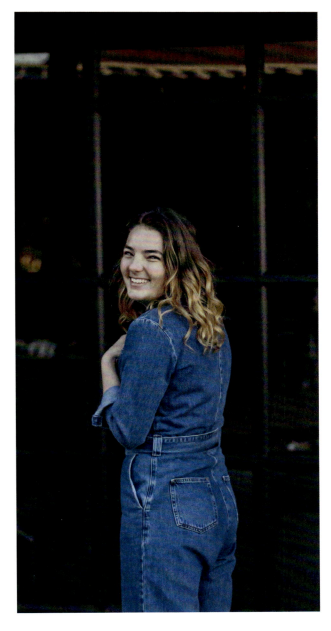

Jeanshosen haben die Welt erobert und alle Trends überdauert, nachdem die strapazierfähige Arbeitsbekleidung 1853 von Jacob Davis und Levi Strauss erfunden wurde. Denimjeans sind so allgegenwärtig, dass es kaum zu glauben ist, dass sie in den 1950er-Jahren in Schulen verboten waren, weil sie mit der Figur des Jim Stark in Verbindung gebracht wurden, der von James Dean in ... *denn sie wissen nicht, was sie tun* gespielt wurde. Zu Starks aufrührerischem Look gehörte eine Lee 101Z Rider Denimjeans, die die junge Generation der damaligen Zeit unbedingt haben musste. In den 1960er-Jahren waren Jeans zur Uniform der Gegenkultur geworden und das Tragen einer Jacke, einer Bluse oder eines Rocks aus Denim war cool. Calvin Klein war der erste Modedesigner, der 1976 Jeanskleidung auf den Laufsteg brachte. Obwohl Jeans ursprünglich von der Arbeiterklasse getragen wurden, waren sie merkwürdigerweise bis Mitte der 1980er-Jahre bei den Behörden der Sowjetunion unbeliebt, da sie in den Augen des kommunistischen Regimes für westliche Dekadenz standen. Jeans gehörten in den Ländern des Ostblocks zu den begehrtesten Waren auf dem Schwarzmarkt. Denim ist ein sehr vielseitiger Stoff, der sich dank neuer Webarten und Farben leicht an unsere virale Kultur anpassen ließ. Aktuell liegen Jeans mit Bündchen oder Patchwork sowie zweifarbige Jeanshosen mit aufgestickten Mustern im Trend.

Denimstoffe

Patterns

10

Muster

Flower Power

The flower power pattern is as much associated with the 1960s as the hippies, The Beatles, Martin Luther King, Woodstock, psychotic substances, songs by Joan Baez and Jane Birkin, miniskirts, bell-bottom pants, or the peace sign. It is a memento of a lost utopia and the symbol of yearning for a peaceful, non-violent world that still resonates today. The floral pattern was an expression of the rebellious romanticism of the time: wearing a garment with a flower power motif was a political statement and a pledge to a future in harmony with nature. Flowers were on kaftan dresses, on cheese-cloth blouses, were worn in the hair, on t-shirts, on scarves and trousers, on mini dresses, all storming the urban spaces with bright psychedelic colours. The taste for floral patterns outlived the 1960s and the golden age of the hippie subculture for more than twenty years through the printed cotton dresses designed by Laura Ashley. The recent revival of the flower power pattern and craze for the daisy print have been called a *new boho* era by some fashion experts.

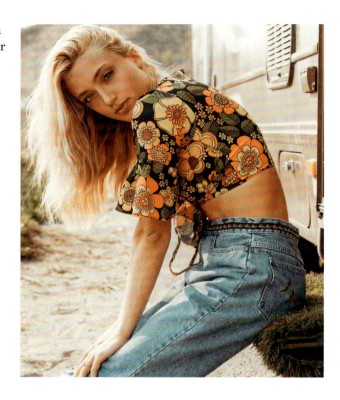

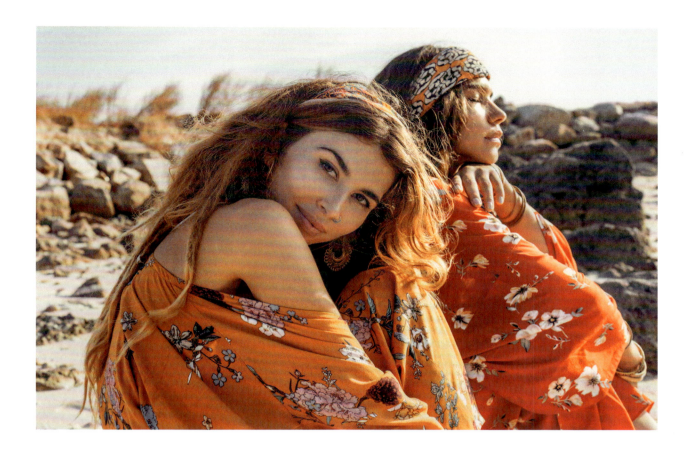

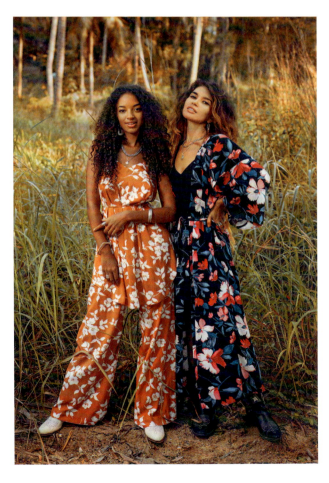

Das Flower-Power-Muster wird ebenso mit den 1960er-Jahren assoziiert wie die Hippies, die Beatles, Martin Luther King, Woodstock, halluzinogene Substanzen, Lieder von Joan Baez und Jane Birkin, Miniröcke, Schlaghosen und das Friedenszeichen. Das Muster erinnert an eine verlorene Utopie und steht symbolisch für die Sehnsucht nach einer friedlichen, gewaltfreien Welt, die auch heute noch nachhallt. Das Blumenmuster war Ausdruck der rebellischen Romantik jener Zeit: Das Tragen eines Kleidungsstücks mit Flower-Power-Motiv war ein politisches Statement und ein Bekenntnis zu einer Zukunft im Einklang mit der Natur. Blumen waren auf Kaftankleidern, Blusen aus Seihtuch, T-Shirts, Schals, Hosen und Minikleidern sowie im Haar zu sehen und verbreiteten sich in leuchtenden, psychedelischen Farben unaufhörlich in den Städten. Die Vorliebe für Blumenmuster überdauerte die 1960er-Jahre und das goldene Zeitalter der Hippie-Subkultur um mehr als zwanzig Jahre durch die von Laura Ashley entworfenen Kleider aus bedruckter Baumwolle. Die jüngste Wiederbelebung des Flower-Power-Musters und die Begeisterung für den Gänseblümchen-Print werden von einigen Modeexperten als neue Boho-Epoche bezeichnet.

Flower-Power

Plaid

Originally deriving from the tartan patterns of the Scottish clans, the plaid pattern has been through so many fashion trends and styles in the 20th century that we take it for granted. An essential element of the hipster dress code nowadays, the plaid motif has repeatedly switched social class over the past hundred years. It established itself in the 1920s as the lumberjack garment by definition, before a flannel variant appealed to the country gentry in the 1930s. In the 1970s, punks appropriated Queen Elizabeth II's favourite plaid pattern to subvert it and turn it into the banner of their revolt against society, aided and abetted by designers such as Vivienne Westwood. This did not deter preppy style fans from taking the pattern over in the 1980s, which saw very fashionable plaid dresses, skirts, and trousers, some worn by Lady Diana. After this bourgeois interlude, the plaid pattern returned to the rebel side in the 1990s with the grunge style. While the plaid shirt looks clearly hipster, there's nothing to stop you from wearing other pieces of clothing with plaid patterns to complement your casual or formal outfits.

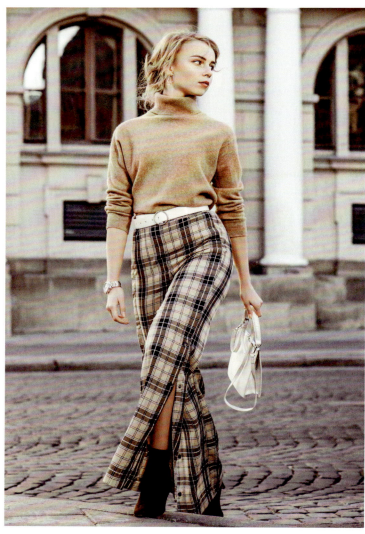

The pattern that suits all styles

Das Muster, das zu allen Stilen passt

Das Karomuster, das ursprünglich von den Mustern der schottischen Clans stammt, hat im 20. Jahrhundert so viele Modetrends und -stile durchlaufen, dass wir es für selbstverständlich halten. Das Karomuster, das heute ein wesentlicher Bestandteil der Garderobe von Hipstern ist, hat in den letzten hundert Jahren immer wieder die Gesellschaftsschichten gewechselt. In den 1920er-Jahren etablierte es sich per Definition als Kleidungsstück für Holzfäller, bevor eine Flanellvariante in den 1930er-Jahren die Landbevölkerung ansprach. In den 1970er-Jahren eigneten sich Punks das Lieblingskaro von Königin Elisabeth II. an, um es zu unterwandern und zum Banner ihrer Revolte gegen die Gesellschaft zu machen, wobei sie von Designern wie Vivienne Westwood tatkräftig unterstützt wurden.
Dies hielt die Fans des *Preppy Style* nicht davon ab, das Muster in den 1980er-Jahren zu übernehmen, als sehr modisch-karierte Kleider, Röcke und Hosen entstanden, die auch von Lady Diana getragen wurden. Nach diesem bürgerlichen Intermezzo kehrte das Karomuster in den 1990er-Jahren mit dem *Grunge Style* auf die Seite der Rebellen zurück. Das karierte Hemd sieht zwar eindeutig nach Hipster aus, aber es spricht nichts dagegen, auch andere Kleidungsstücke mit Karomuster zu tragen, um Ihre Freizeitlooks oder formellen Outfits abzurunden.

Karos

Leopard spots

The idea that felinity and femininity are linked is as old as the goddesses Bastet and Sekhmet of ancient Egypt, who were depicted with lioness faces and female bodies. Seshat, the goddess of wisdom, was represented wearing a leopard skin, as were several royal princesses. The analogy between feminine grace and feline beauty has survived the centuries, even if it may sound like an overused cliché today. While real leopard skin coats or toques have always been an unaffordable luxury, the introduction of fabrics inspired by the feline's spots, credited to Christian Dior in 1947, has democratised the look. In the 1950s and early 1960s, leopard spots were everywhere: from Bettie Page's sexy underwear to Joan Collins' coat and Gina Lollobrigida's dresses. After a relative eclipse in the 1980s, it resurfaced in the following decade: "From the Spice Girls and Lil Kim to Naomi Campbell and Kate Moss in Alaïa, the naughty nineties embraced the print in both tasteful and trashy realms"[12], noted fashion journalist Poppy Cory-Wright. In the early 2020s, you can easily dress in leopard spots from head to toe: from the underwear to the coat and from rubber boots to caps, no piece of clothing escapes the feline style. People such as Michelle Obama, Anna Wintour, and Beyoncé have endorsed this perennially popular pattern. It is all you need to look fierce and feminine at once.

Patterns / Muster

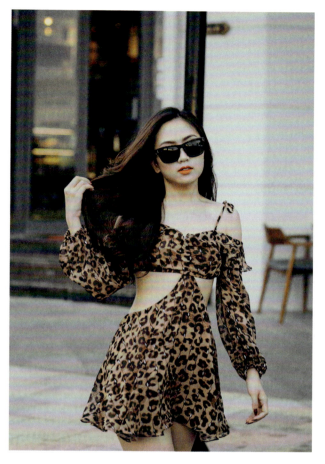
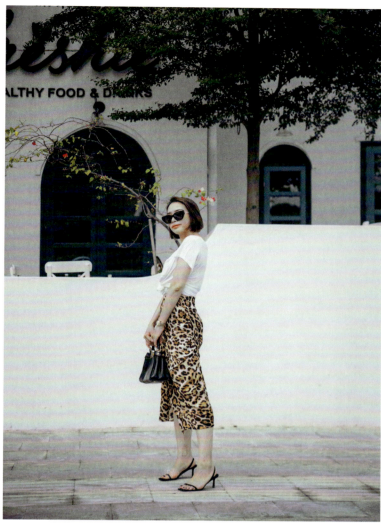

Die Vorstellung, dass Felinität und Femininität miteinander verbunden sind, ist so alt wie die Göttinnen Bastet und Sekhmet im alten Ägypten, die mit Löwinnengesichtern und weiblichen Körpern dargestellt wurden. Seshat, die Göttin der Weisheit, wurde in einem Leopardenfell abgebildet, ebenso wie mehrere königliche Prinzessinnen. Die Analogie zwischen weiblicher Anmut und katzenhafter Schönheit hat die Jahrhunderte überdauert, auch wenn sie heute wie ein überstrapaziertes Klischee wirken mag. Während echte Leopardenfellmäntel und -mützen schon immer ein unerschwinglicher Luxus waren, wurde der Look durch die Einführung von Stoffen demokratisiert, die von den Flecken der Katze inspiriert sind und Christian Dior für das Jahr 1947 zugeschrieben werden. In den 1950er- und frühen 1960er-Jahren waren Leopardenflecken allgegenwärtig: von der sexy Unterwäsche von Bettie Page über den Mantel von Joan Collins bis hin zu den Kleidern von Gina Lollobrigida. Nachdem sie in den 1980er-Jahren relativ in den Hintergrund getreten waren, tauchten sie im folgenden Jahrzehnt wieder auf: „Von den Spice Girls und Lil' Kim bis hin zu Naomi Campbell und Kate Moss in Alaïa – in den frechen Neunzigern wurde der Print sowohl in geschmackvollen als auch in trashigen Bereichen eingesetzt"[12], so die Modejournalistin Poppy Cory-Wright. In den frühen 2020er-Jahren kann man sich kinderleicht von Kopf bis Fuß im Leopardenmuster kleiden: von der Unterwäsche bis zum Mantel und von den Gummistiefeln bis zur Mütze – kein Kleidungsstück entkommt dem katzenhaften Look. Persönlichkeiten wie Michelle Obama, Anna Wintour und Beyoncé haben sich für dieses immer wieder beliebte Muster ausgesprochen. Um wild und feminin zugleich auszusehen, brauchen Sie nicht mehr.

Leopardenflecken

Polka dots

In the 1840s, the polka, a fast-paced dance originating in Bohemia, conquered the ballrooms of the western world. The craze lasted for almost half a century and led to the creation of an ornamental pattern made of coloured dots, which was called after the dance. The most plausible explanation for this name is that the dots, when a dress was in motion, looked as if they were dancing the polka. Polka dots add a touch of fun and youthful spirit to the garment. They draw the eye with a hypnotic effect reminiscent of an optical illusion, allowing the wearer to stand out from the crowd. This quality probably prompted Coco Chanel to bring the pattern into the spotlight in the 1920s. One of the first celebrities to wear a polka-dot dress was, strangely enough, a mouse: in 1928, Walt Disney dressed Minnie Mouse in a red dress with white polka dots and a matching headband, thus emphasizing her "girlish" look. Other Hollywood divas followed suit: Marilyn Monroe, Katharine Hepburn, and Liz Taylor, while some of the greatest post-war fashion designers, such as Christian Dior and Cristóbal Balenciaga, made them one of their signature patterns. In the 1970s, the polka dots were enlarged and turned into psychedelic elements, as befit the time. The recent vintage trend has brought this pattern back to the forefront and it now extends to everything from shoes to glasses frames.

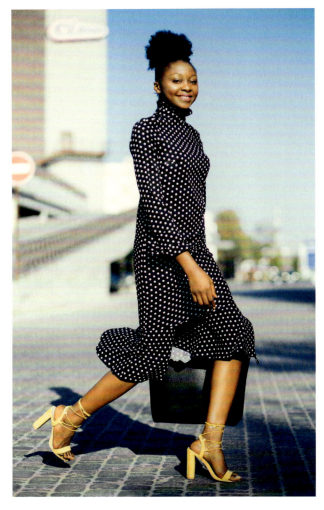

Small or big, polka dots are always a favourite

Wenn Sie Freude vermitteln wollen, tragen Sie Polka-Dots

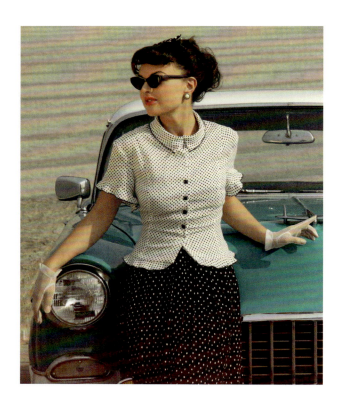

Patterns / Muster

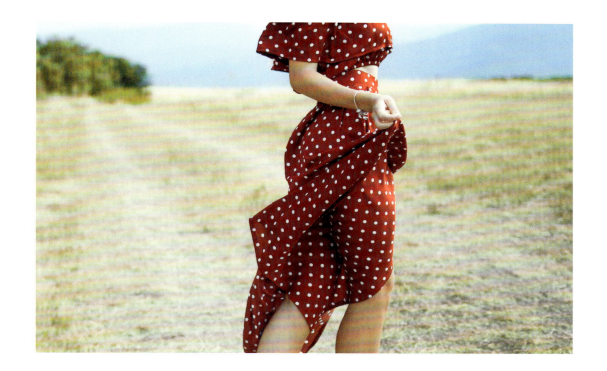

In den 1840er-Jahren eroberte die Polka, ein aus Böhmen stammender schneller Tanz, die Ballsäle der westlichen Welt. Die Begeisterung hielt fast ein halbes Jahrhundert lang an und führte zur Gestaltung eines ornamentalen Musters aus farbigen Punkten, das nach dem Tanz benannt wurde. Die plausibelste Erklärung für diesen Namen ist, dass die Punkte, wenn sie in Bewegung waren, aussahen, als würden sie Polka tanzen. Die Tupfen verleihen einem Kleidungsstück einen Hauch von Spaß und jugendlichem Elan. Sie ziehen das Auge mit einem hypnotisierenden Effekt an, der an eine optische Täuschung erinnert, und lassen die Trägerin aus der Masse herausstechen. Diese Eigenschaft veranlasste Coco Chanel wahrscheinlich dazu, das Muster in den 1920er-Jahren ins Rampenlicht zu rücken. Eine der ersten Berühmtheiten, die ein gepunktetes Kleid trugen, war merkwürdigerweise eine Maus: 1928 kleidete Walt Disney Minnie Mouse in ein rotes Kleid mit weißen Punkten und einem passenden Stirnband und betonte damit ihr „mädchenhaftes" Aussehen. Andere Hollywood-Diven wie Marilyn Monroe, Katharine Hepburn und Liz Taylor folgten diesem Beispiel, während einige der größten Modeschöpfer der Nachkriegszeit wie Christian Dior und Cristóbal Balenciaga es zu einem ihrer typischen Muster machten. In den 1970er-Jahren wurden die Polka-Dots vergrößert und entsprechend der Zeit in psychedelische Elemente verwandelt. Der jüngste Vintage-Trend hat dieses Punktemuster wieder in den Vordergrund gerückt und erstreckt sich nun auf alles – von Schuhen bis zu Brillengestellen.

Polka-Dots

Paisley

Classic and bohemian at once, the paisley motif has its history rooted in the steppes of Central Asia. In the Zoroastrian culture, around the 6th century BCE, the droplet-shaped ornament represented seeds of the tree of life. This association with a symbol of eternity and fertility certainly contributed to its widespread popularity. It was first brought to Europe in the 18th century on cashmere shawls and has fascinated generations ever since with its delicate yet flamboyant look: it was *fin de siècle* in the era of Oscar Wilde, and revolutionary during the hippie wave of the 1960s and 1970s. As Lindsay Baker, of BBC Style noted it, the paisley motif has "adorned the bandanas of cowboys and bikers, been adopted by the 19th century boho set, been popularised by The Beatles, ushered in the hippy era, and become an emblem of rock 'n' roll swagger and swank."[13] So, more than enough reasons for enjoying its lasting revival on dresses, blouses, skirts and even sneakers.

A pattern of sensual exuberance

Sinnlich und ausgelassen, klassisch und dennoch unkonventionell. Ein Muster voller Gegensätze

Das klassische und zugleich unkonventionelle Paisleymuster hat seine Wurzeln in den Steppen Zentralasiens. In der zoroastrischen Kultur (etwa um das 6. Jahrhundert v. Chr.) stellte das tropfenförmige Ornament die Samen des Lebensbaums dar. Diese Assoziation mit einem Symbol der Ewigkeit und der Fruchtbarkeit trug sicherlich zu seiner großen Beliebtheit bei. Es wurde erstmals im 18. Jahrhundert auf Kaschmirschals nach Europa gebracht und hat seither Generationen mit seinem zarten und zugleich extravaganten Look fasziniert: Es gehörte zum *Fin de Siècle* in der Ära von Oscar Wilde und galt als revolutionär während der Hippiewelle der 1960er- und 1970er-Jahre. Wie Lindsay Baker von *BBC Style* feststellte, hat das Paisleymotiv „die Halstücher von Cowboys und Bikern geschmückt, wurde von der Boho-Szene des 19. Jahrhunderts übernommen, von den Beatles populär gemacht, leitete die Hippieära ein und wurde zu einem Symbol der Angeberei und Protzerei des Rock 'n' Roll"[13]. Mehr als genug Gründe also, sich an seinem dauerhaften Revival auf Kleidern, Blusen, Röcken und sogar Sneakers zu erfreuen.

Paisley

Houndstooth

Just like the plaid motif, the houndstooth pattern first appeared in Scotland, however much later than the former – in the 1880s – and in the Lowlands, whereas the tartan is traditionally linked to the Highland clans. It is composed of alternating bands of four white and four black threads that form irregular checks. This structure gives the fabric a dynamic look, similar to an optical effect called "motion illusion". The pattern was initially exclusive to men's suits and coats before Coco Chanel and later Christian Dior adopted it and made it a chic and timeless pattern in women's fashion. Nowadays, it is a favourite of Lady Gaga, Gwen Stefani and Beyoncé, among many other celebrities.

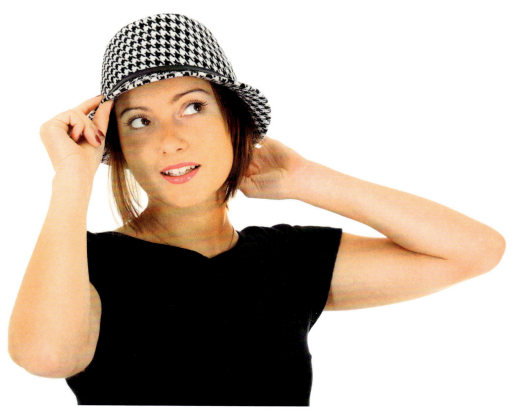

Patterns / Muster

The two-toned textile pattern that comes back again and again

Das zweifarbige Textilmuster, das alle Comeback-Rekorde bricht

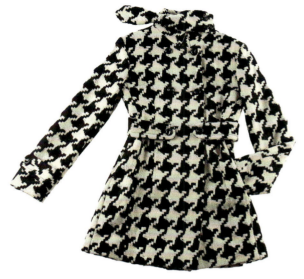

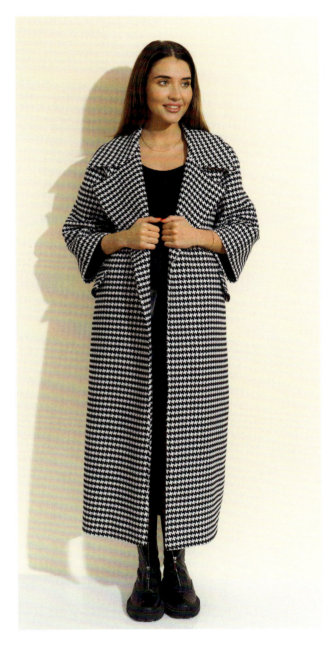

Wie das Karomuster tauchte auch das Hahnentrittmuster erstmals in Schottland auf, allerdings viel später als ersteres – nämlich in den 1880er-Jahren und noch dazu in den Lowlands, während der Tartan traditionell zu den Highland-Clans gehört. Das Muster besteht aus abwechselnden Bändern aus vier weißen und vier schwarzen Fäden, die unregelmäßige Karos bilden. Diese Struktur verleiht dem Stoff ein dynamisches Aussehen, ähnlich einem optischen Effekt, der als „Bewegungsillusion" bezeichnet wird. Das Muster war zunächst ausschließlich für Herrenanzüge und -mäntel vorgesehen, bevor Coco Chanel und später Christian Dior es übernahmen und als schickes und zeitloses Muster für Damenmode nutzen. Heutzutage ist es beliebt bei Lady Gaga, Gwen Stefani, Beyoncé und vielen anderen berühmten Personen.

Hahnentritt

Geometric patterns

In addition to polka dots and houndstooth, other geometric patterns regularly come back into fashion. Chevrons, checkerboard, colour-block stripes, patchwork-like motifs, and diamond shaped ornaments are among the best known. The cocktail dress designed by Yves Saint-Laurent in 1965 as a tribute to Piet Mondrian has been revisited and reinterpreted many times. In the same spirit, the psychedelic swirls of the 1970s have returned to popularity in streetwear. They enhance outfits with bright, contrasting colours and magnificent graphic interlacing.

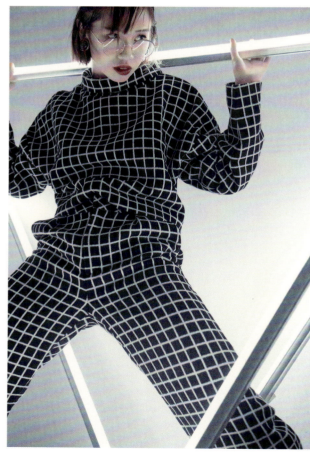

From simple to complex, the universe of geometric patterns is limitless

Von einfach bis komplex, das Universum der geometrischen Muster ist grenzenlos

Neben Polka-Dots und Hahnentritt kommen auch andere geometrische Muster regelmäßig wieder in Mode. Zu den bekanntesten gehören Fischgrät- und Schachbrettmuster, Farbblockstreifen, patchworkartige Motive und rautenförmige Ornamente. Das Cocktailkleid, das Yves Saint-Laurent 1965 als Hommage an Piet Mondrian entwarf, wurde immer wieder aufgegriffen und neu interpretiert. In diesem Sinne sind auch die psychedelischen Wirbel der 1970er-Jahre in der Streetwear wieder populär geworden. Sie werten das Outfit mit leuchtenden, kontrastreichen Farben und großartigen grafischen Verflechtungen auf.

Geometrische Formen

Thinking about sustainability? Here are some tips

When buying a garment today, it is important to consider not only the way it was produced, but also the carbon footprint generated by the manufacturing and logistic activities involved. Locally produced clothes (within a country or continent) can be a good option because they will not have travelled halfway around the world before being sold and are often manufactured using traditional, high-quality techniques. Even small-scale manufacturers will have a website where they present the garments and accessories they sell. You might pay a bit more than on high-street fashion shops run by international groups, but sometimes it makes sense to spend a little more to buy clothes made from natural, environmentally friendly, quality textiles that will last. As they will last longer, you can – and should – hold on to them when they go out of fashion, because, as this book shows, iconic garments of a given era come back, in a slightly different form, after a decade or two.

Second-hand clothes are another good solution if you want to expand your wardrobe without breaking the bank. While you may not be able to find all the original garments and accessories mentioned in this book in your mother's, aunts', great-aunts' and grandmothers' wardrobes, with regular visits to second-hand clothes or charity shops you may be able to pick-up some gems from the past decades. It's a game of patience, both in terms of garment types and sizes, but you'll have the advantage of owning pieces with a history and, while they might have light wear marks, are authentic.

Using your creative skills, you can also crochet or knit dresses or jumpers in the style you want. If you know your way around a sewing machine, you can sew or alter garments to suit your taste: a t-shirt with wear holes in the bottom can be cut to make a crop top (unless you keep it so to create a grunge look). Also consider personalizing clothing by embroidering designs such as flowers on a pair of jeans to add a little flower power.

According to a survey by the World Economic Forum, the fashion industry "produces 10% of all humanity's carbon emissions (more than all international flights and maritime shipping combined) and is the second-largest consumer of the world's water supply"[14]. The same study points out that "while people bought 60% more garments in 2014 than in 2000, they only kept the clothes for half as long." Reason enough to start considering what we can do to reuse and recycle our clothes and contribute to reducing the fashion industry's impact on natural resources.

Wie kann ich Mode mit Nachhaltigkeit verbinden?

Wenn man heute ein Kleidungsstück kauft, ist es wichtig, nicht nur auf die Art der Herstellung zu achten, sondern auch auf den CO_2-Fußabdruck, der durch die Herstellung und die gesamte Logistik entsteht. Lokal produzierte Kleidung (innerhalb eines Landes oder Kontinents) kann eine gute Option sein, da sie nicht um die halbe Welt gereist ist, bevor sie verkauft wird, und häufig mit traditionellen Techniken in hoher Qualität hergestellt wird. Selbst kleine Hersteller verfügen über eine Website, auf der sie die von ihnen verkauften Kleidungsstücke und Accessoires präsentieren. Sie zahlen vielleicht etwas mehr als in den von internationalen Konzernen betriebenen Modegeschäften, aber manchmal zahlt es sich aus, etwas mehr auszugeben, um Kleidung aus natürlichen, umweltfreundlichen und hochwertigen Textilien zu kaufen, die lange hält. Da die Kleidungsstücke länger halten, kann – und sollte – man an ihnen festhalten, wenn sie aus der Mode kommen, denn solche ikonischen Stücke einer bestimmten Epoche kommen nach ein oder zwei Jahrzehnten in leicht veränderter Form wieder auf – wie dieses Buch zeigt.

Secondhandkleidung ist eine weitere gute Möglichkeit, wenn Sie Ihre Garderobe erweitern, aber dabei nicht das Budget sprengen wollen. Auch wenn Sie in den Kleiderschränken Ihrer Mutter, Tanten, Großtanten und Großmütter nicht alle in diesem Buch erwähnten Originalkleidungsstücke und -accessoires finden werden, können Sie bei regelmäßigen Besuchen in Secondhandläden oder Wohltätigkeitsgeschäften vielleicht ein paar „Sammlerstücke" aus den vergangenen Jahrzehnten finden. Das ist zwar ein Geduldsspiel, sowohl in Bezug auf die Art von Kleidung als auch auf die Größen, aber Sie haben dadurch den Vorteil, Kleidung mit einer Geschichte zu besitzen, die mitunter leichte Gebrauchsspuren aufweist, aber dafür authentisch ist.

Sie können auch selbst kreativ werden und sich Kleider oder Pullover in dem von Ihnen gewünschten Stil häkeln oder stricken. Wenn Sie mit der Bedienung einer Nähmaschine vertraut sind, können Sie Kleidungsstücke nach Ihrem Geschmack nähen oder abändern: Ein T-Shirt mit Löchern im unteren Bereich kann zu einem bauchfreien Top zugeschnitten werden (oder Sie lassen es so für den echten Grunge-Look). Sie können auch Ihre Kleidung personalisieren, indem Sie z. B. Blumen auf eine Jeans sticken, um ihr ein wenig Flower-Power zu verleihen.

Laut einer Studie des Weltwirtschaftsforums „verursacht die Modeindustrie 10 Prozent der Kohlenstoffemissionen der gesamten Menschheit (mehr als alle internationalen Flüge und die Schifffahrt zusammen) und ist der zweitgrößte Verbraucher von Wasser auf der Erde". Dieselbe Studie weist auch darauf hin, dass „die Menschen 2014 zwar 60 Prozent mehr Kleidung kauften als 2000, diese aber nur halb so lange behielten"[14]. Das sollte Grund genug für uns sein, darüber nachzudenken, wie wir unsere Kleidung wiederverwenden und recyceln können, um dazu beizutragen, die Auswirkungen der Modeindustrie auf die Umwelt zu verringern.

List of references / Quellenverzeichnis

Quotes
1: Gilles Lipovetsky, L'Empire de l'éphémère, folio essais, p. 65
2: Gilles Lipovetsky, L'Empire de l'éphémère, folio essais, p. 25
3: Interview on KPCC (Southern California Public Radio). https://www.kpcc.org/show/take-two/2014-01-10/diane-von-furstenbergs-iconic-wrap-dress-turns-40-photos
4: https://theminiskirtrevolution.wordpress.com/history-2/
5: https://www.vogue.fr/fashion/article/white-tank-top-trend
6: Sadie Hechkoff in CR Fashion Book. https://crfashionbook.com/fashion-a28355194-bodysuit-history/
7: https://edition.cnn.com/cnn-underscored/fashion/bike-shorts-fashion-for-summer
8: https://edition.cnn.com/cnn-underscored/fashion/bike-shorts-fashion-for-summer
9: https://www.vogue.fr/fashion/article/vogues-fashion-encyclopedia-the-jumpsuit
10: https://www.mrporter.com/en-de/journal/fashion/how-to-style-baggy-jeans-straight-leg-trousers-10656296
11: https://www.grandviewresearch.com/industry-analysis/athleisure-market
12: https://www.culturewhisper.com/r/fashion/history_of_leopard_print_in_fashion/11894
13: https://www.bbc.com/culture/article/20151021-paisley-behind-rocks-favourite-fashion
14: https://www.weforum.org/agenda/2020/01/fashion-industry-carbon-unsustainable-environment-pollution/

Acknowledgements / Danksagung

A big thank you to the entire team at teNeues, and in particular to Nadine Weinhold for her support and unfailing enthusiasm, which encouraged us in the writing and the layout of this gorgeous book. Our gratitude also goes to our English copyeditor, Lee Ripley, and to the German translator, Rebecca Rosenthal. Many thanks also to Elisabeth Clauss, who kindly contributed her extensive knowledge of fashion phenomena to this book, and to all those who provided pictures for this book, especially Florence Bellée of the Saint James brand.

Wir danken dem gesamten Team von teNeues, insbesondere Nadine Weinhold für ihre Unterstützung und ihren unermüdlichen Enthusiasmus, der uns beim Schreiben und Layouten dieses wunderschönen Buches angespornt hat. Unser Dank gilt auch unserer Englisch-Lektorin, Lee V. Ripley, und unserer Übersetzerin, Rebecca Rosenthal. Großer Dank gebührt ebenso Elisabeth Clauss, die freundlicherweise ihr umfangreiches Wissen über Modephänomene mit uns geteilt hat, und allen, die Bilder für dieses Buch zur Verfügung gestellt haben, insbesondere Florence Bellée von der Firma Saint James.

Photo Credits / Bildnachweis

p.: page/Seite, t: top/oben, b: bottom/unten, r: right/rechts, l: left/links

p. 2-3: © agcreativelab/Adobe; p. 8, p. 10: © Ganaëlle Glume, courtesy of Elisabeth Clauss; p. 12 Chalo Garcia/Unsplash; p. 14 t: © Engin Akyurt/Unsplash, b: © George Marks/iStock; p. 15 l: © Godisable Jacob/Pexels, r: © Marionel Luciano/Unsplash; p. 16 t: © Tom Kelley Archive/iStock, b: © Monika Silva/Unsplash; p. 17 t: ©Ridofranz/iStock, b: © PeopleImages/iStock; p. 18 t: © Angelo Pantazis/Unsplash, b: © Jun/iStock; p. 19 t: Alena Ozerova/Adobe, b: © Flávia Gava/Unsplash; p. 20 t: © SpaceCat/Adobe, b: © PepeLaguarda/iStock; p. 21 l: © triocean/iStock, r © Tarzhanova/iStock; p. 22 t: © James Lewis/Unsplash, b © Vanessa Serpas/Unsplash; p. 23 t: © Tamara Bellis/Unsplash, b: © Rendy Novantino/Unsplash; p. 24: © Julian Myles/Unsplash; p. 25: © Slaven Vlasic/Getty Images; p. 26: © Robert Linder/Unsplash; p. 27 l: © Sule Makaroglu/Unsplash, r: © Tam Nguyen/Unsplah; p. 28 t: © lisegagne/iStock, b: © Les Anderson/Unsplash; p. 29 t: © domoyega/iStock, b: © Giulio Fornasa/iStock; p. 30 t: © Stockbyte/iStock, b: © George Marks/iStock; p. 31 tl: © PeopleImages/iStock, tr: © Molina86/iStock, b: © a-wrangler/iStock; p. 32 t: © mtreasure/iStock, b: © SomeMeans/iStock; p. 33: © Anetlanda; p. 34 t: © Georges Marks/iStock, b: © Lea Kelley/Pexels, p. 35 t: © Maksim Goncharenok/Pexels, b: © Valeria Boltneva/Pexels; p. 36: © Nate Miles/Unsplash; p. 38 © t: © Mike Von/Unsplash, b: © Fitz/Adobe p. 39: © AzmanL/iStock, b: © Laura Chouette/Unsplash; p. 40 t: © Adene Sanchez/iStock, b: © ta-nya/iStock; p. 41 t: © mentatdgt/Pexels, b: © Wesley Carvalho/Pexels, p. 42: Casarsa/iStock © ; p. 43 t: © KoolShooters/Pexels, b: © Claire Rush/Unsplash; p. 44 l: © Peppersmint/iStock, r: © wanderluster/iStock; p. 45: © Alex_Utvoko/iStock; p. 46 t: © Stockbyte/iStock, b: © winjohn/iStock; p. 47 t: © vandervelden/iStock, b: © Viktor_Gladkov/iStock; p. 48 t: © Anwar Hussein/Getty Images, b: © Miya/Adobe; p. 49: © Bevis G/Unsplash; p. 50 t: © Tom Kelley Archive/iStock, b: © Image Source/iStock; p. 51 t: © Luca de Massis/Pexels, b: © Kermen Tutkunova/Unsplash; p. 52 t: © Lightfield Studios/Adobe, b: © Casarsa/iStock; p. 53 t: © Yaroslav Shuraev/Pexels, b: © Darina Belonogova/Pexels; p. 54: © George Marks/iStock; p. 55 t: © SolStock/iStock, b: © nicoletaionescu/iStock; p. 56: © LeChatNoir/iStock; p. 57 l: © simonkr/iStock, r: © Emmanuel Bior/Unsplash; p. 58: © Lightfield Studios/iStock; p. 60 t: © Jack Kay/Hulton Archive/Getty Images, b: © Tom Kelley Archive; p. 61 t: © tixti/iStock, b: © Snapeturemoments/Pexels; p. 62 © Edward Berthelot/iStock; p. 63 t: © Logan Delaney/Unsplash; b: © Nagy Arnold/Unsplash, p. 64 l: © pictures alliance, b: © Tom Kelley Archive/iStock; p. 65 l: © Laura Chouette/Unsplash, r: © Polke/iStock; p. 66 Victoria Chudinova/Adobe, p. 67 l: © Look!/Adobe, r: © Victoria Chudinova/Adobe; p. 68 t: © Engin Akyurt/Unsplash, b: © MSDB/CBS; p. 69 t: © Calvin Lupiya/Unsplash, b: © Joshua Rawson Harris/Unsplash; p. 70 © Keith Hamshere/Moviepix/Getty Images; p. 71 tl: © Michael Ochs Archives/Getty Images, tr: © Donald Gianatti/Unsplash, b: © CoffeeAndMilk/iStock; p. 72 ©: Mike Von/Unsplash; p. 73 t: © Christopher Campbell/Unsplash, b: © Mike Von/Unsplash; p. 74 t: © George Marks/iStock; b: © Olivia Leger/Unsplash; p. 75 l: © Andrew Neel/Unsplash, r: © Christopher Campbell/Unsplash; p. 76 t: © Anwar Hussein/Getty Images, b: © Tom Kelley Archive/iStock; p. 77 tl: © Vladimir Fedotov/Unsplash, tr: © 4FR/iStock, b: © ta-nya/iStock p. 78 t: © James Devaney/GC Images/Getty Images, b: © McKeown/Hulton Archive/Getty Images; p. 79 t: © Amy Geier/Unsplash, b: © MoustacheGirl/iStock; p. 80 t: © Steve Granitz/Getty Images, b: © Raymond Hall/Getty Images; p. 81 t © Ayo Ogunseinde/Unsplash, b: © Konstantin Aksenov/iStock; p. 82 t: © Jean-Daniel Francoeur/Pexels, b: © Joshua Rondeau/Unsplash; p. 83: © Delmaine Donson; p. 84 © Edward Berthelot/Getty Images; p. 85 t: © AnnaZhuk/Adobe, b: © Jesse Ballantyne/Unsplash; p. 86: © Arnaldo Magnani/Getty Images; p. 87 t: © David DM/Unsplash, b: © Nastya Palehina/Adobe; p. 88: © Nassim Boughasi/Unsplash, p. 90: © RB/Bauer-Griffin/GC Images/Getty Images; p. 91 t: © Cottonbro/Pexels, b: © Maria Galtseva/iStock; p. 92 t: © Dmitry Tsvetkov/Adobe, b: © Eugene Kammerman/Gamma-Rapho/Getty Images; p. 93 t and b: © annanahabed/Adobe; p. 94: © Apostolos Vamvouras/Unsplash, p. 96 t: © Tom Kelley Archive, b: © Streetstyleshooters/Getty Images; p. 97 tl: © Lightfield Studio/Adobe, tr: © Michael Afonso/Unsplash, b: © Jason Yoder/Unsplash, p. 98: © Keystone/Getty Images; p. 99 t: © Tamara Bellis/Unsplash, b: © Hamide Jafari/Unsplash; p. 100 t: © Max Mumby/Indigo/Getty Images, b: © Pool/Samir Hussein/WireImage/Getty Images; p. 101 t: © Ospan Ali/Unsplash, b: © Olga Poza Martin/iStock; p. 102: © Saint James; p. 103: © Saint James; p. 104 © Hulton Deutsch/Corbis Historical/Getty Images; p. 105 t: © Emile Mbunzama/Unsplash, b: © CoffeeAndMilk/iStock; p. 106: © faestock/Adobe, p. 107: © Jean Guichard/Gamma-Rapho/Getty Images, b: © Nick Karvounis/Unsplash, p. 108 t: © Ali Karimiboroujeni/Unsplash, b: © Ekaterina_Marory/Unsplash, p. 109: © Daniil Lobachev/Unsplash, b: © Sasha Changli/Pexels, p. 110 © S_Chum/iStock, b: © alonesdj/Adobe; p. 111 t: © Ales_Utvoko/iStock, b: © Fennah Chereka/Pexels, p. 112: © Ryan Plomp/Unsplash, p. 114: © Apostolos Vamvouras/Unsplash, b: © Verity Sanders/Unsplash; p. 115 t: © 4FR/iStock, b: © Jean-Luc Catarin/Unsplash; p. 116: © Bettmann/Getty Images; p. 117: © JeDo/Adobe; p. 118: © Apostolos Vamvouras/Unsplash; p. 119: © glebchik/iStock; p. 120: © kbwills/iStock; p. 121 t: © MarkSkalny/iStock, b: © Tanya Dusett/Unsplash; p. 122: © Alex Azabache/Unsplash; p. 123 l: © Sun Ming/Unsplash, r: © Alex Azabache/Unsplash; p. 124 t: © Viktor_Gladkov/iStock, b: © Victoria Chudinova/Adobe, p. 125: © vitaliymateha/Adobe, p. 126: © cocomtr/iStock, p. 127 t: © Godisable Jacob/Pexels, b: © Apostolos Vamvouras/Unsplash; p. 128 t: © ginkgofoto/Adobe, b: © Cisco_96/Adobe; p. 129: © Nikhil Uttam/Unsplash; p. 130 t: © Apostolos Vamvouras/Unsplash, b: © Serhat Beyazkaya/Unsplash; p. 131 Emile Guillemot/Unsplash; p. 132 l: © Jetrel/iStock, r: © Jordi Samora/Unsplash; p. 133: © DuoNguyen/Unsplash; p 134: © paffy/Adobe; p. 135 t: © Claudia Schmalz/Pexels, b: © Nida/Pexels; p. 136: © Christan Luis/Pexels; p. 138 t: © Eli DeFaria/Unsplash, b: © Justin Essah/Unsplash; p. 139 t: © Tamara Bellis/Unsplash b: © Hannah Busing/Unsplash; p. 140: © Tom Kelley Archive/Getty Images; p. 141 tl: © joelvalve/Unsplash, tr: © Jonathan Borba/Unsplash, b: © Joeyy Lee/Unsplash; p. 142 t: © Autri Taheri/Unsplash, b: © Ekaterina_Marory/iStock; p. 143: © Bostan Natalia/Adobe; p. 144 t: © Mike Von/Unsplash, b: © Matas Katinas/Unsplash; p. 145 t: © Alena Beliaeva/Unsplash, b: © anderpe/Adobe; p 146 t: © Bia Sousa/Pexels, b: © stockfour/iStock; p. 147 t: © Bella Zhong/Pexels, b: © Cottonbro/Pexels; p. 148: © Tim Mossholder/Unsplash; p. 149: © Red Umbrella&Donkey/Adobe; p. 150 t: © Phenyo Deluxe/Pexels, b: © Ksenia Varapaeva/Unsplash; p. 151 t: © Nicolas Ladino Silva/Unsplash, b: © AGCreativeLab/iStock; p. 152 t: © CoffeeAndMilk/iStock, b: © yo-yo/Unsplash; p. 153 tl: © Ali Ahmadi/Unsplash, tr: © Godisable Jacob/Pexels, b: © Artem Ivanchencko/Unsplash; p. 154 t: © ayaka_photo/Adobe, b: © Bettmann/Getty Images; p. 155: © Rawpixel.com/Adobe; p. 156 t: © Bansah Photography/Unsplash, b: © Aedrian/Unsplash; p. 157 t: © Katya Wolf/Pexels, b: © MartProduction/Pexels; p. 158 Dom Hill/Unsplash; p. 160 t: © Rawpixel, b: © k8most/Unsplash; p. 161 t: © Creatista/iStock, b: © Nejron Photo/Adobe; p. 162 t: © Pixabay/Pexels; b: © Tom Kelley Archive/iStock; p. 163 t: © michelangeloop/iStock, b: © Ali Karamiboroujeni/Pexels; p. 164 t: © Raymond Hall/GC Images/Getty Images, b: © Donato Sardella/WireImage/Getty Images; p. 165: © Edward Berthelot/Getty Images; p. 166 t: © PhotoEuphoria/iStock, b: © Jason Yoder/Unsplash; p. 167 t: © Felix Mizioznikov/Adobe, b: © Edward Berthelot/Getty Images; p. 168: © Pavlo Ballukh/iStock; p. 169: © shopformoose/iStock, b: © Renthel Cueto/Pexels; p. 170 t: © Riccardo Vicidomini/Unsplash, b: © Jetrel/iStock; p. 171: © Allef Vinicius/Unsplash, p. 172 t; © ta-nya/iStock, b: © Bogdan Perfiliev; p. 173 t: © Kevin Laminto/Unsplash, b: © ta-nya/iStock; p. 174 t: © Jetrel/iStock, b: © RetroAtelier/iStock; p. 175 t: © Yaroslava Astakhov/iStock, b: © Cottonbro/Pexels; p. 176 ©: Elina Sazonova/Pexels; p. 177 t: © ta-nya/iStock, b: © Tamara Bellis/Unsplash; p. 178 t: © spaxiax/Adobe, b: © Alexandra Tran/Unsplash; p. 179 l: © Susosu Water/Unsplash, r: © Izusek/iStock; p. 180: © Cottonbro/Pexels; p. 182 t: © Divine Effiong/Unsplash, b: © Nykeya Paige/Unsplash; p. 183 t: © baytunc/iStock, b: © PeopleImages/Unsplash; p. 184 t: © AGCreativeLab/iStock, b: © PeopleImage/Unsplash; p. 185 t: © PeopleImages/iStock, b: © Monstera/Pexels; p. 186 t: © David Suarez/Unsplash, b: © Marcus Santos/Unsplash; p. 187 t: © David Suarez/Unsplash, b: © Sincerely Media/Unsplash; p. 188: © Normform/iStock, p. 190 t: © 2mmedia/Adobe, b: © marmite/iStock; p. 191: © zolotareva_elina/Adobe; p. 192 t: © MoustacheGirl/Adobe, b: © Victoria Chudinova/Adobe; p. 193 t: © BigLike Images/Adobe, b: © Mirko di Micco/Unsplash; p. 194 t: © Rohappy/iStock, b: © mtcurado/iStock; p. 195: © Hong Son/Pexels; p. 196 t: © Godisable Jacob/Pexels, b: © RetroAtelier/iStock; p. 197 t: © Tamara Bellis/Unsplash, b: © Alex Shaw/Unsplash; p. 198 t: © sanneberg/Adobe, b: © tvirbikis/iStock; p. 199 t: © Dana Keli/Adobe, b: © Red Umbrella&Donkey/Adobe; p. 200 t: © JeanUrsula/iStock, b: © Kalim/Adobe; p. 201 t: © lalouetto/Adobe, b: © Aleksander Kaczmarek/iStock; p. 202 t: © Wesley Tingey/Unsplash, b: © Dynamic Wang/Unsplash; p. 203 t: © Min An/Pexels, b: © Molly Mears/Unsplash; p. 204: © Roman Ivanschenko/Adobe; p. 205: © Andrea Piacquadio/Pexels; p. 206: © prairie_eye/iStock

Front cover: © iconogenic/iStock
Back cover: © Engin Akyurt/Unsplash (Daisy Duke shorts/Shorts); © EdNurg/Adobe (John Lennon glasses/John-Lennon-Brille); © motimeiri/iStock (Platform shoes/Plateauschuhe); © Magdalena/Adobe (Pleated skirt/Plisseerock); © Tarzhanova/iStock (Slip dress/Slipkleid)

© 2022 teNeues Verlag GmbH

Texts: © Agata and Pierre Toromanoff, Fancy Books Packaging UG. All rights reserved.

Editorial coordination by Nadine Weinhold, teNeues Verlag
Production by Sandra Jansen-Dorn, Alwine Krebber, teNeues Verlag
Photo editing, colour separation by Fancy Books Packaging and Luczak Studio
Design by Agata Toromanoff, Fancy Books Packaging UG

Translation into German by Rebecca Rosenthal
Copyediting by Lee V. Ripley (English text), Nadine Weinhold, teNeues Verlag (German translation)

ISBN: 978-3-96171-421-6 (English cover)
978-3-96171-422-3 (German cover)
Library of Congress Number: 2022942834

Printed in Slovakia by Neografia a.s.

Picture and text rights reserved for all countries. No part of this publication may be reproduced in any manner whatsoever.

While we strive for utmost precision in every detail, we cannot be held responsible for any inaccuracies, neither for any subsequent loss or damage arising.

Every effort has been made by the publisher to contact holders of copyright to obtain permission to reproduce copyrighted material. However, if any permissions have been inadvertently overlooked, teNeues Publishing Group will be pleased to make the necessary and reasonable arrangements at the first opportunity.

Bibliographic information published by the Deutsche Nationalbibliothek:
The Deutsche Nationalbibliothek lists this publication in the Deutsche Nationalbibliografie; detailed bibliographic data are available on the Internet at dnb.dnb.de.

Published by teNeues Publishing Group

teNeues Verlag GmbH
Ohmstraße 8a
86199 Augsburg, Germany

Düsseldorf Office
Waldenburger Straße 13
41564 Kaarst, Germany
e-mail: books@teneues.com

Augsburg/München Office
Ohmstraße 8a
86199 Augsburg, Germany
e-mail: books@teneues.com

Berlin Office
Lietzenburger Straße 53
10719 Berlin, Germany
e-mail: books@teneues.com

Press Department
e-mail: presse@teneues.com

teNeues Publishing Company
350 Seventh Avenue, Suite 301
New York, NY 10001, USA
Phone: +1-212-627-9090
Fax: +1-212-627-9511

www.teneues.com

teNeues Publishing Group
Augsburg/München
Berlin
Düsseldorf
London
New York

teNeues